# RUSSELL WESTBROOK

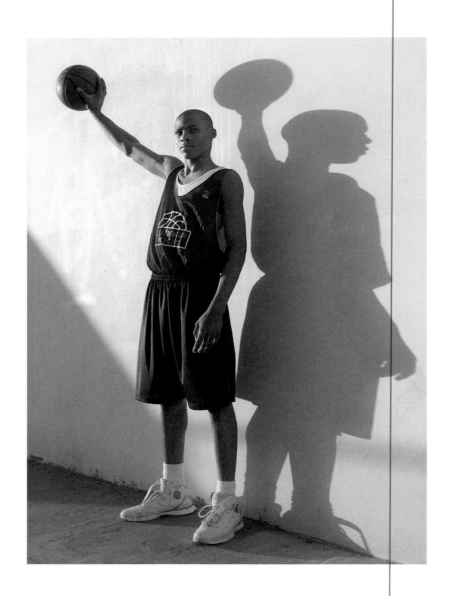

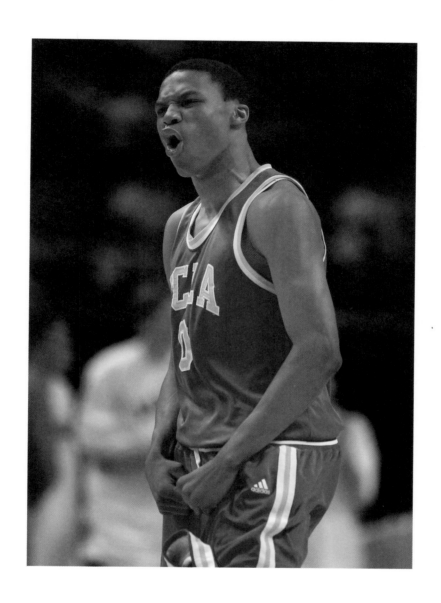

Russell Westbrook
Edited by Jonathan Evans

RIZZOLI NEW YORK

New York · Paris · London · Milan

# WESTBROOK

# RUSSELL

# STYLE

# DRIVERS

YOU MAY HAVE NOTICED IT, OVER THESE PAST FEW YEARS: THE RISE OF A NEW BREED OF CREATIVE AND INFLUENTIAL PEOPLE.

THEY DEFY CATEGORIZATION, AT LEAST IN THE CONVENTIONAL SENSE. THEY DEMAND HYPHENS AND SLASHES, MULTI-PART EXPLANATIONS OF WHAT, EXACTLY, THEY DO. BECAUSE THEY DO A LOT, AND THEY DO IT ALL AT ONCE.

THEY AREN'T CONTENT TO FOLLOW THE RULES. INSTEAD, THEY'RE WRITING THEIR OWN. THEY'RE THE REBELS AND THE INNOVATORS. THE PEOPLE WHO AREN'T JUST PARTICIPATING IN THE CONVERSATION BUT PUSHING IT FORWARD.

THEY ARE STYLE DRIVERS. EXISTING AT THE INTERSECTION BETWEEN THE WORLDS OF MUSIC, ART, FASHION, TECH, AND A HOST OF OTHER INDUSTRIES AND ENDEAVORS, THEY'RE SHAPING THE FABRIC OF MODERN CULTURE AND STYLE IN WAYS WE DIDN'T EVEN KNOW WERE POSSIBLE UNTIL THEY CAME ALONG. AND WITH THIS BOOK, WE'RE PAYING HOMAGE TO THEM THROUGH THE LENS OF THE QUINTESSENTIAL STYLE DRIVER: RUSSELL WESTBROOK. THE PERSONALITIES ARE VARIED, BUT THE QUALITIES THAT HELP DEFINE THEM—CONFIDENCE, CURIOSITY, AND A COMPLETE DISREGARD FOR THE OLD RULES—ARE THE COMMON THREAD.

**JONATHAN EVANS**

DANIEL ARSHAM
MARCELO BURLON
DAO-YI CHOW
TIM COPPENS
VICTOR CRUZ
SIMON DOONAN
LAPO ELKANN
JENNIFER FISHER
BEN GORHAM
NIPSEY HUSSLE
DJ KHALED
STEVEN KOLB
LONG NGUYEN
MAXWELL OSBORNE
BYRON PEART
DEXTER PEART
RAYMOND PETTIBON
PUSHA T
SELIMA SALAUN
CHARLOTTE SEDDON
BRANDON SVARC
WILL WELCH
HOWARD "H" WHITE
SERENA WILLIAMS

# RUSSELL WESTBROOK

10    In Conversation
with Russell Westbrook

14    Introduction
by Simon Doonan

18    **NEW RULES**

30    The Concrete Runway

40    Style Driver Steven Kolb

50    Style Driver Daniel Arsham

52    Style Driver Pusha T

68    Style Driver Victor Cruz

76    **COLLABORATION**

84    Style Driver Marcelo Burlon

89    Style Driver Charlotte Seddon

90    Style Driver Ben Gorham

96    Style Drivers Byron + Dexter Peart

102    Style Driver Selima Salaun

112    Style Driver Howard "H" White

114    Sneakers
Westbrook 0.1 and 0.2

130    **STYLE IS A SPECTATOR SPORT**

136    Style Drivers Dao-Yi Chow +
Maxwell Osborne

139    Style Driver Jennifer Fisher

152    Style Driver Tim Coppens

168    **WHY NOT?**

174    Style Driver Lapo Elkann

180    Style Driver Brandon Svarc

184    Style Driver Nipsey Hussle

190    Style Driver Long Nguyen

192    Style Driver Will Welch

194    Style Driver Simon Doonan

204    **PLAYING THE GAME**

216    Style Driver Serena Williams

228    Style Driver DJ Khaled

244    Accolades and Honors

258    Russell Westbrook + Family

# IN CONVERSATION RUSSELL WESTBROOK

Early on in the process of planning the book you hold in your hands right now, someone asked me why I was doing it. What did I want people to get out of it? The answer is simple: I want people to be able to see and understand that I'm able to do many things. That we all are.

Because whenever you're true to yourself and true to what you believe in, you can always find success. At least that's how I look at it.

The personalities included in these pages—the Style Drivers —all live the kind of life I'm talking about. I'm inspired by them because they offer another perspective on what it means to do so many different things at once. Because when you're driving style forward, there are a lot of things that come with it. From self-presentation to innovation, everything is a part of that conversation.

There are so many different ideas and opportunities and paths that people can relate to and explore, and that's really what this book is about: understanding not just the destination but the journey.

**R.W.**

*RUSSELL AND I SAT TOGETHER TO TALK ABOUT HOW THIS PROJECT CAME TOGETHER AND WHAT IT MEANS. WE CHATTED ABOUT CREATIVITY, AND FEARLESSNESS. ABOUT WHAT'S NEXT FOR HIM, AND WHAT HE WANTS PEOPLE TO GET FROM THE PAGES THAT FOLLOW. HERE'S WHAT HE HAD TO SAY.*

**JONATHAN EVANS**

## ON STYLE

For me, there's no true definition of what it means to be stylish. It just goes on just how you feel it. The state of mind you're in. The confidence and swagger that you want to portray during those times.

## ON TAKING RISKS

My slogan is "Why not?" And that's the way I live. That's the slogan I stand by—the name of my foundation. In anything that I do, it's the "Why not?" mentality. I think that's kind of how my mind is. For one, I don't care what other people think of me, because that really doesn't matter. As long as you feel comfortable and confident in what you're doing, I think you should be fine with wearing or doing whatever, as long as it's positive.

## ON NOT BEING AFRAID

Some people are scared to make mistakes. Some people are scared to mess up. Not worrying about messing up or making mistakes makes me be more fearless to do anything that I want to put my mind to. Honestly, I don't know where it comes from. I think just blessings. Regardless of what other people say, it doesn't affect me. It doesn't change my life any, that's kind of how I look at it.

## ON EXPRESSING YOURSELF THROUGH STYLE

I cared about it a lot when I was younger, I just didn't have the platform that I have now—the ability to be able to meet different people, the ability to travel, the ability to buy certain things. I've been blessed with the opportunity to be able to play the game of basketball and be provided this platform, so I better use it to be able to expand my ability to create, to be able to show my creative side when it comes to style.

## ON BUILDING A PRESENCE IN THE WORLD OF STYLE

Honestly, I didn't know that was a lane that was for me. But I always knew I liked it, to express how I was feeling through fashion. It caught some speed and people were paying attention; whether it was good or bad, people were paying attention to it. I think it gave me an opportunity to be able to not just showcase style, but to sit down with people, style icons—like Anna Wintour, André Leon Talley, those type of people—to be able to sit down and express how I feel about fashion and pick their brains, and meet different people across the world. It gave me some credibility in that space, to be able to do different things that I want to do.

## ON STYLE BEING A PSYCHOLOGICAL WEAPON

I think being stylish is a lot more important now. I think people pay much more attention, because I think before it wasn't as important. But now, people—whether it's athletes or people into music, entertainment, or actors or actresses—it's a lot more important for them now. I think there's probably a lot of different reasons why people may want to do it; I'm not really sure. Maybe it's another way for them to express themselves, like myself, or another way for them to kind of get themselves out there and meet a different brand of people. Everybody's got their own reasons.

## ON STYLE IN SOCIAL MEDIA

Now, in this day and age, you can't do much without somebody seeing you. You're going to be noticed for the things that you're doing, so I think it definitely has an effect on it.

## ON PERSONAL STYLE

It all depends on what you believe in or if you care what other people think about it. When I'm getting dressed, I'm not getting dressed for anybody else. I get dressed because I like it. That's how it is. People who are stylish have their own style, whether it's Pharrell, whether it's Kanye—whoever it is. "Okay, that's their style. That's what they do." I think now I'm at a place where people are like, "Okay, that's a Westbrook style. That's what he does."

## ON AUTHENTICITY

I think a lot of people dress based on what other people are doing, based on the trend. Me personally, I don't follow trends. I like to create my own and do whatever I'm feeling at the time, and kind of just go with that.

## ON WHO HE IS

People know me, obviously, for basketball, for different reasons, or maybe for fashion. But when somebody asks me what I do, I tell them I do a combination of a lot of things. That's the real answer. I think it's almost trying to be like a Renaissance man: a Renaissance man does this, he does that, he's got this, he's got this going on, he's trying this. That's how I try to look at it.

## ON THE PERSONALITIES IN THE BOOK

They're people who have professions and who do something, but that also do other things in the world that can relate to how I see it—be it people who are more creative, people who have been in different worlds. Whether it was in fashion or in music, or whether it was in sports and fashion, or whether it's in cars and fashion, or whatever it is. People who have their hands in different things. The way the world is and the way people see fashion and where it's going, I think they are pushing it.

## ON THE FUTURE OF FASHION

It honestly gets me excited that people are more open to being themselves. I think the more and more I see fashion, a lot more people are deciding to step out of their comfort zones. That makes me more excited, because that means people are being themselves, people are being more outside of the box and want to expand, and I think that's the best part about it.

## ON WHAT'S NEXT

Honestly, that's hard for me to say. Because there are different things that I may want to do that I think about everyday but haven't come into play yet. Every day I try to find ways to keep expanding my brand—expanding my brand in the style world, in the fashion world—and try to find ways to be successful.

INTRODUCTION

**DO YOU HAVE WHAT IT TAKES TO BECOME A STYLE DRIVER?**
**THERE'S ONLY ONE WAY TO FIND OUT.**
**BELOW ARE MY STYLE DRIVER COMMANDMENTS.**
**TAKE A GANDER, AND THEN TAKE YOUR STYLE FOR A SPIN . . .**

SIMON DOONAN

**S**wagger, don't stagger.

Becoming a Style Driver demands bucketloads of confidence and utter conviction. Wearing wacky duds is all fine and dandy, just make sure you mean it.

**T**aunt your enemies.

Style is a competitive game. Peacock your way to prominence. Nothing wrong with wanting to be the best. If you have any doubts, go talk to Mr. Westbrook.

**Y**acht rock?

Minimize your exposure to everything ersatz. Fill your playlist with groovy innovation. Cherry pick your way through the culture and seek out the best. Bowie? Joy Division? King Sunny Ade? That's more like it.

**L**et your freak flag fly.

Style Driving is all about experimentation. If you are fundamentally straight-laced and conservative, then better surrender your Style Driver's license now, before you commit some kind of gnarly traffic violation.

**E**nema.

Let's face it, your closet needs a big one. Start by dumping all the basics, the blah, and the bland. Everything in your wardrobe should count. Every T-shirt, bomber, and sneaker should be a thing. Even your socks and undies. Correction: especially your socks and undies.

**D**on't not laugh.

There's nothing more terrifying than a super-stylish bloke with no sense of humor.

**R**ely on a signature flourish.

You need it. We all do. I am talking about that little gesture of eccentricity that is yours and yours alone. Iris Apfel has her mega owl specs. I have my flowery shirts, and Russell? Hello! Russell has his "Why Not?" motto. What's your flourish?

**I**ndicate.

Always remember that others are following your Style Driver moves. When you are getting ready to make a sharp left turn into even greater fabulosity, turn your blinker on and give your followers a little advanced warning. It's only fair.

**V**intage fashion!

Style Drivers dig nudie cowboy shirts, vintage biker tees, '90s rapper drag, early Margiela, '90s Comme des Garçons, '80s Cazals and Chanel and Gucci, Pucci and Fiorrucci.

**E**ducate you.

It's not enough to be unconventional dresser. You must also become an unconventional thinker. #philosophicalmusings #uniteyourmindfromyourbehind #deepthoughts #onceinawhilegetoffyourphoneandreadabook

**R**emember Mother's Day, and Father's Day.

Honor the people who gave you life and enabled you to become the ball-busting, taboo-breaking, ass-kicking Style Driver that you are today.

TO MY FAMILY

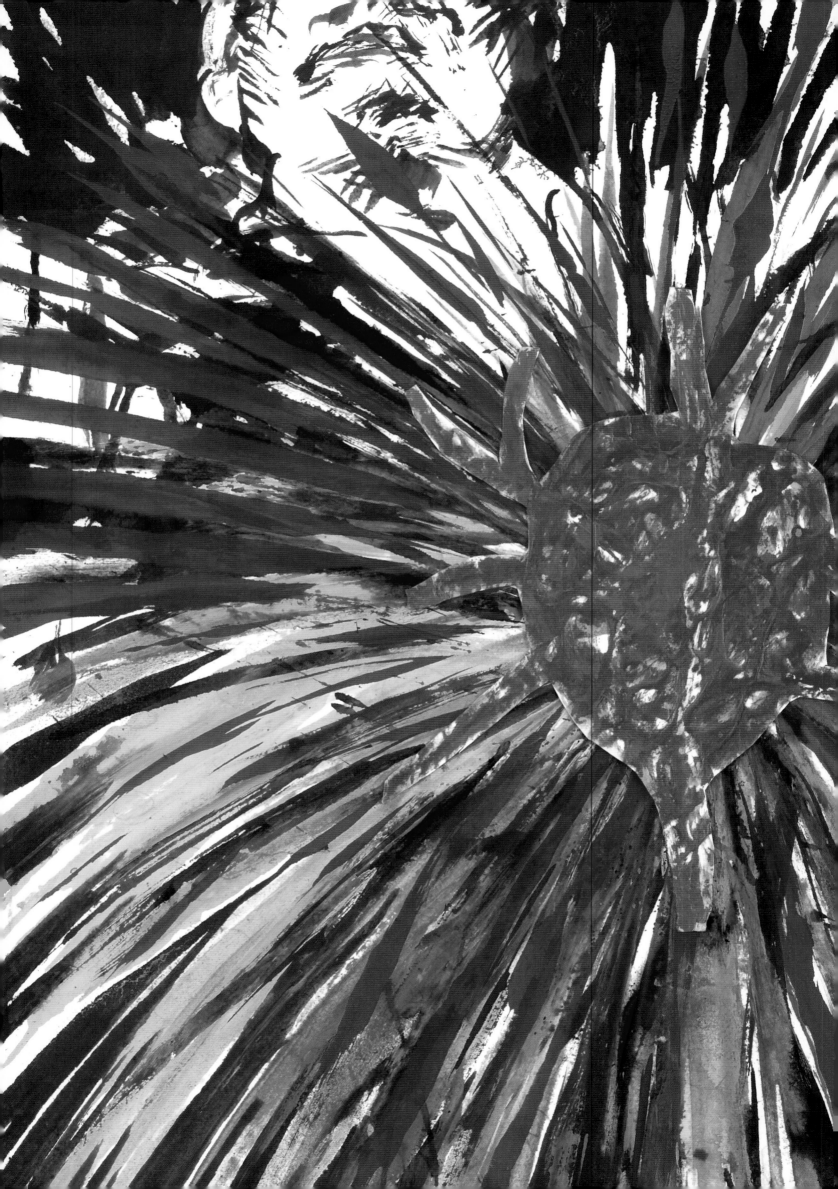

# NEW RULES

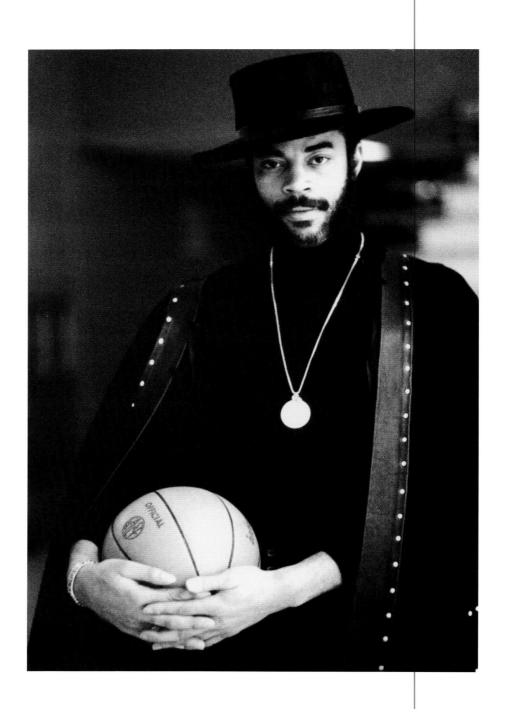

///// ///  That sense has probably been
around forever. Look back at Clyde Frazier.
The mink coats, the Rolls Royces . . .
**Howard "H" White**

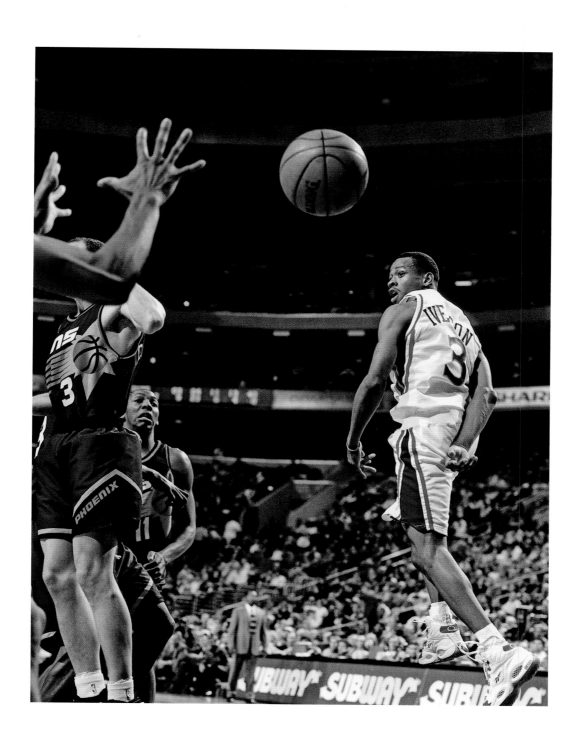

///// ////// / Alan Iverson was a guy
I really looked at.
He had something different on the court.
R.W.

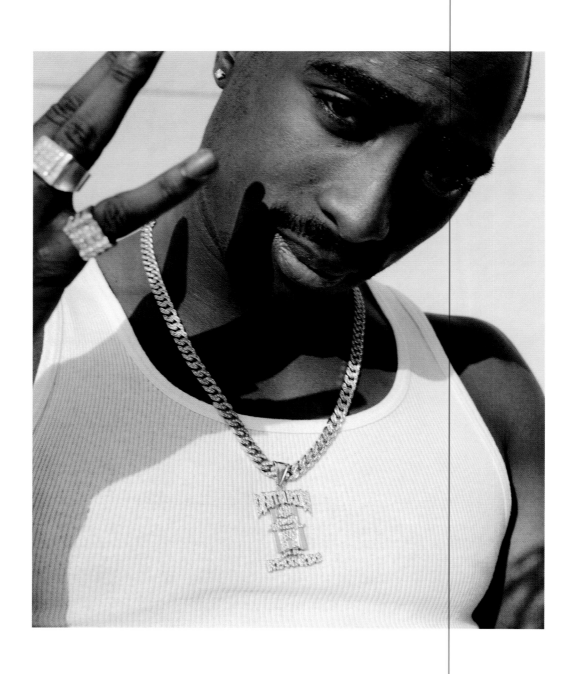

/////////// ////  Tupac wasn't like anyone else.
R.W.

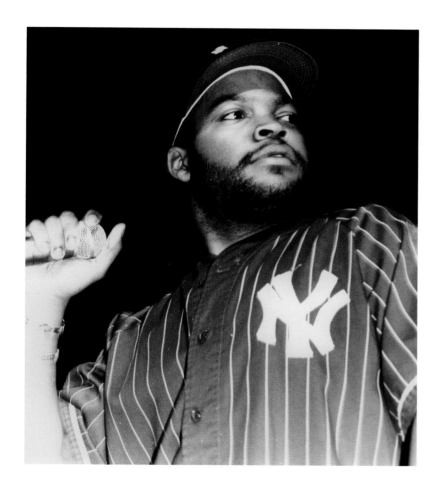

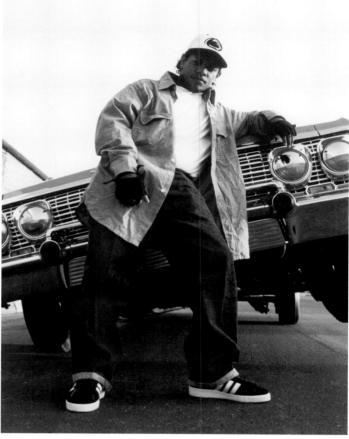

// ///////// / NWA and Ice Cube gave us a
new star to follow.
R.W.                                                    23

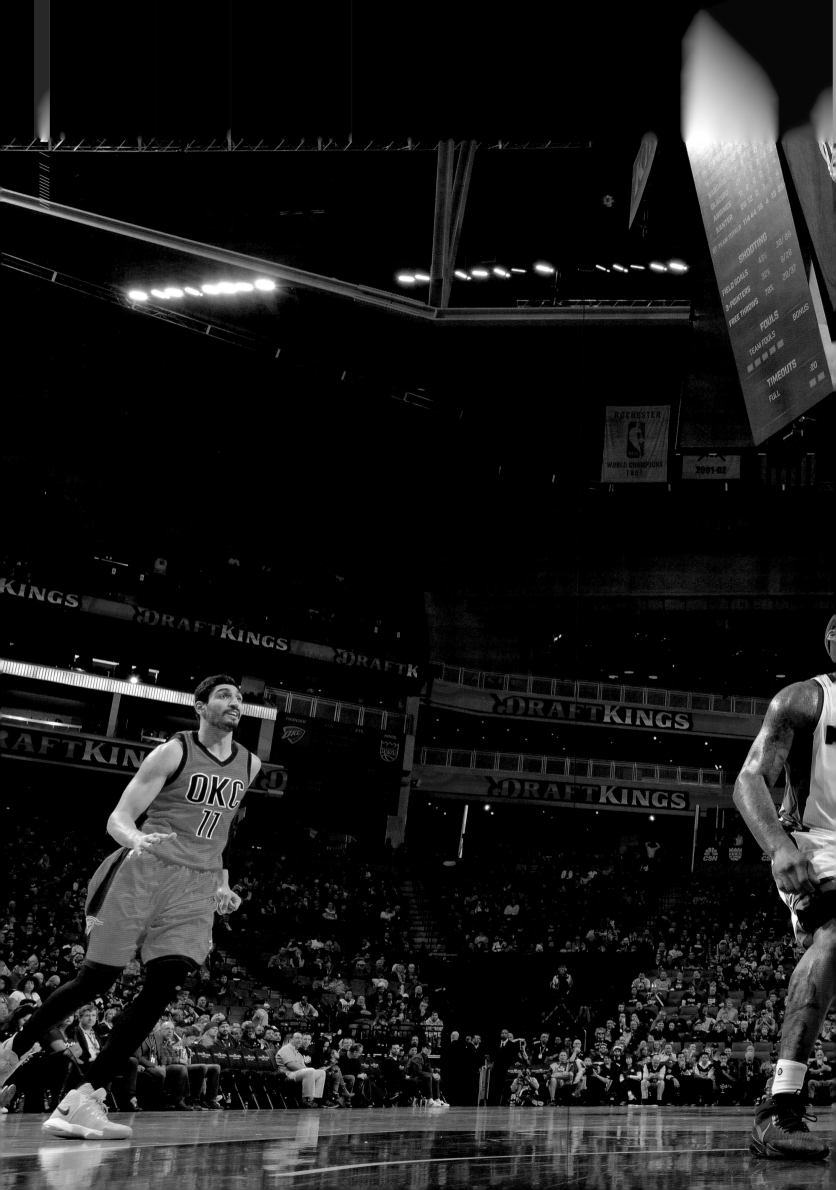

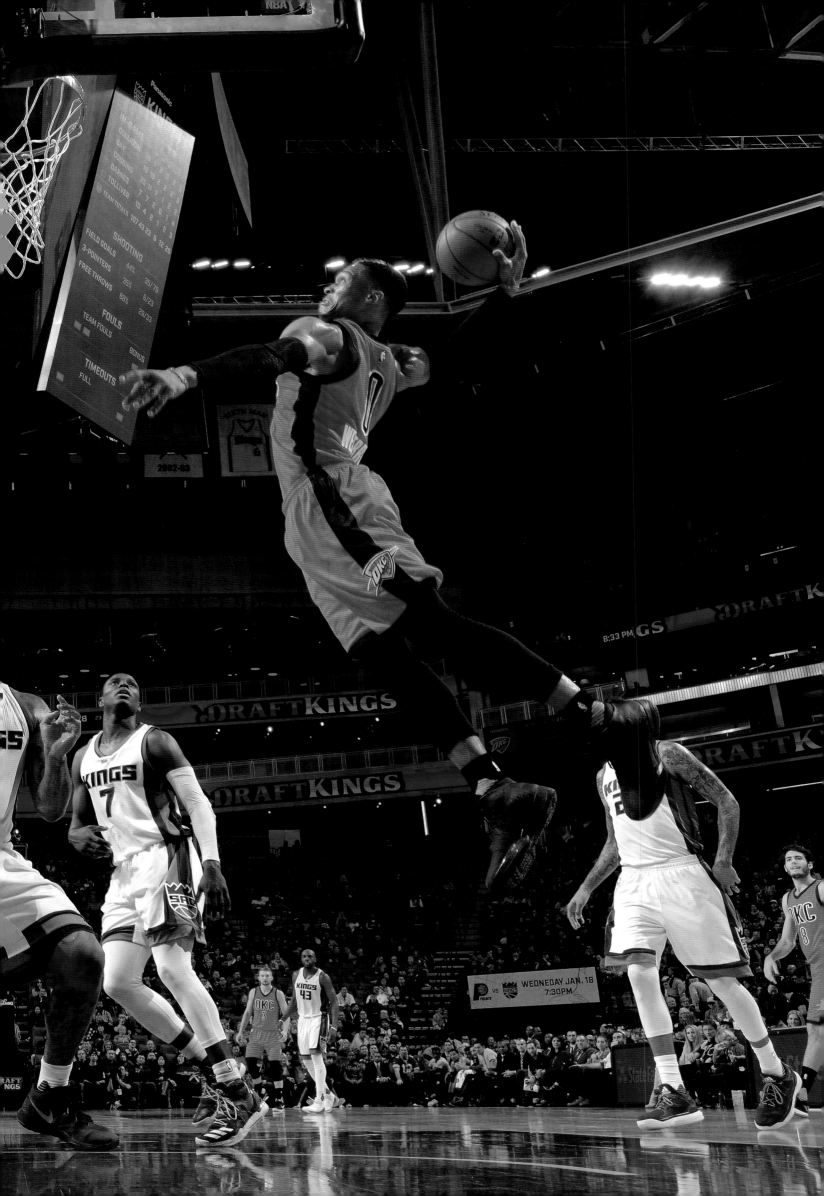

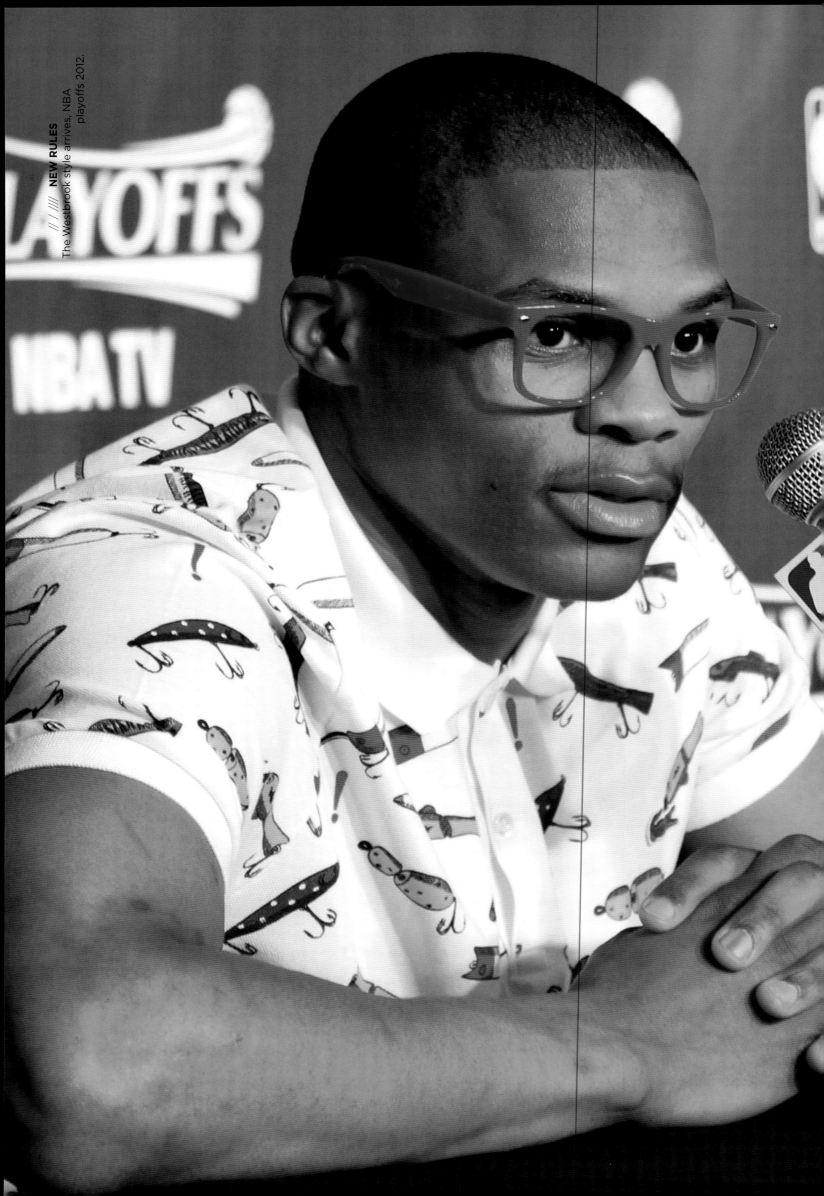

**"When I'm getting dressed, I'm not getting dressed for anybody else. I get dressed because I like it. That's how it is.
"**

R.W.

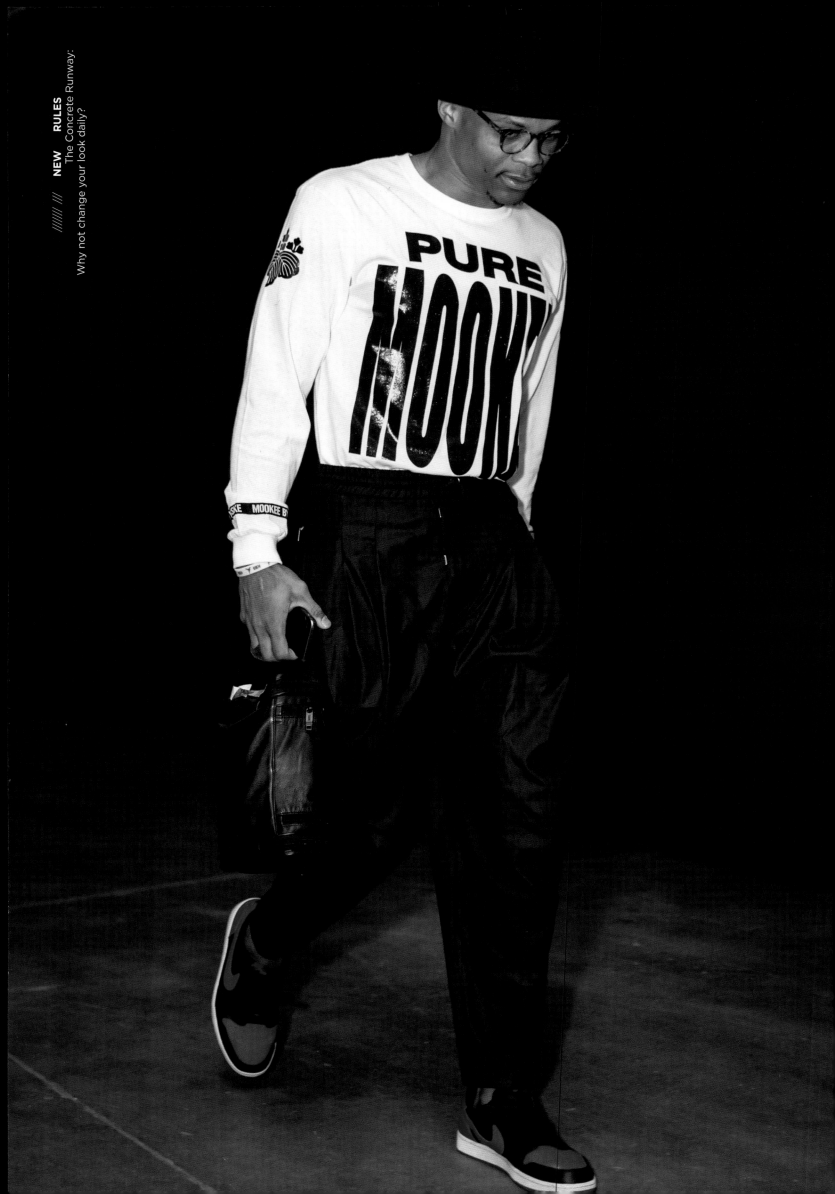

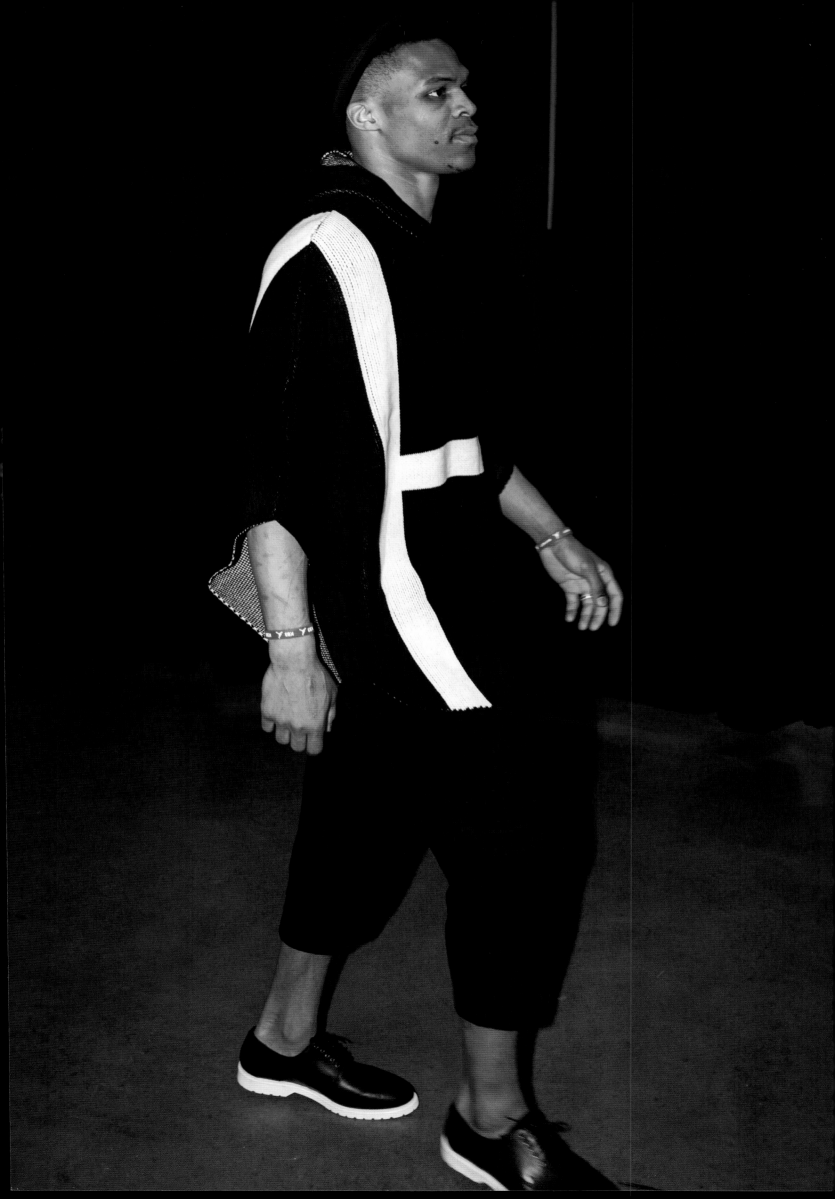

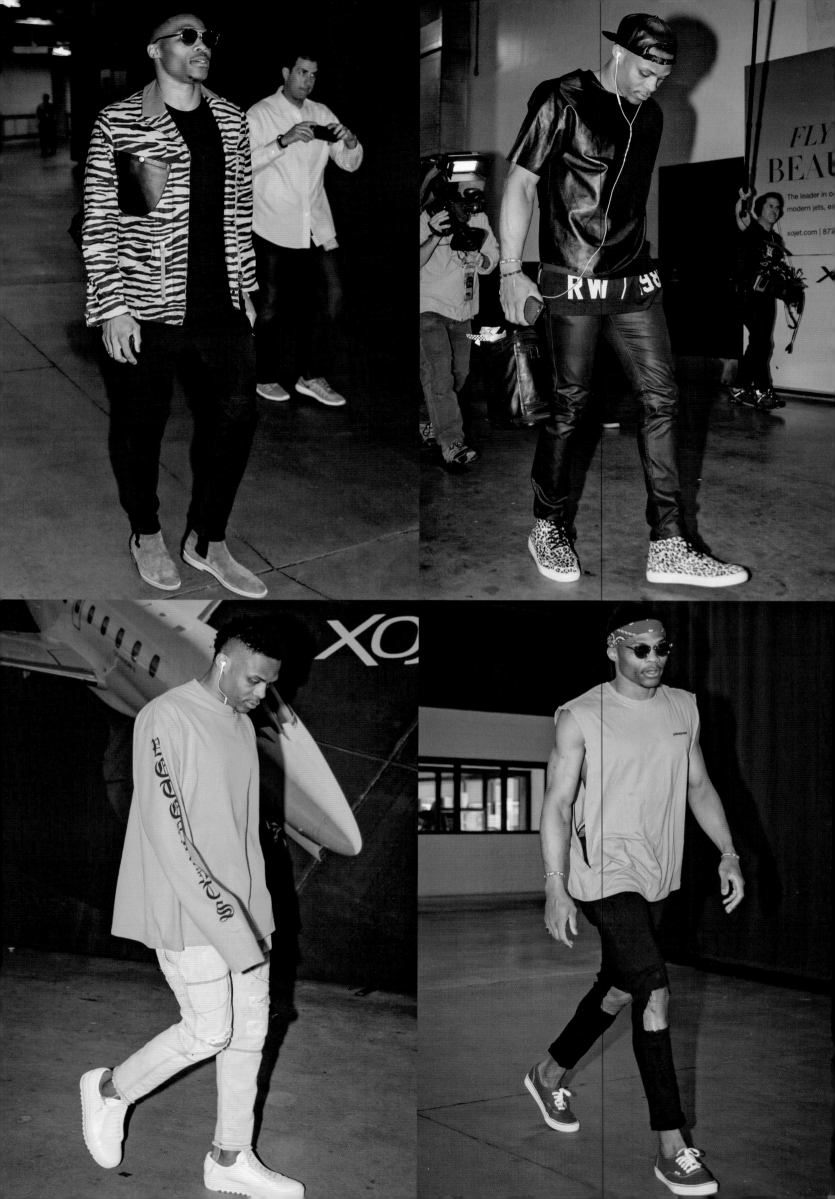

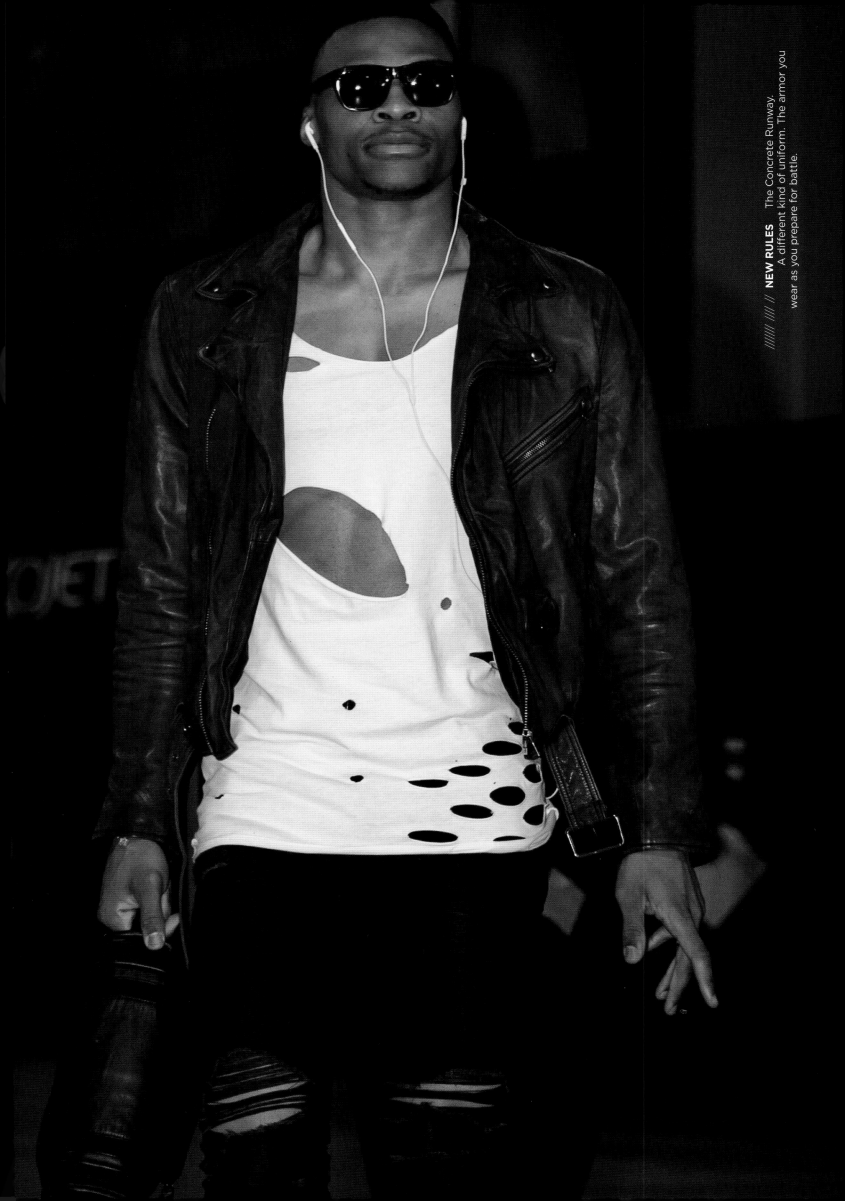

///// ///// // **NEW RULES** The Concrete Runway. A different kind of uniform. The armor you wear as you prepare for battle.

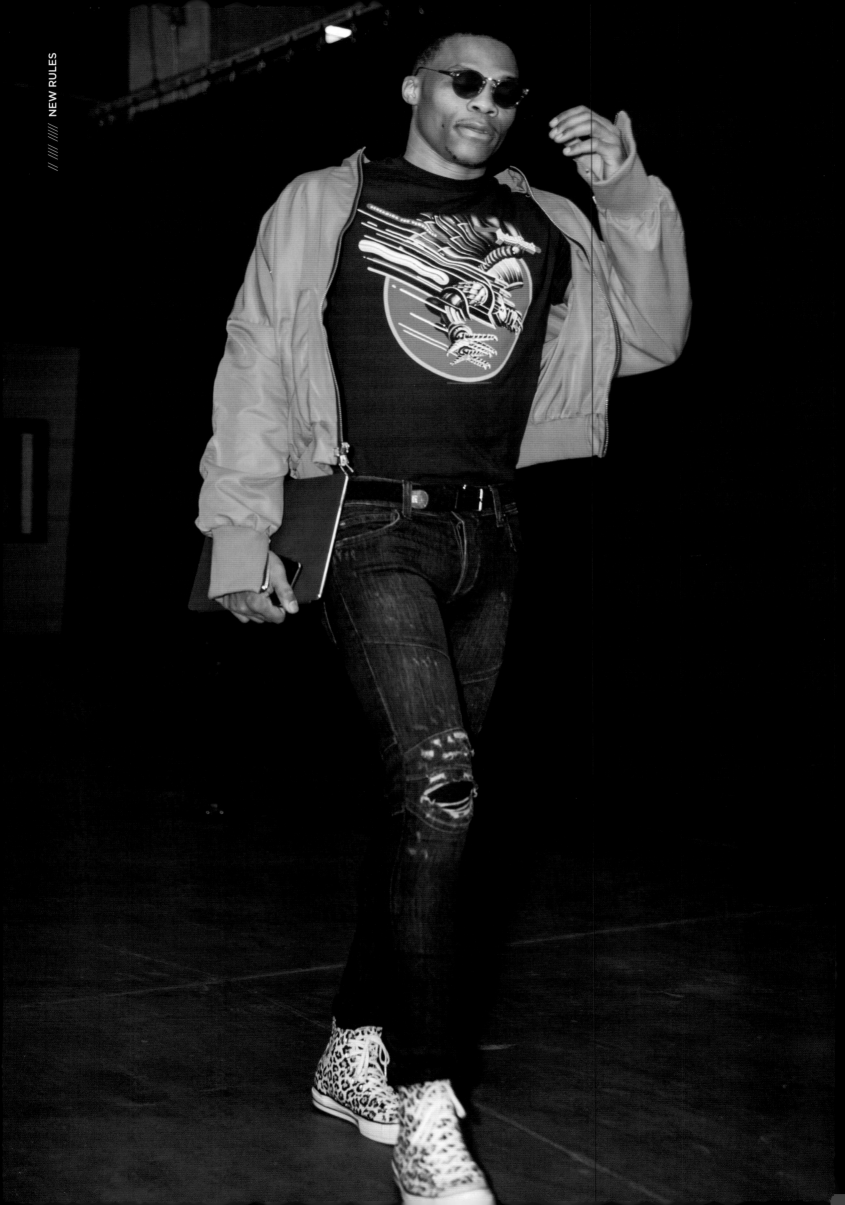

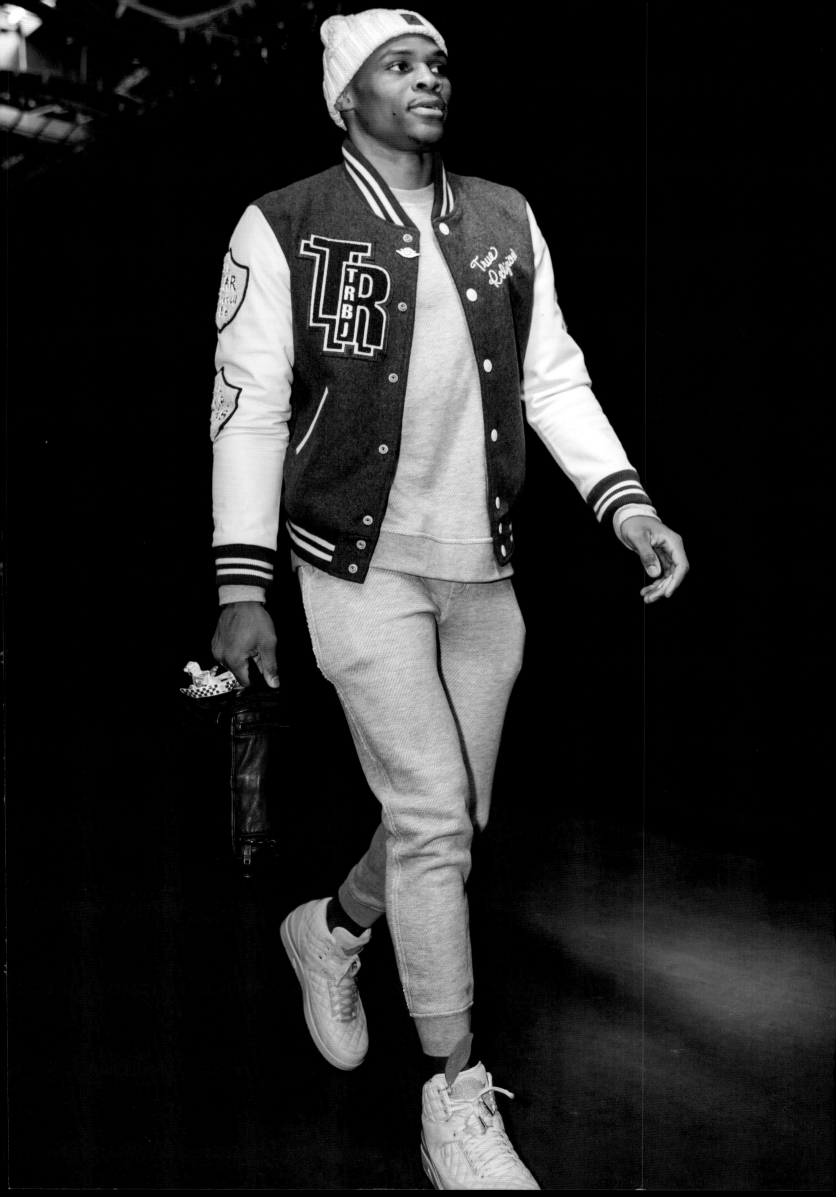

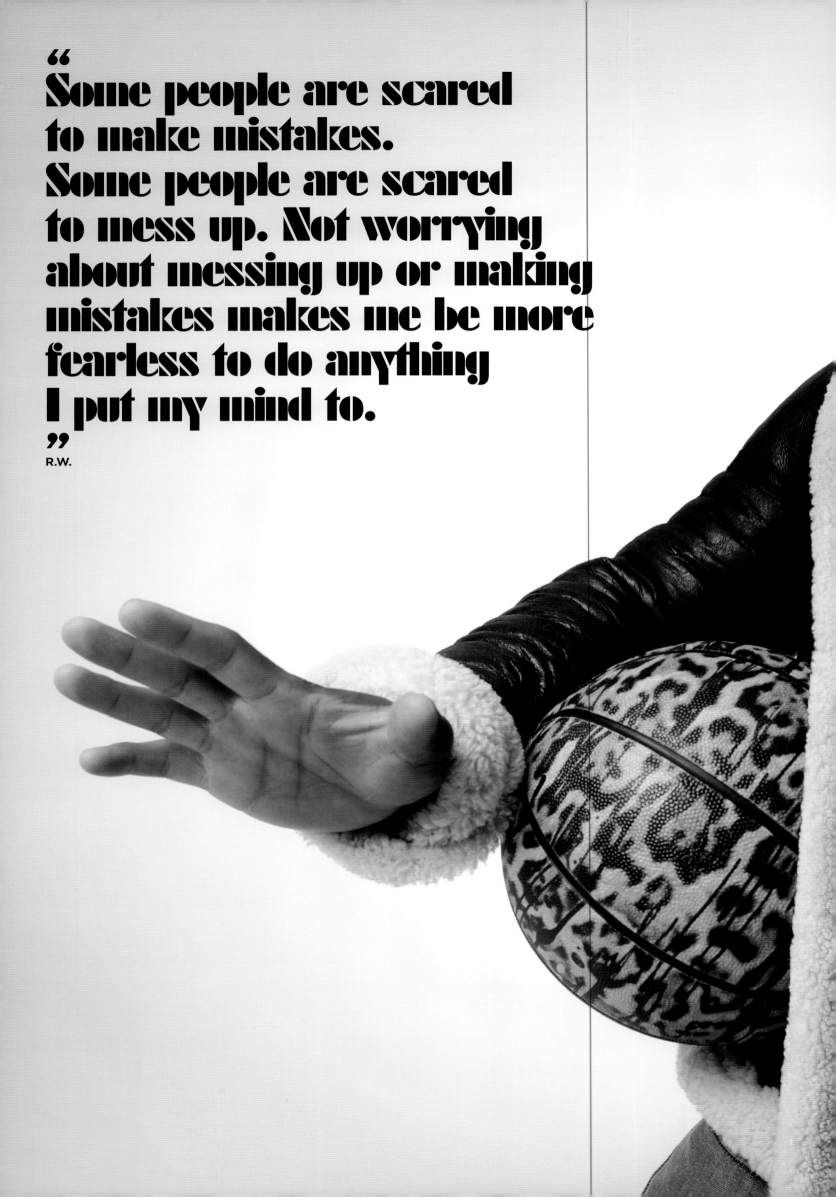

" **Some people are scared to make mistakes. Some people are scared to mess up. Not worrying about messing up or making mistakes makes me be more fearless to do anything I put my mind to.** "

R.W.

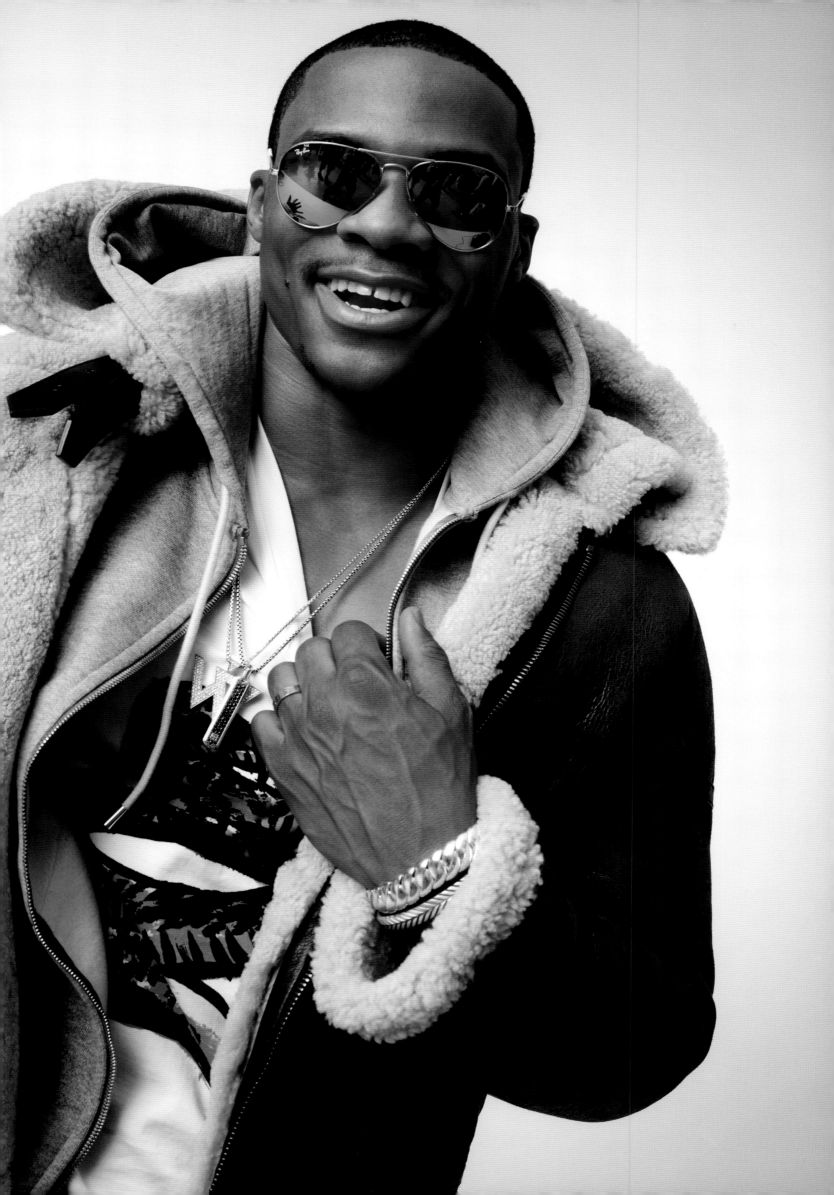

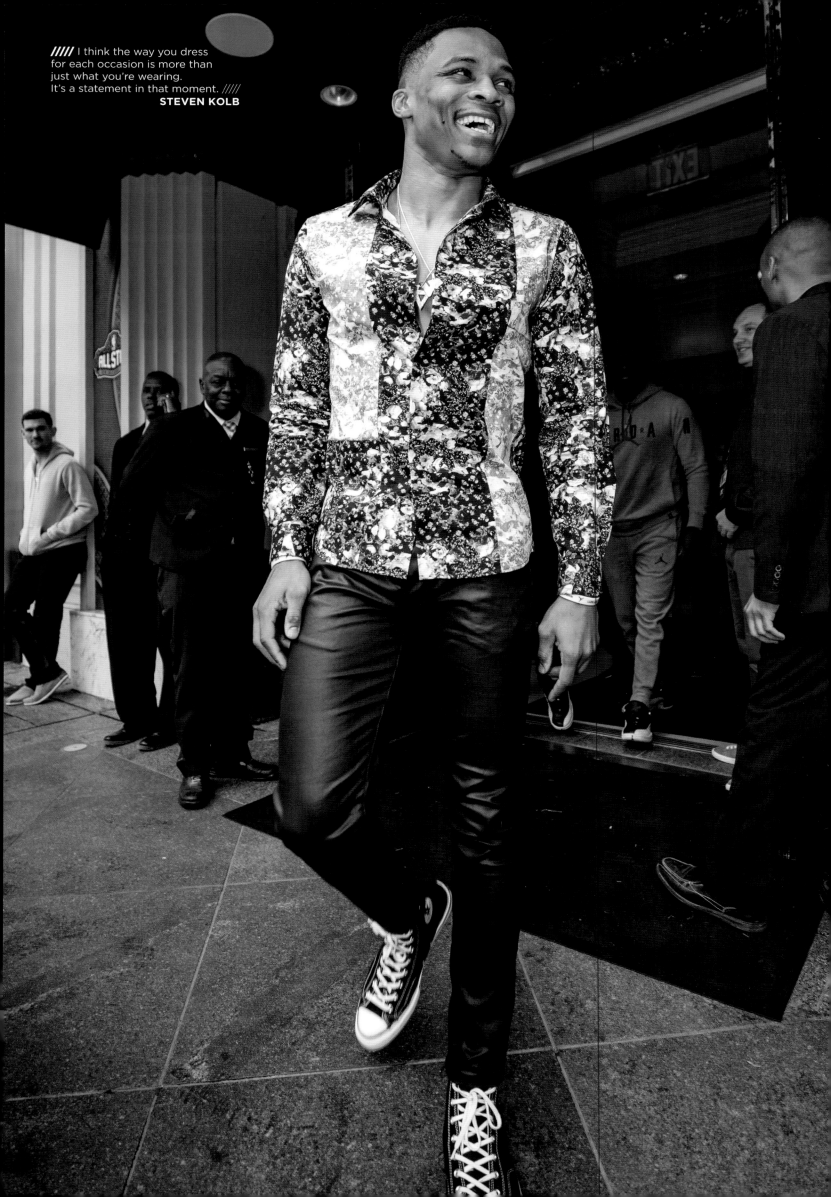

///// To have a style that makes you unique and that makes the objects you do unique for yourself or for others, you need to constantly and continuously have in your mind and in your heart and in your soul this famous word, which is "curiosity." /////
**LAPO ELKANN**

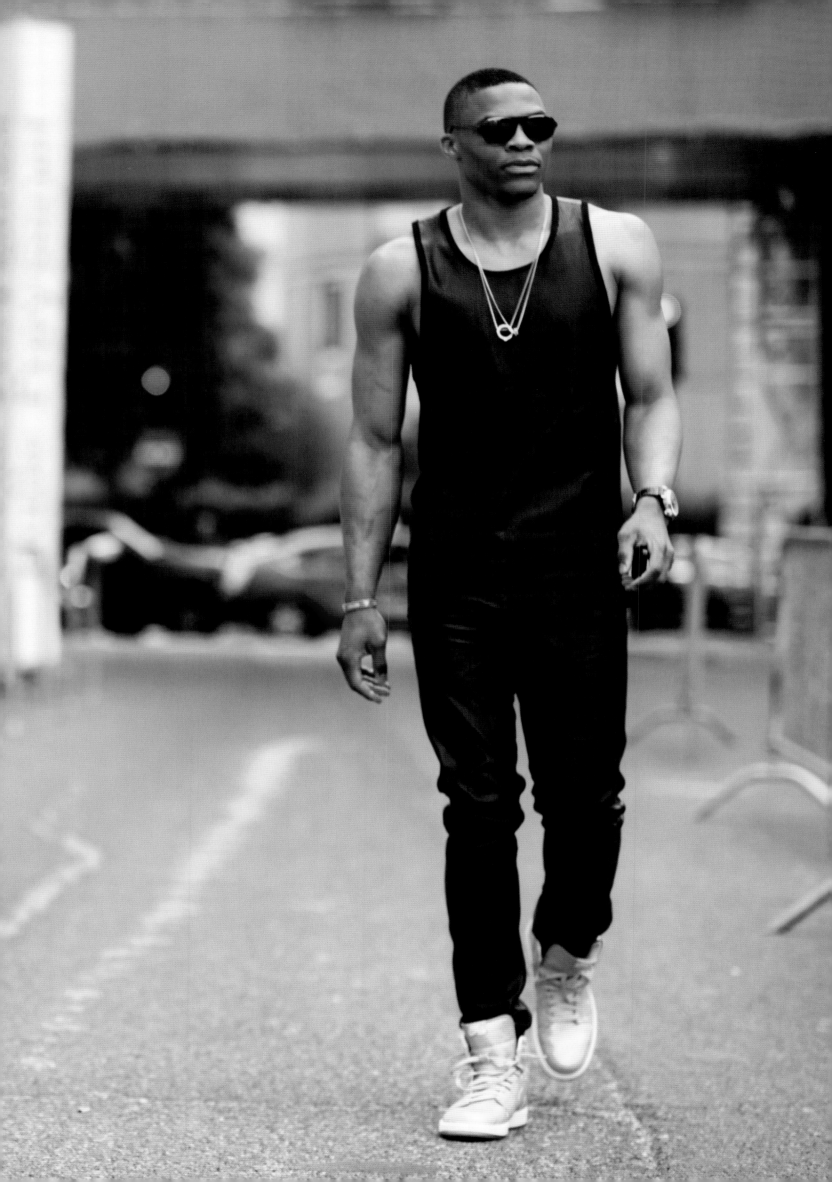

"Sometimes Russell will come through the tunnel in some shit that people be like,

# 'What the hell he got on?'

And a couple months later that'll be less surprising to see somebody in that. And you've got to credit that as breaking a little bit of ice. "

NIPSEY HUSSLE

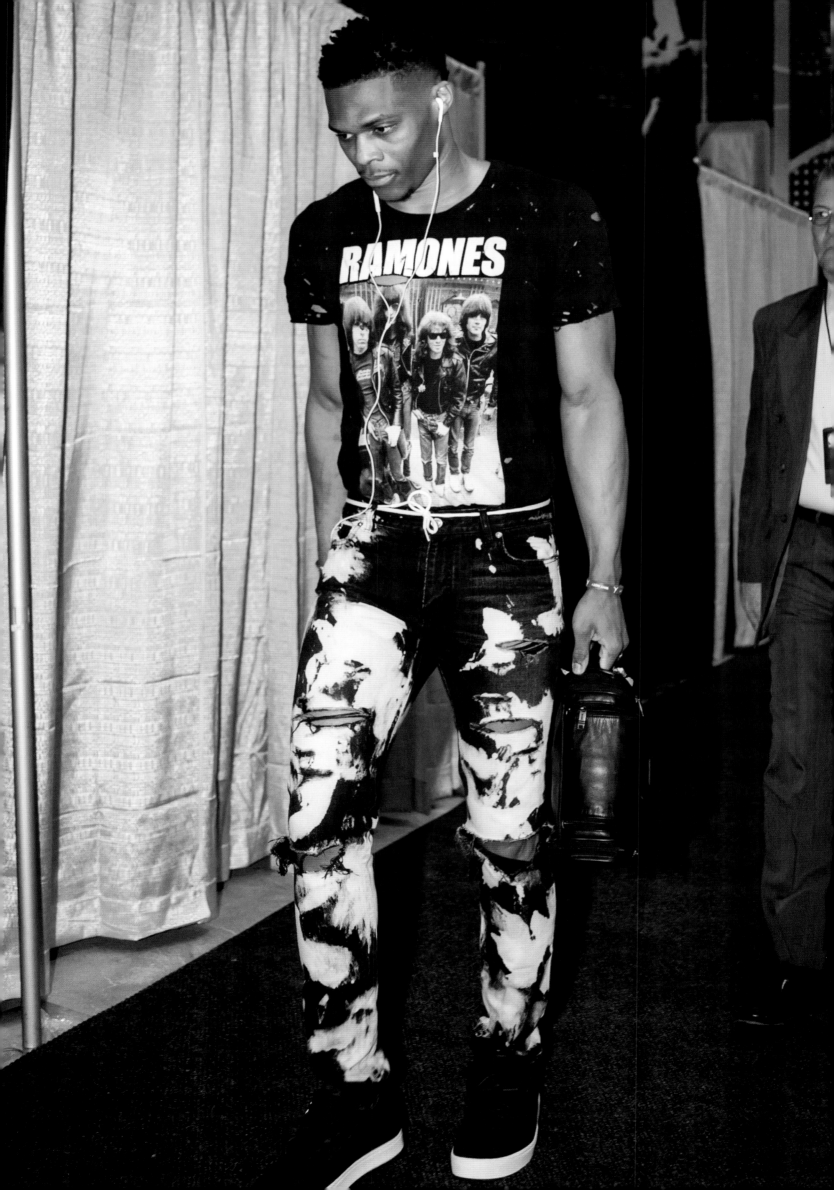

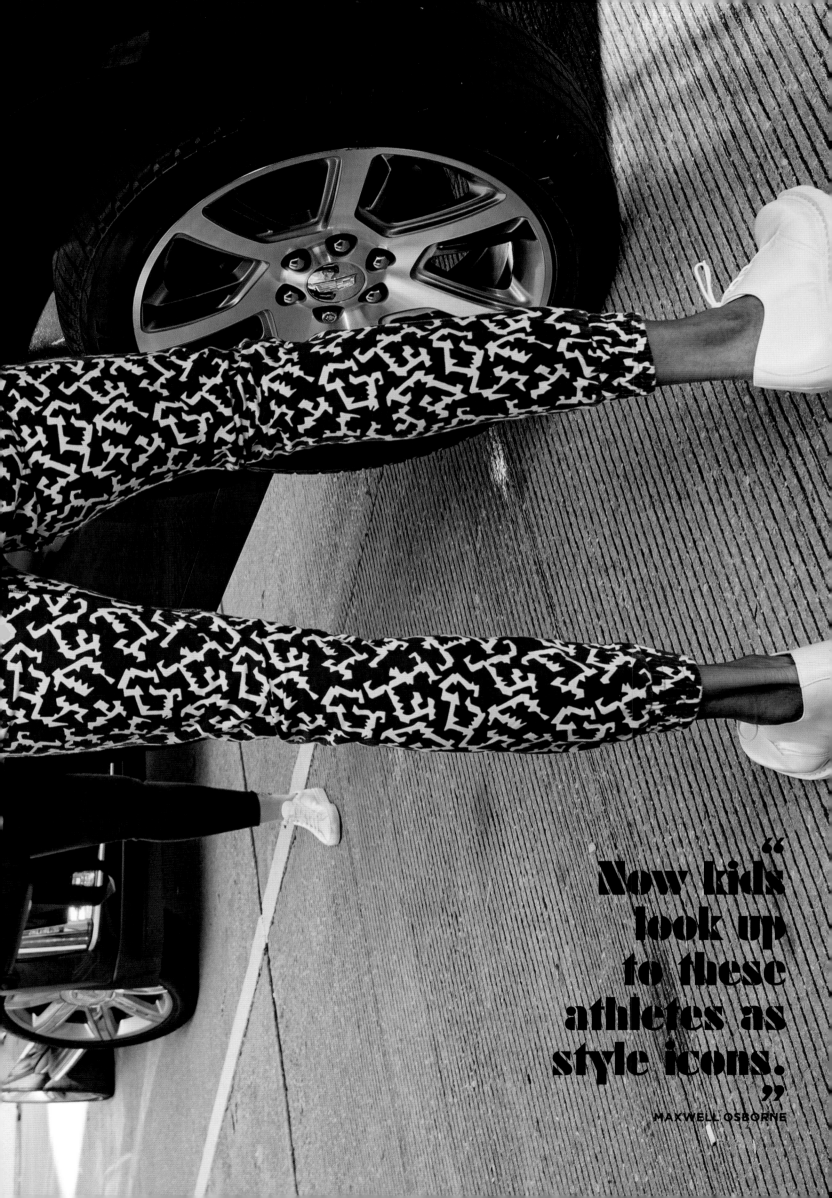

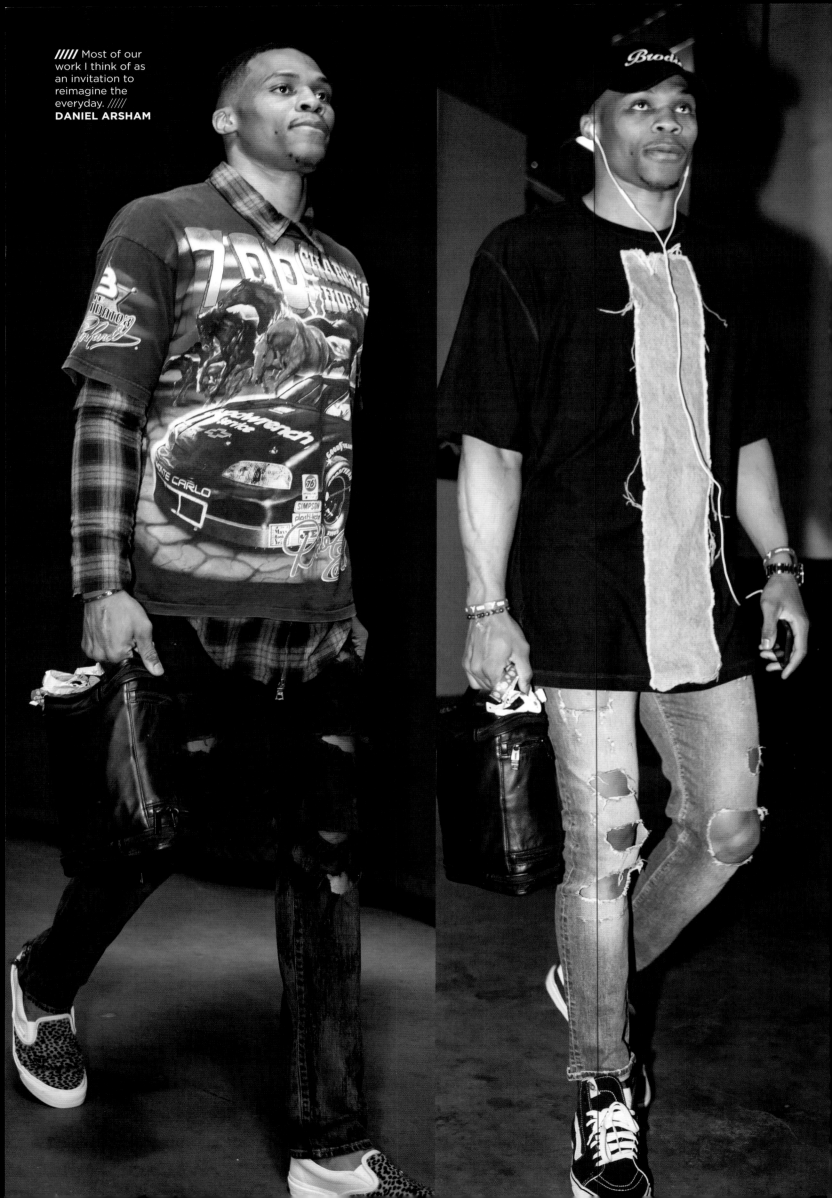

///// Most of our work I think of as an invitation to reimagine the everyday. /////
**DANIEL ARSHAM**

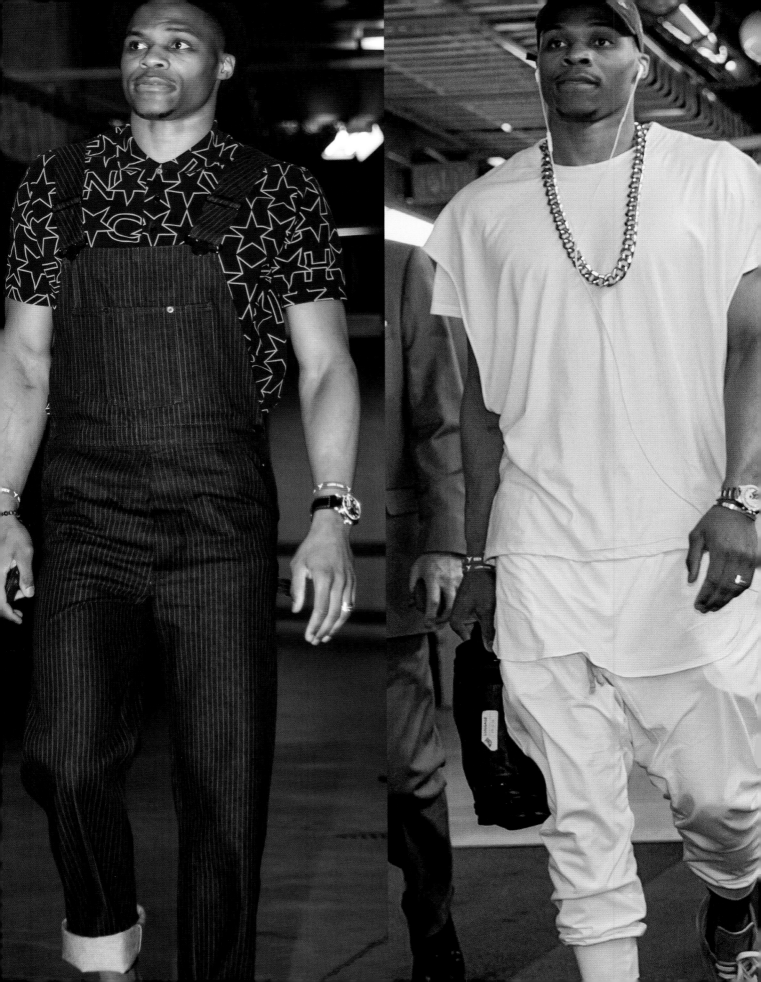

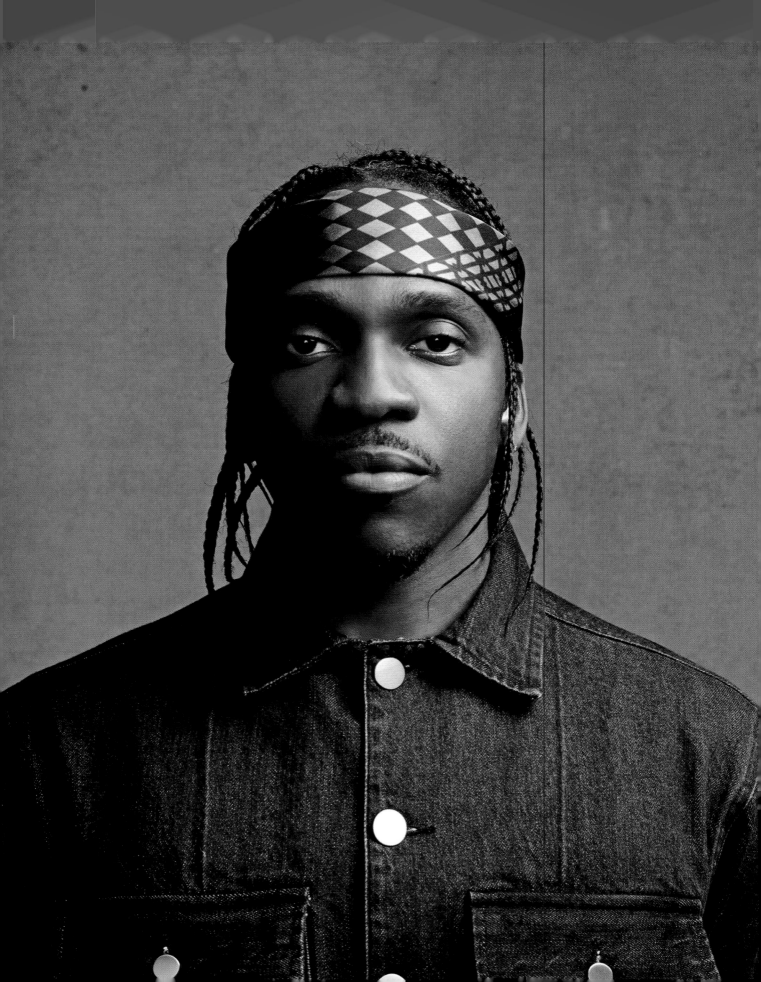

**"**

# When I think of style, I think of someone's presence. Good, bad, or indifferent to my personal taste— their presence is the first thing I think of. What they're giving off. That's their style.

**"**

PUSHA T

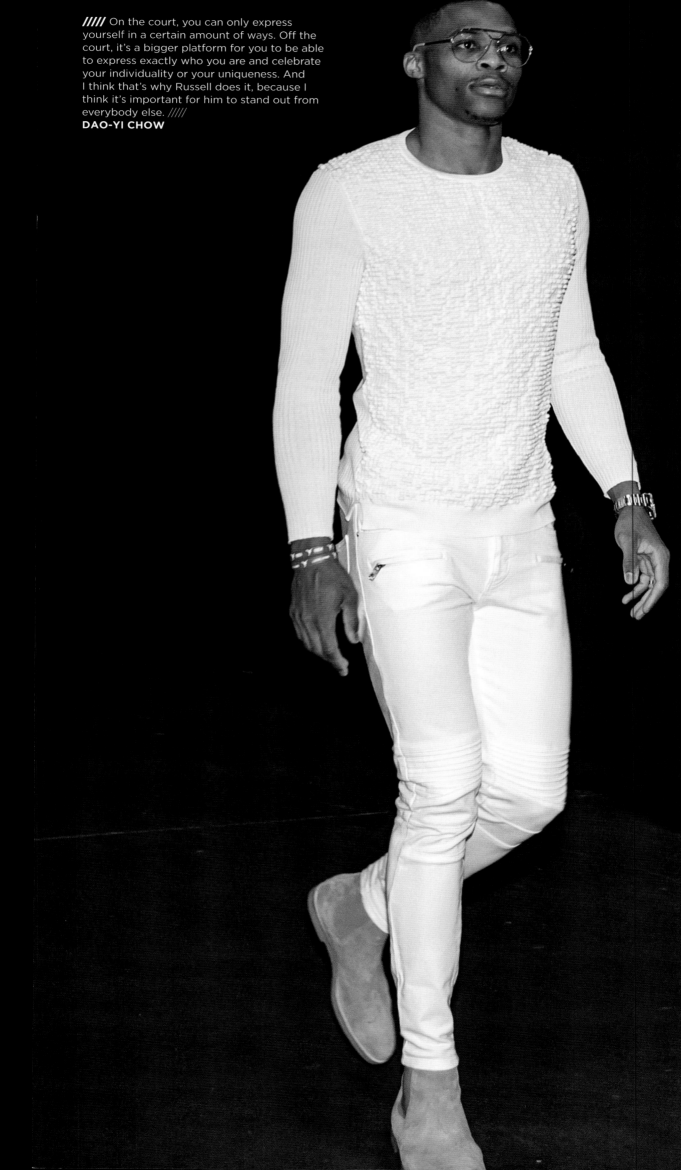

///// On the court, you can only express yourself in a certain amount of ways. Off the court, it's a bigger platform for you to be able to express exactly who you are and celebrate your individuality or your uniqueness. And I think that's why Russell does it, because I think it's important for him to stand out from everybody else. /////
**DAO-YI CHOW**

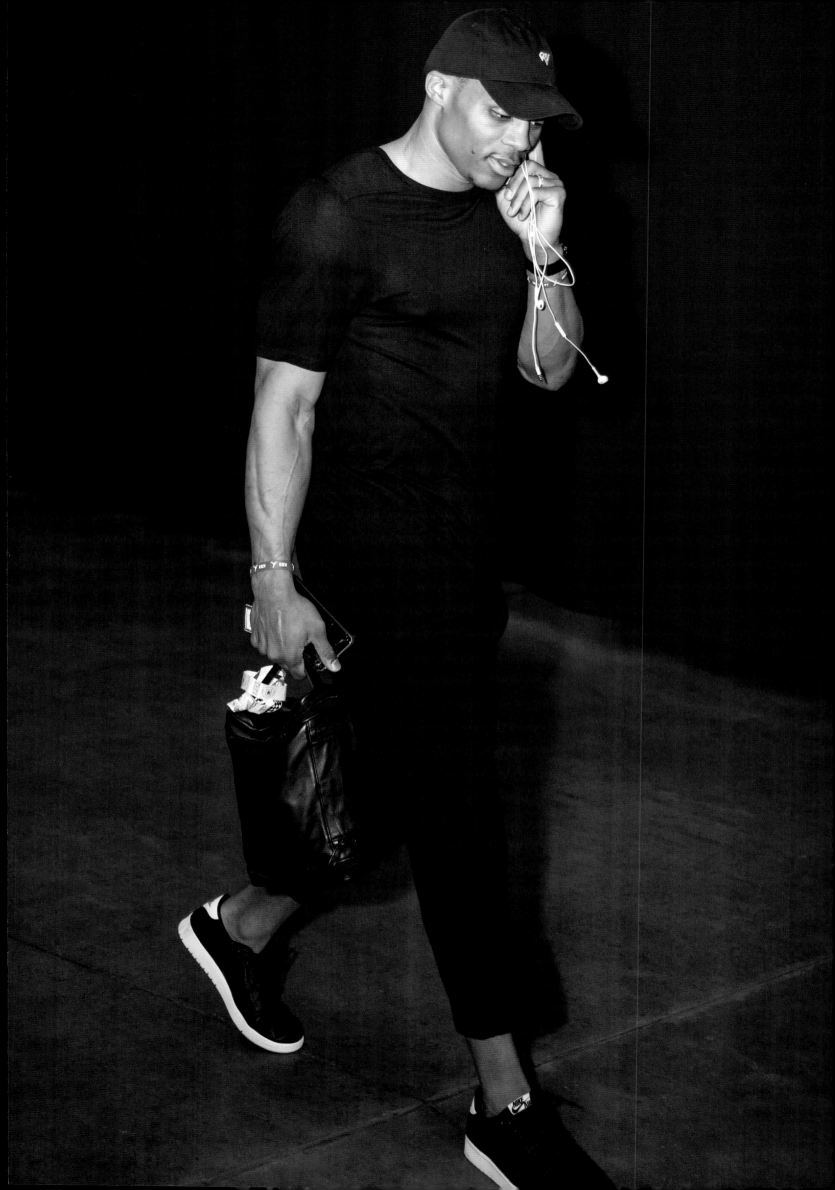

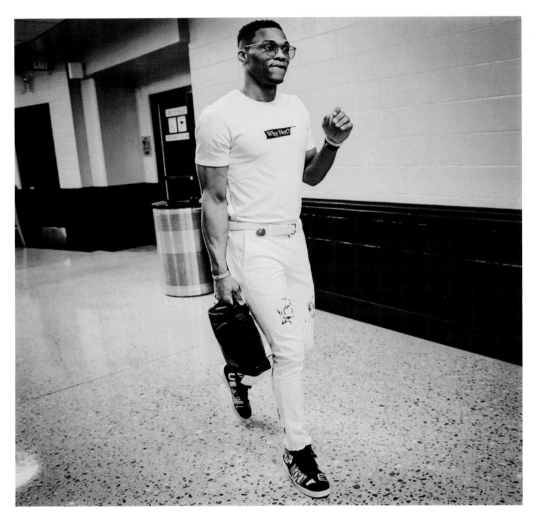

**323,490 likes**                                    1w

**russwest44** All about your Mindset...
#whynot

load more comments

**239.minto** Every body follow me

**josh_the_barber07** @russwest44
when u gonna have a shoe or clothes
line!?... You earned it this year.

**wesfrancissantana** WESBROOK
LOCO HA EL TRIPLE DOBLE 43
PORFAVOSS

**wesfrancissantana** HOY

**215_kris10** @d.hooper_5 not even 42
triple double and better than harden

**uglyfock** MVP

**uglyfock** MVP

**dreezymania** Top

**nicks828** Great!

**blessedifnothinelse** Why not us! I'm

Log in to like or comment.                    o o o

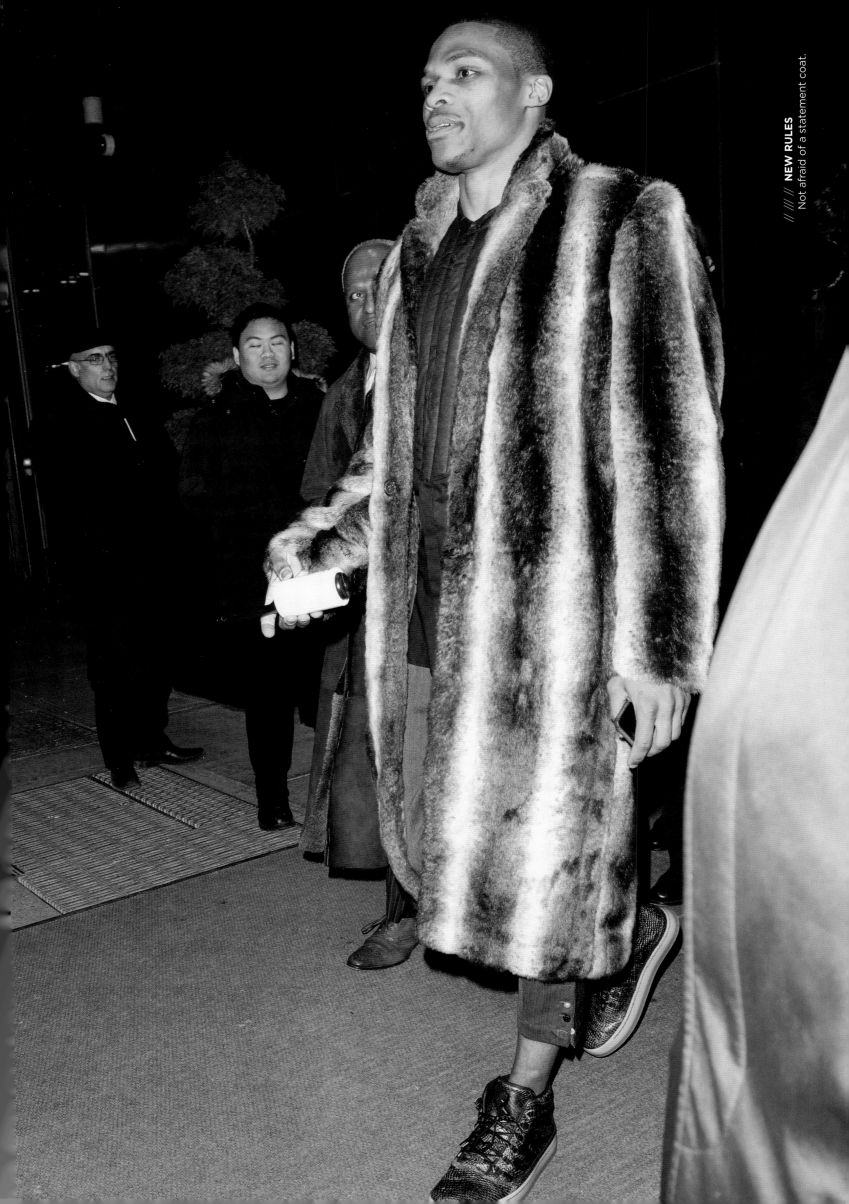

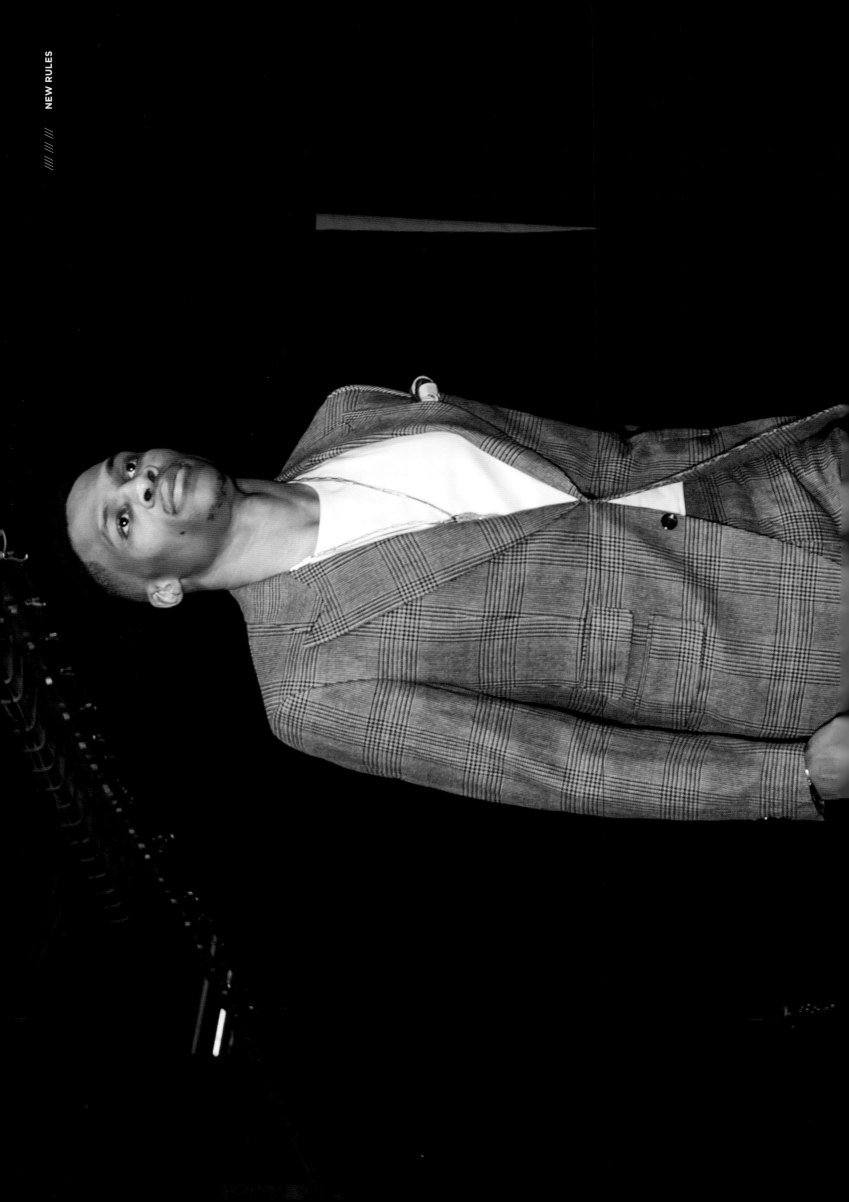

"If there's one rule in style, you've got to be able to pull it off."

TIM COPPENS

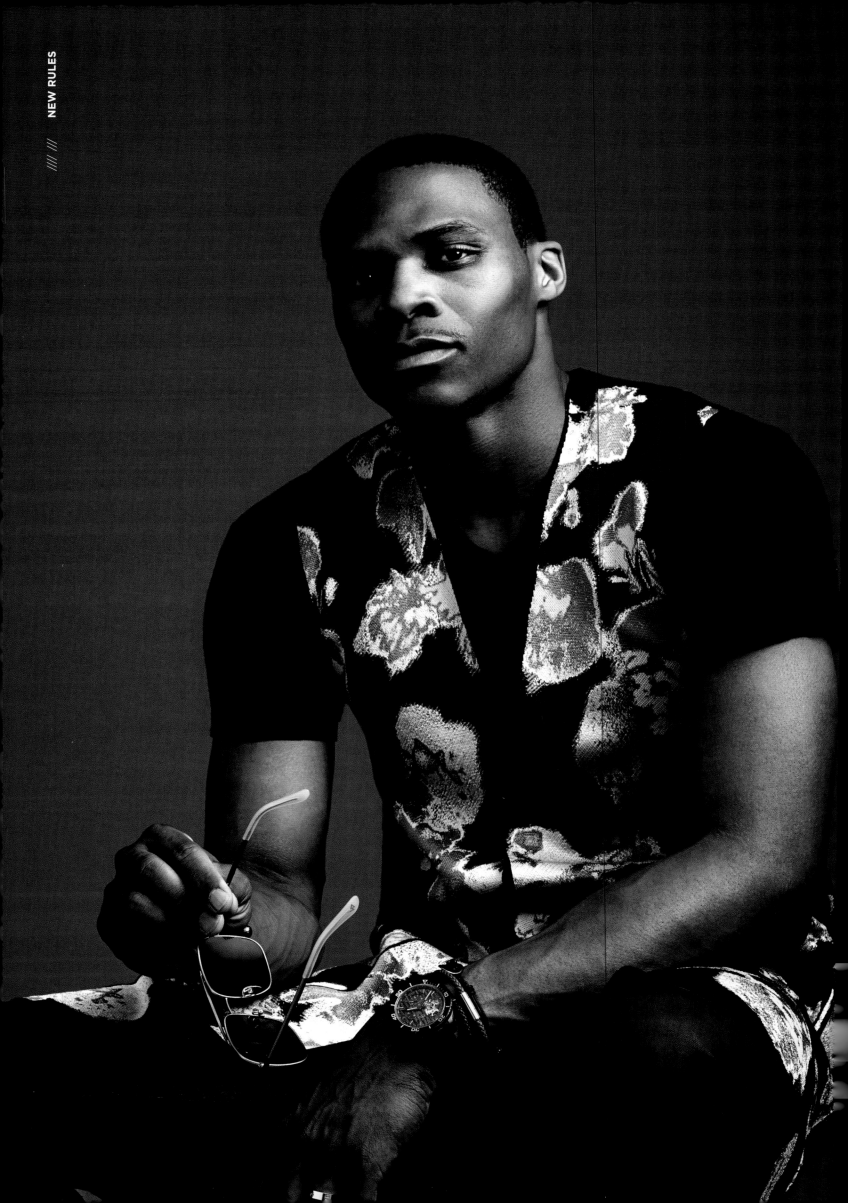

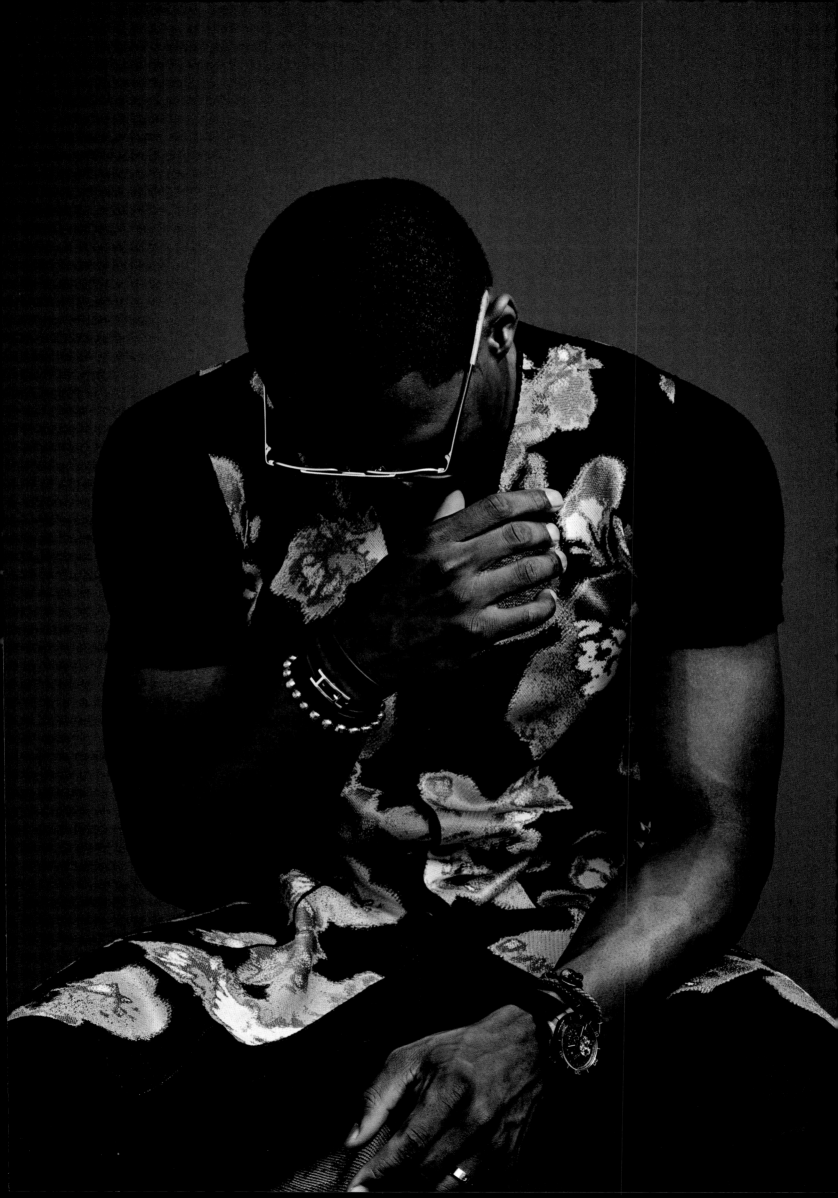

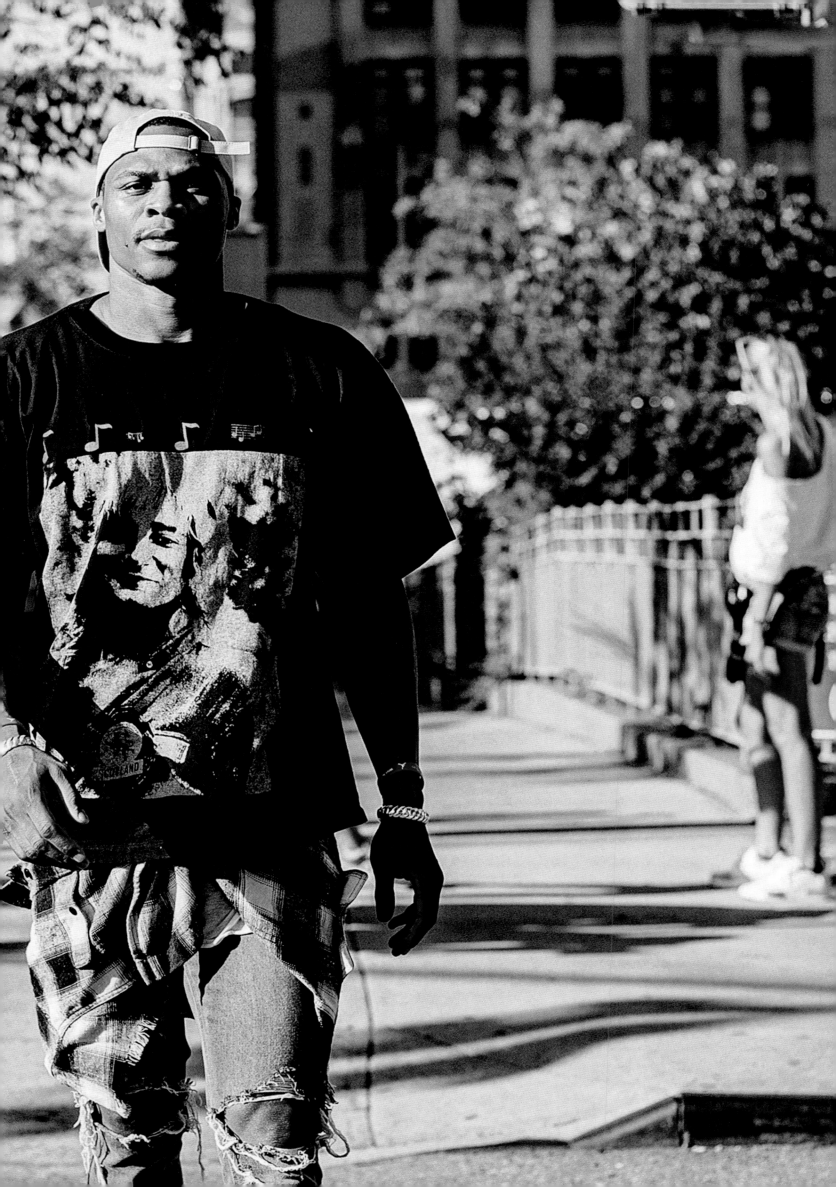

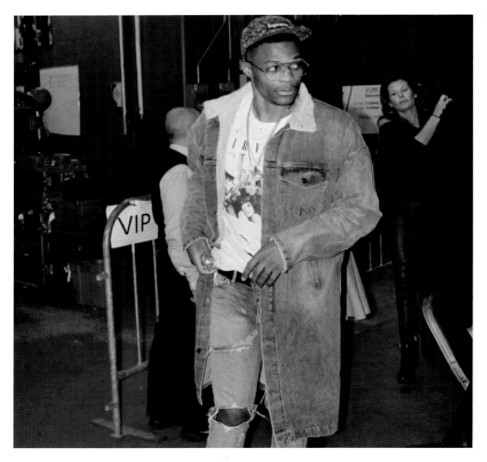

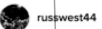 russwest44    Follow

68,791 likes                                48w

russwest44 🔳🔳🔳🔳#fashionking
view all 1,931 comments

nancyy.rt @julia_sle

nick_aslani @ava_svadjian

fernando_mb @adelaclotis

dbewt @connor_craw

blackroses_85 @themysfit this is one

jwells_3 @djanae.s

milf.monroe_ 😩😩😩😩😩😩✨✨✨✨🎄
🎄🏆🏆🏆🏆🌟✳️✳️✳️✳️✳️💥💥💥💥💥❄️❄️❄️❄️🎁🎁
📍📍📍📍🔳🔳🔳🔳 #DetailsAreKey , This
Outfit Is Denim Genius 🤑

jacob_williams44 @cwilliams2213

gazinova_ That's shit dope 💯💯👢

esposito_jesse @jay_hampton u got the
same hat oooh

valton_bashota 👌👌

♡   Add a comment...                    ○○○

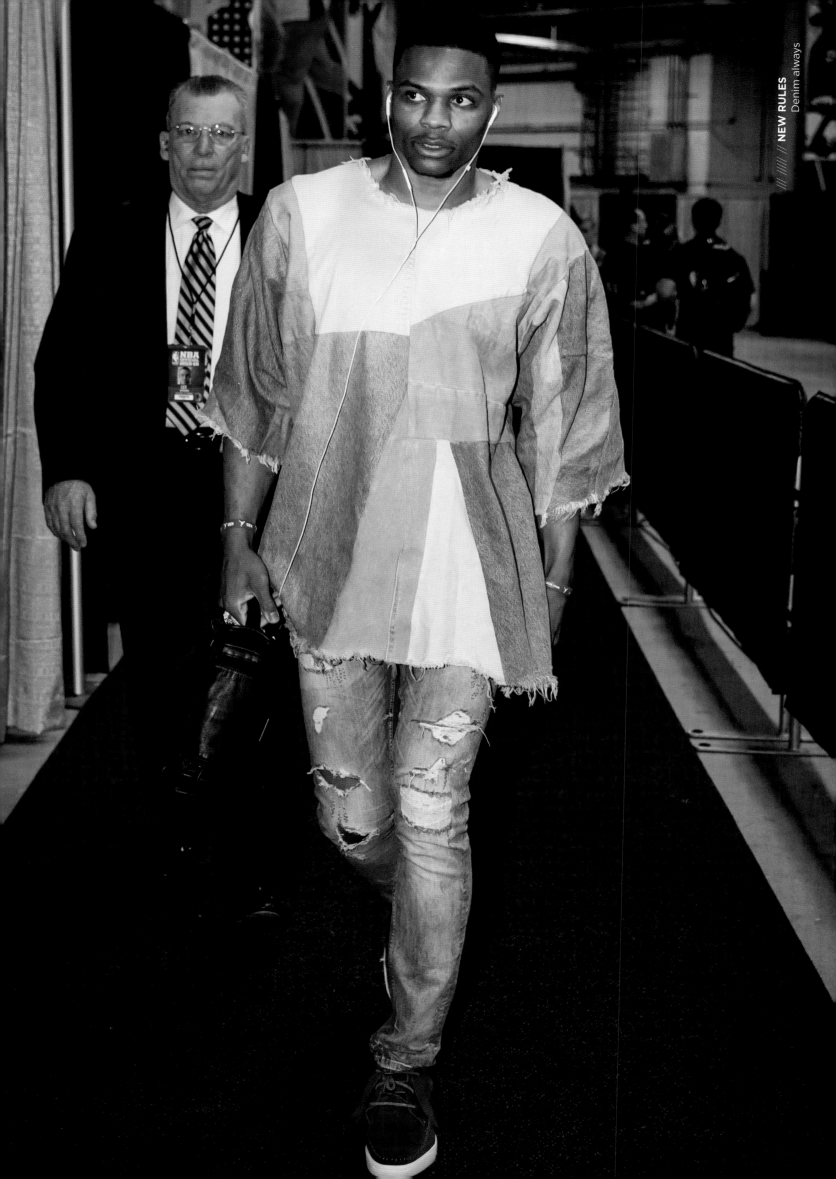

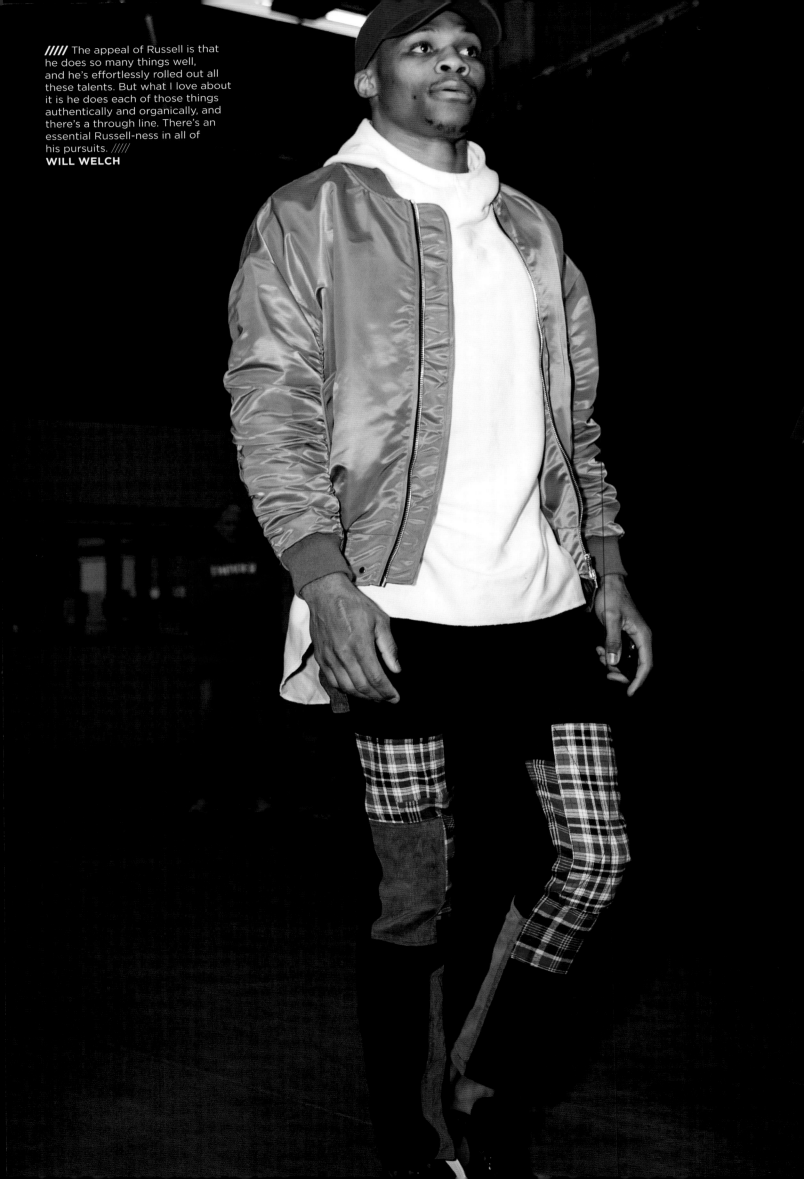

///// The appeal of Russell is that he does so many things well, and he's effortlessly rolled out all these talents. But what I love about it is he does each of those things authentically and organically, and there's a through line. There's an essential Russell-ness in all of his pursuits. /////
**WILL WELCH**

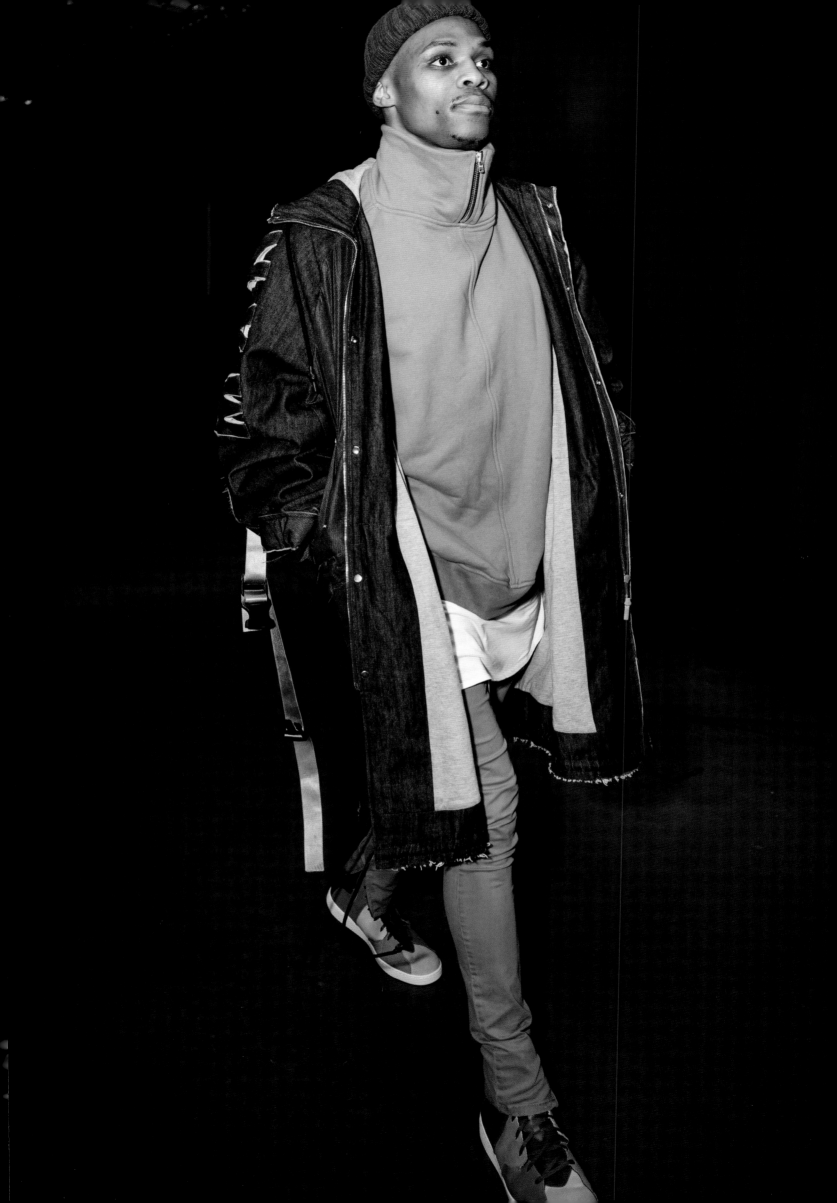

"

# Style is definitely bound in authenticity. Everyone you see has a kind of style that embodies their look, and embodies what they are and who they are. I think it goes hand in hand. As long as I stay true to me and what I know, and the things that I love, and how I love to wear things, I can stick to that and then hopefully people understand it and love it— or they'll come around to it and understand it later on.

"

**VICTOR CRUZ**

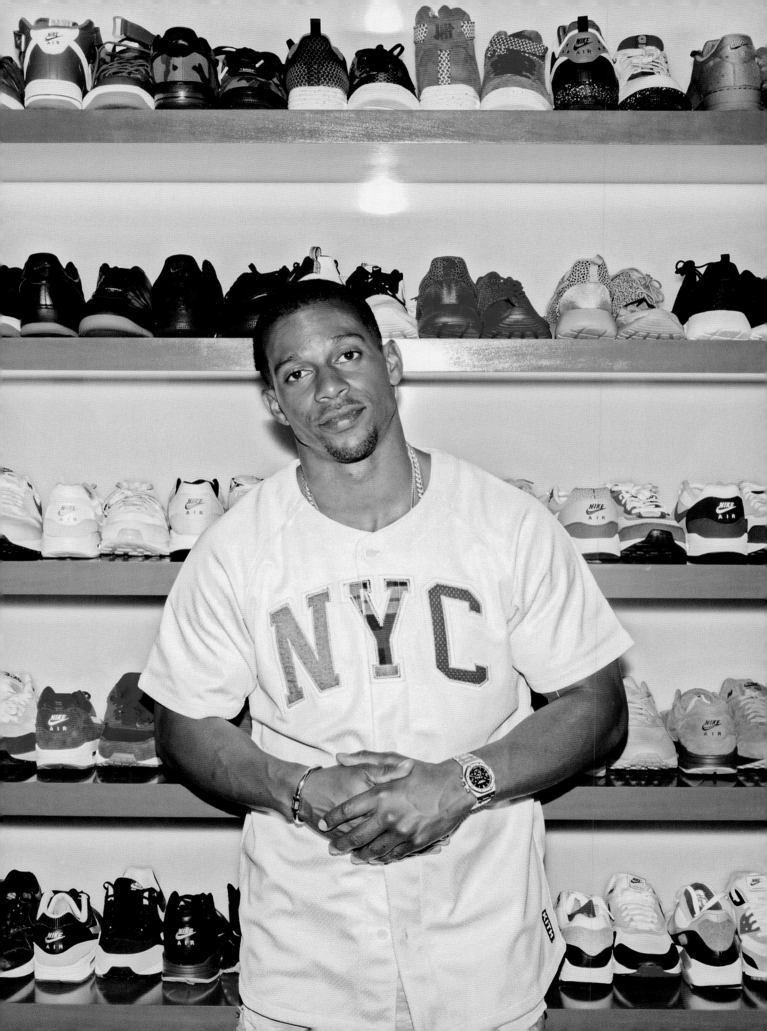

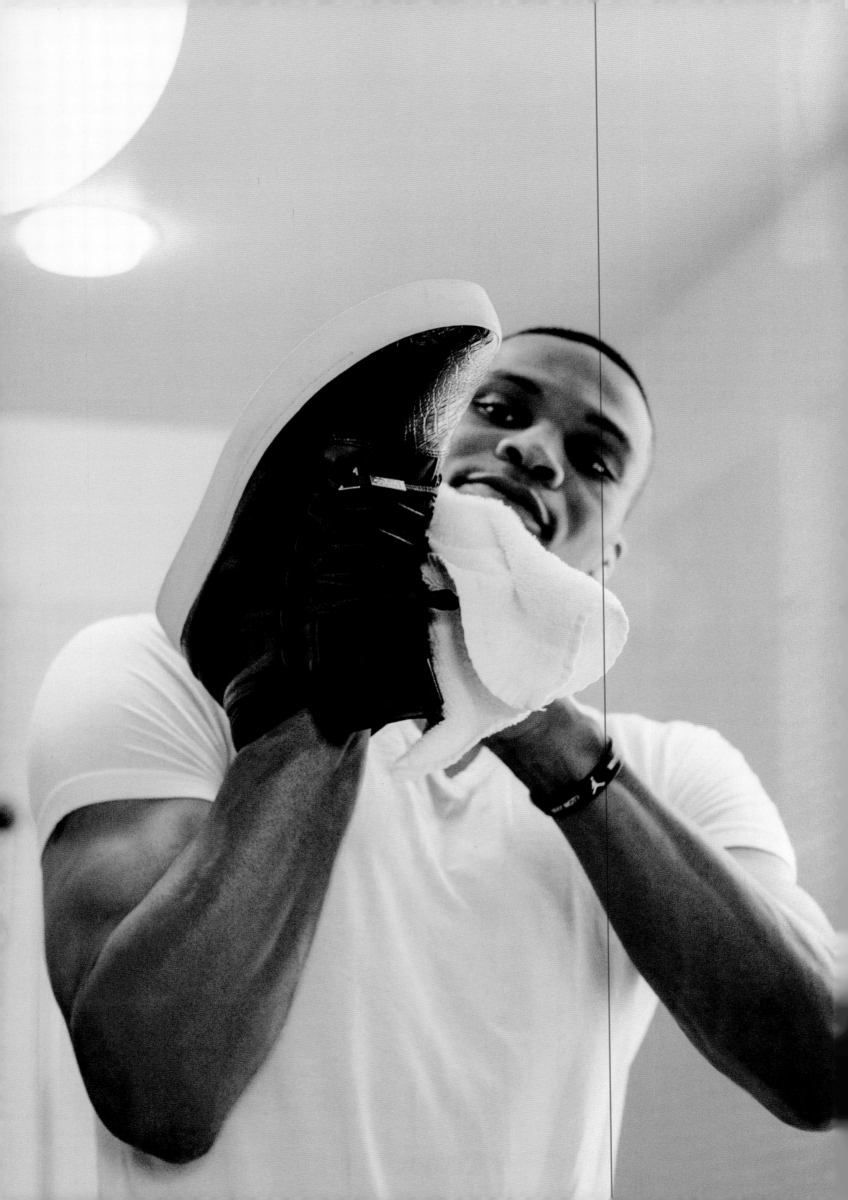

# NEW RULES

The lines have never been blurrier. What makes someone stylish right now isn't just what he wears. It's where he travels. How he acts. What he posts—or doesn't. From clothes to manners to social media, it's all interconnected.

"I think it embodies everything," says Victor Cruz, who, aside from his football career, collaborates with brands like 3x1 and Nike. "I think everything kind of plays hand in hand with style because it's so multifaceted. It's not just wearing clothes; it's a lot of different things."

Of course, this isn't a new phenomenon. Style has always been elemental—as much about personality and swagger as it is about the actual clothes. It was true for Walt "Clyde" Frazier in the '60s. It was true for Tupac in the '90s. And it's true for the style drivers of the modern age. But the rules have changed.

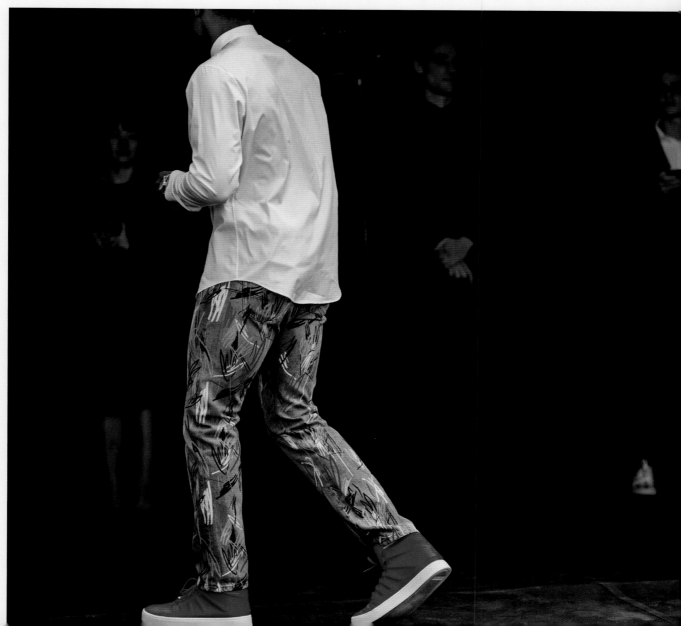

With the death of the standard suit-and-tie approach to dressing and the rise of almost infinite fashion subcultures spurred on by likes and reblogs, the twenty-first-century landscape is one defined by endless options. "I feel that we are at a point of total freedom," says Barneys creative ambassador-at-large Simon Doonan. "There are so many ways to present yourself, each of which is totally legit. You just have to find your own groove."

Of course, finding that groove isn't something that just magically happens. You have to work at it, carving out a space that feels not just distinctive but distinctively you. "Style is something that you build or that you create on your own," says Lapo Elkann, grandson of the famously stylish Fiat CEO Gianni Agnelli and a "creative entrepreneur" who's done everything from working with Ferrari to launching his own eyewear label. "Fashion is something that you follow." The takeaway: simply riding the trends won't make you stylish. It has to be real.

Like Elkann, rapper Nipsey Hussle has a knack for branching out: aside from music, he also runs The Marathon Clothing. "Fashion is one of the categories that, if you're a certain type of music artist—or, in Russell's case, an athlete—you become influential in those spaces," he explains. Though the two are now friends and hail from the same part of Los Angeles, Hussle's style is quieter. But he's got respect for guys who push the envelope. "I think that everybody has a radar, and it's about learning to trust your radar," he says.

So, if you want to go crazy, go for it. "One can wear basically anything without being perceived as transgressive or outrageous," says designer Marcelo Burlon, who has collaborated with Russell, referring to the subcultures—from punk to hip-hop—that pushed aesthetics to a whole new place at the end of the twentieth century. Now, he says, "You're only outrageous when you're not wearing enough."

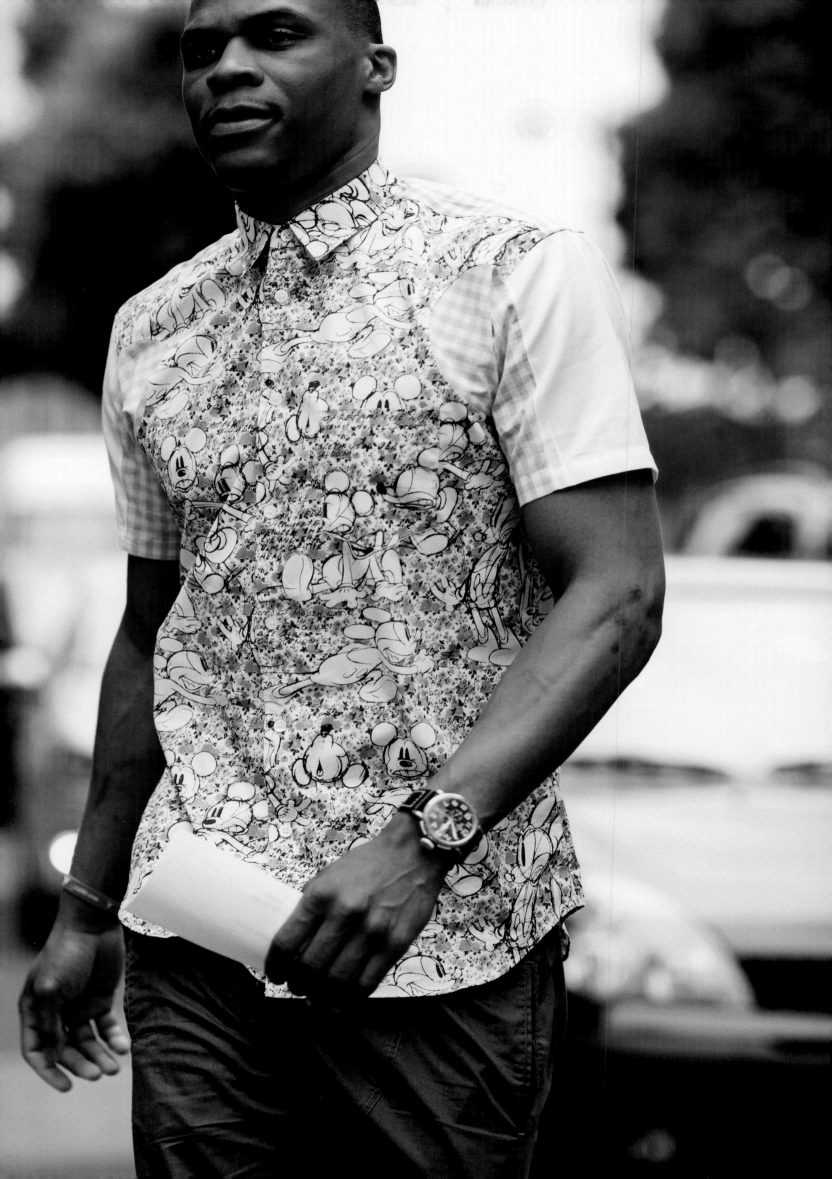

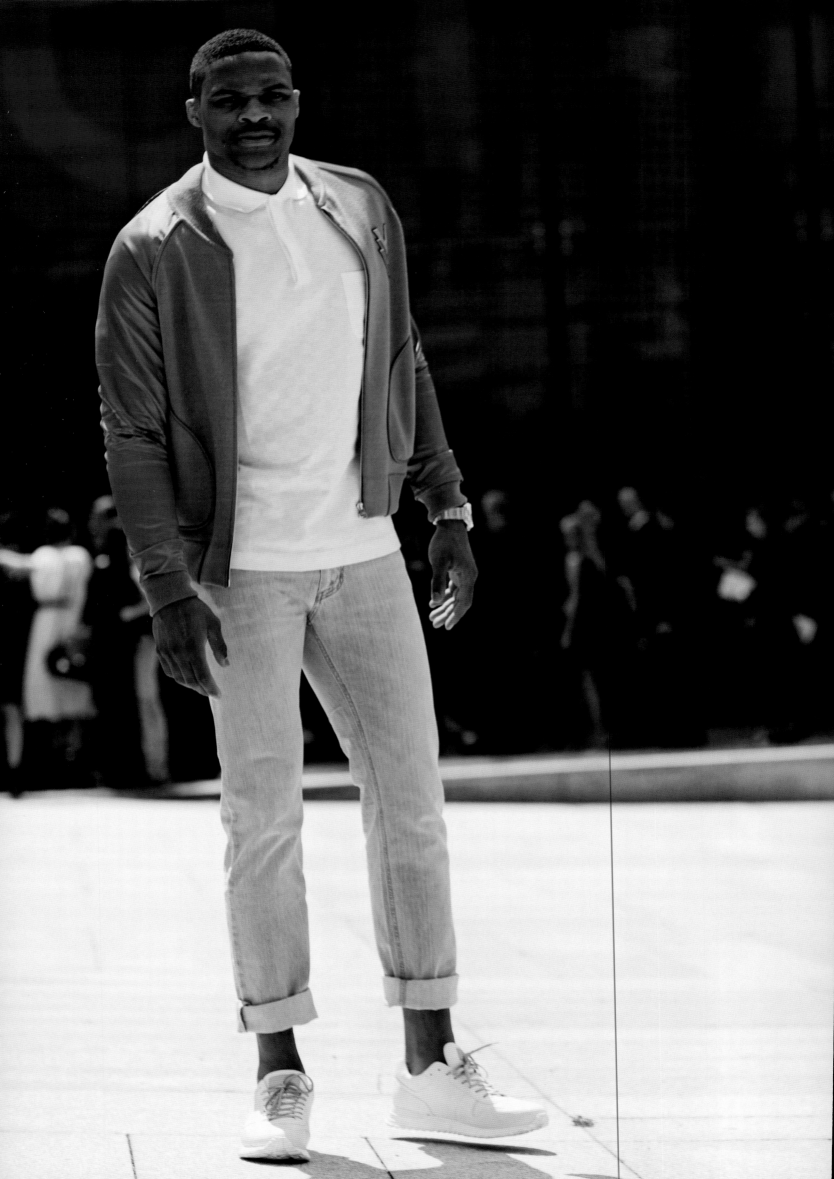

At the center of all of this, though, is one essential element: confidence.

Howard "H" White has worked at Jordan Brand since its inception. He was there for the Air Jordan 1 and he was there for Russell Westbrook's first shoe, the Westbrook 0. He knows what it takes to build a style legacy. When he thinks about what makes Westbrook a force both on the court and on the concrete runway, it's all about self-assurance.

"He's confident in his own skin. And when you're confident about who you are, you know, those people are very hard to beat," H says. "If there's one thing that I would give to my daughter, it's the confidence. Because that does not go away." And when it comes to style, it comes back to that elemental feeling that made guys like Walt "Clyde" Frazier icons in their own right. "Fashion fades, only style remains," says H. "That is those confident people, those people who have their own essence."

It's all about finding what works for you, whether it's understated or completely over-the-top. And it takes time to tune into that. "I think at a certain point, when you work through the mathematics of all the different iterations of how you're going to put something together, you happen on the one that works best for you," says WANT Les Essentiels designer Dexter Peart, who runs the label with his brother Byron and has collaborated with Westbrook. "And that's the best one. That's the one that you feel the most confident in, that's the one you feel most yourself in."

So, what are the new rules of style? We all write our own. Well, OK, maybe that's not entirely accurate. As designer and Westbrook collaborator Tim Coppens points out, some things are universal: "If there's one rule in style, you've got to be able to pull it off."

I THANK THE MAYOR OF HEAVEN AND EARTH.

# COLLABORATION

"
I don't follow trends.
I like to create my own
and do whatever I'm
feeling at the time and
kind of just go with that.
I try to bring that to every
collaborative project.
"
R.W.

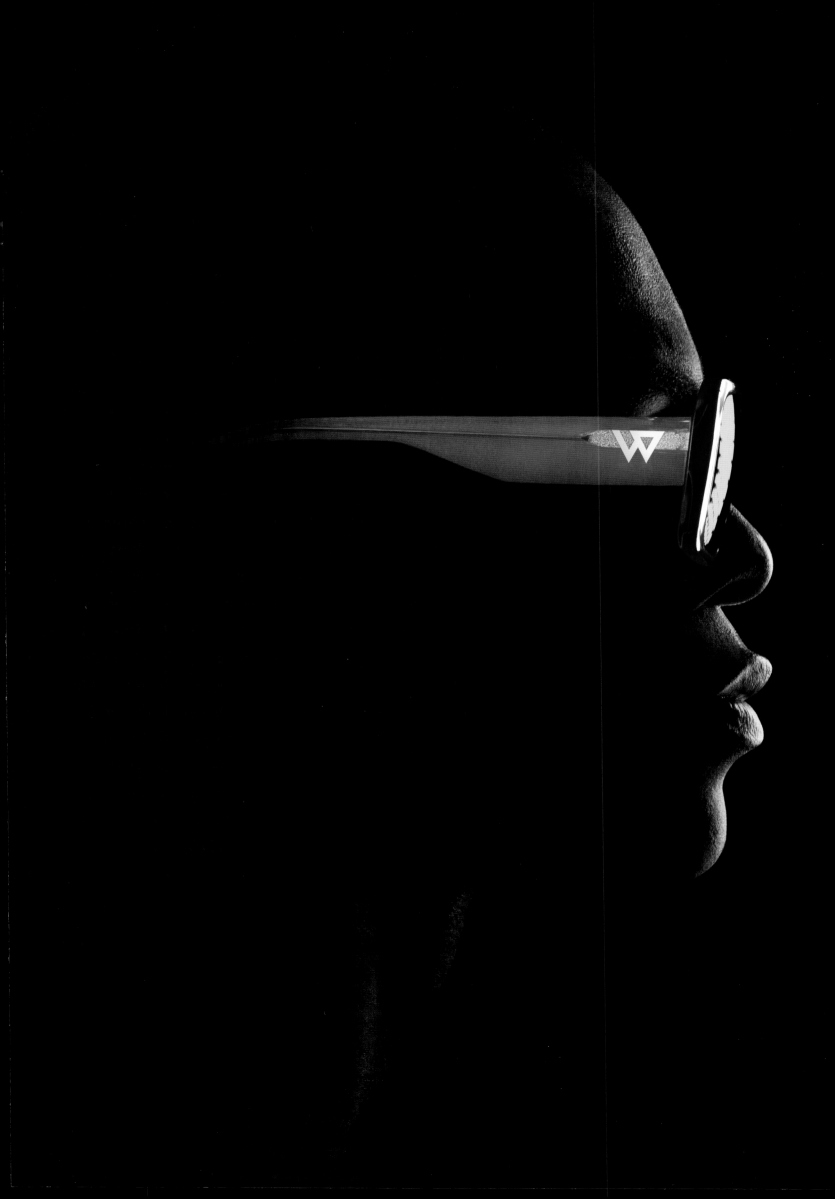

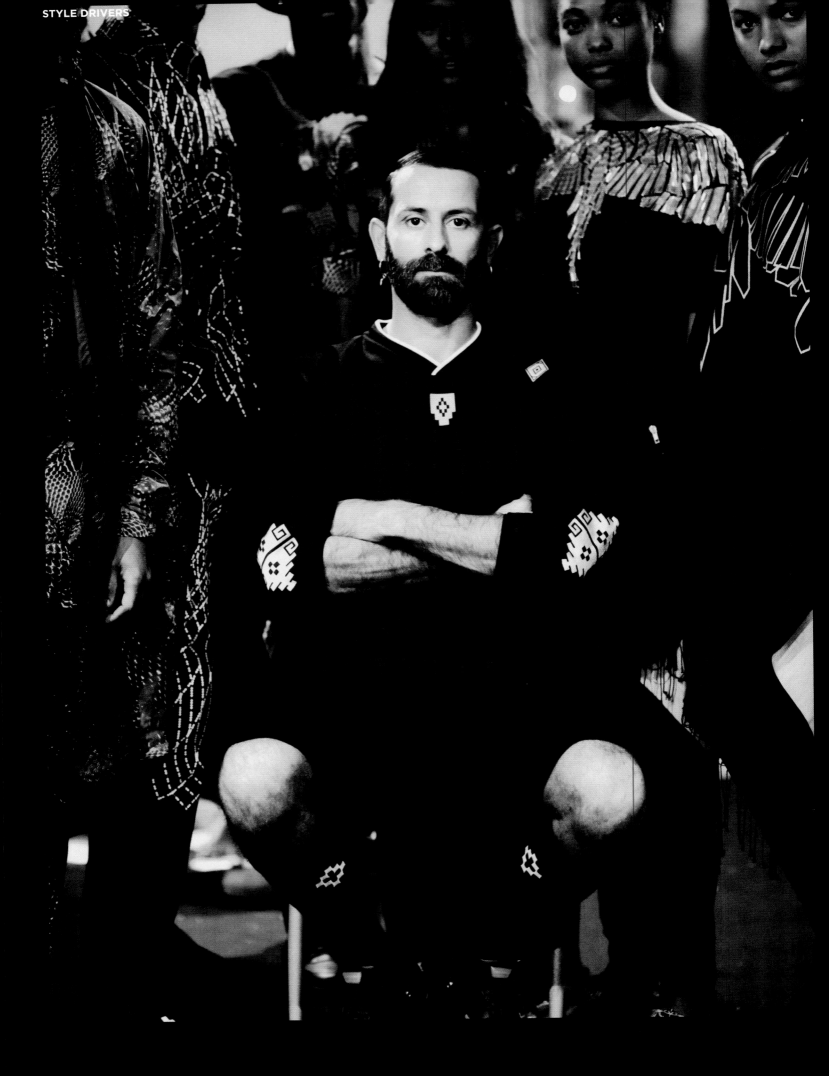

"

I don't actually think I ever got it wrong. If you think about it within a situation and what year it was, it was just right. When people refer to things as 'timeless' or 'chic,' they're usually talking about long dresses and things like jewelry and watches. And these are timeless just because these things were played safe. Things that never go out of fashion aren't interesting to me.

"

**MARCELO BURLON**

//// The Globe-Trotter case maintains a strong connection to its past through the inclusion of iconic components and age-old manufacturing methods. We've been able to modernize the cases by expanding our color palette and different stylistic interpretations have been achieved through collaborations with designers like Alexander McQueen, Hermès, and Russell Westbrook. ////
**CHARLOTTE SEDDON**

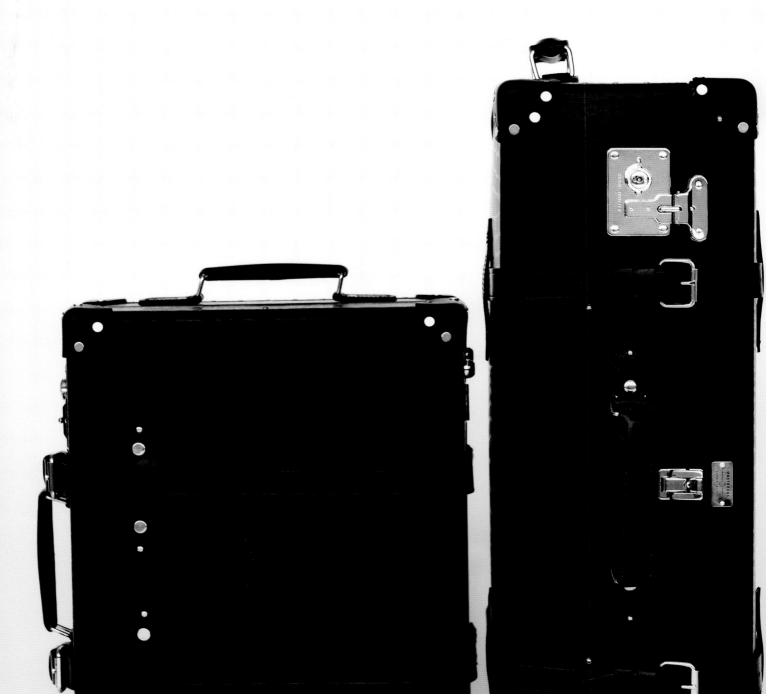

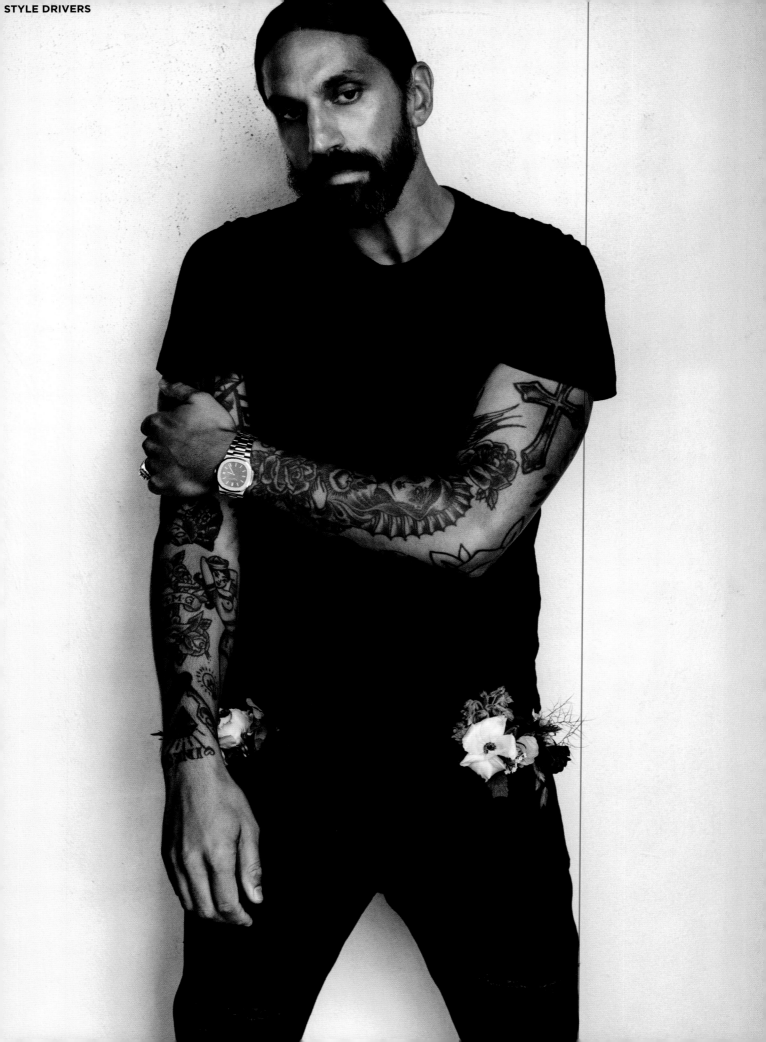

"

**Style is a reflection of who you are as a person, which can be cultural or can be aesthetic preferences. But it's also a combination of this ambition, this projection of how you want to be interpreted, and who you want to be. I think what's interesting in that regard, is that people have really subjective approaches to how much of their style is them, as opposed to this projection. I always think it's a combination of the two.**

"

BEN GORHAM

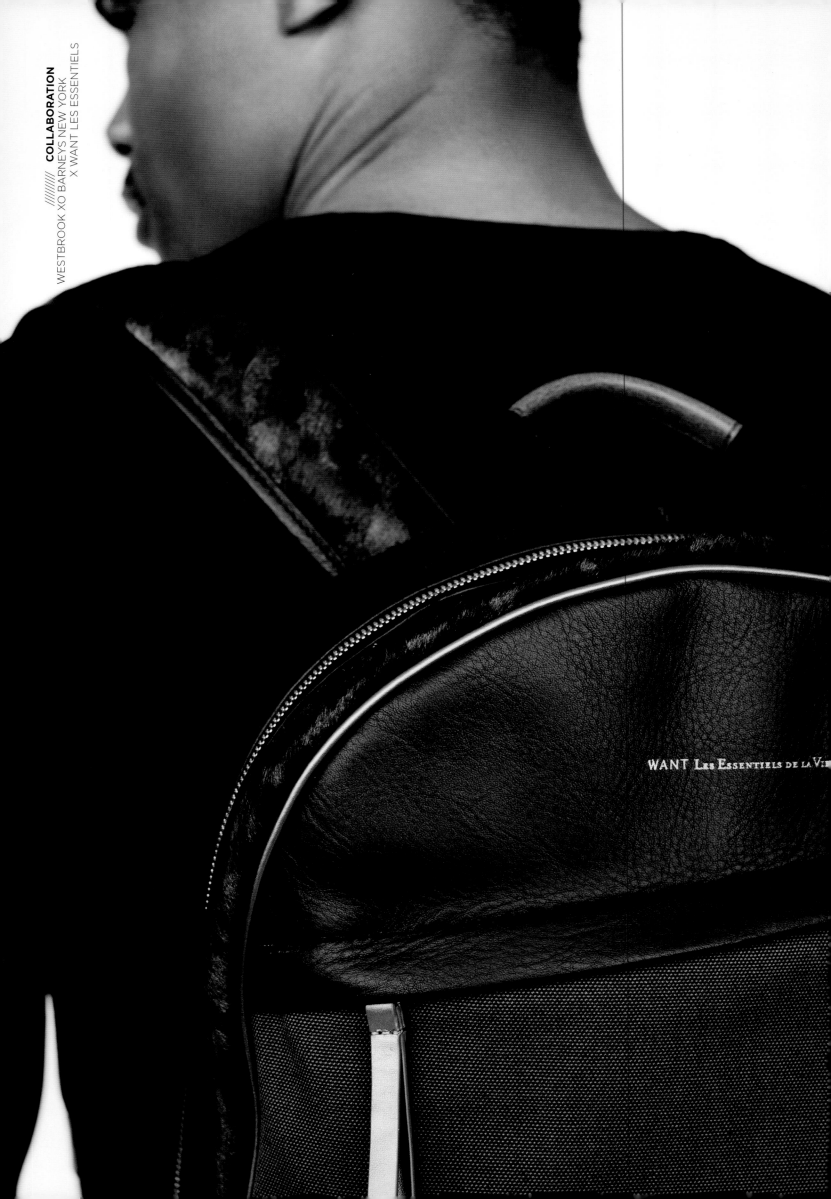

WANT Les Essentiels de la Vie

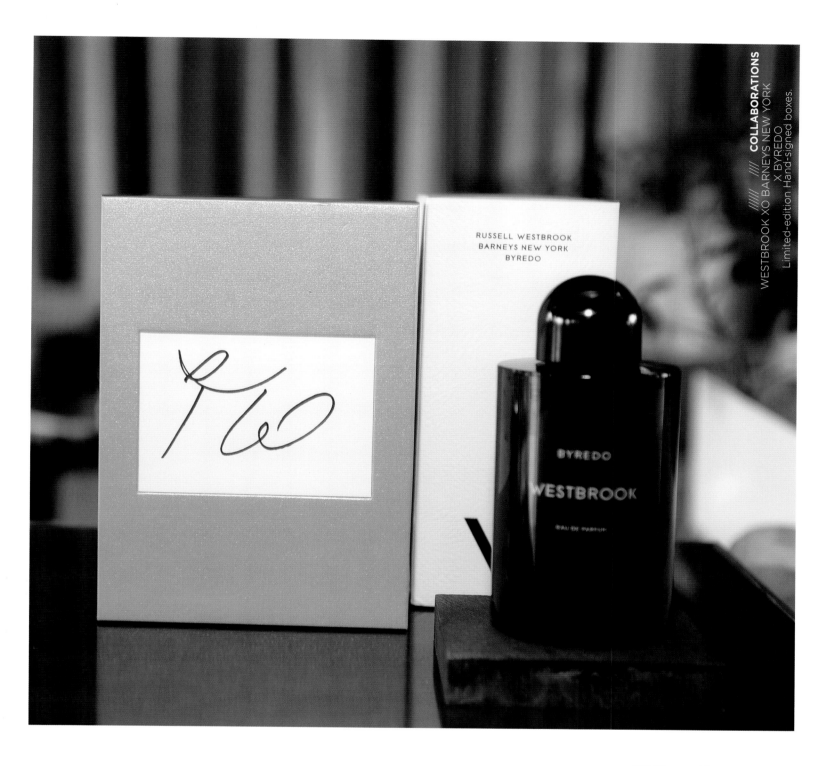

RUSSELL WESTBROOK
BARNEYS NEW YORK
BYREDO

BYREDO

WESTBROOK

EAU DE PARFUM

**////** We got this opportunity to work with Russell, and we were like, "This is so cool, because now we're going to start looking at other fabrics or finishes or prints." It took us out of our wheelhouse, and it was interesting because he was able to bring us along. *////*
**BYRON PEART**

JENNIFER FISHER

TIM COPPENS

TIM COPPENS

JUST DON

TIM COPPENS

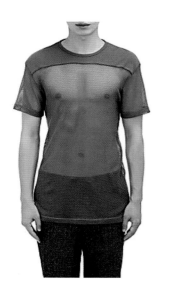

PUBLIC SCHOOL

JENNIFER FISHER

NSF

NSF

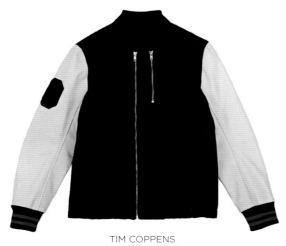

TIM COPPENS

JENNIFER FISHER

"
**It really comes down to having the ability to shape that confidence in your personal style. It's about having someone in your life who can help you figure out where exactly your confidence is. And if you don't have a twin brother, at least have somebody who can call you out when you take it too far.**
"

BYRON PEART

"
**From an early stage, style was an interesting space where we could experiment—where we could find a dual space between being well put-together but also being ourselves. Being twins plays a huge role in that. Those are the kind of root, foundation parts. From our very early stage it was very important that we were well considered in how we put ourselves together.**
"

DEXTER PEART

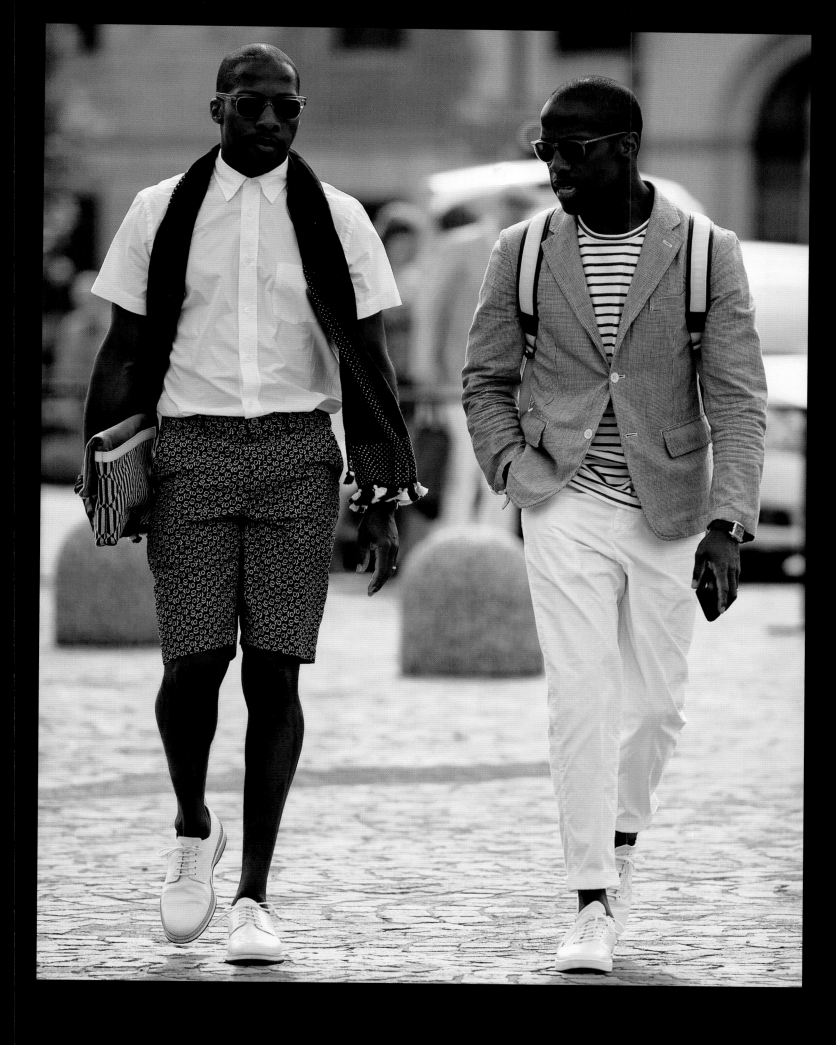

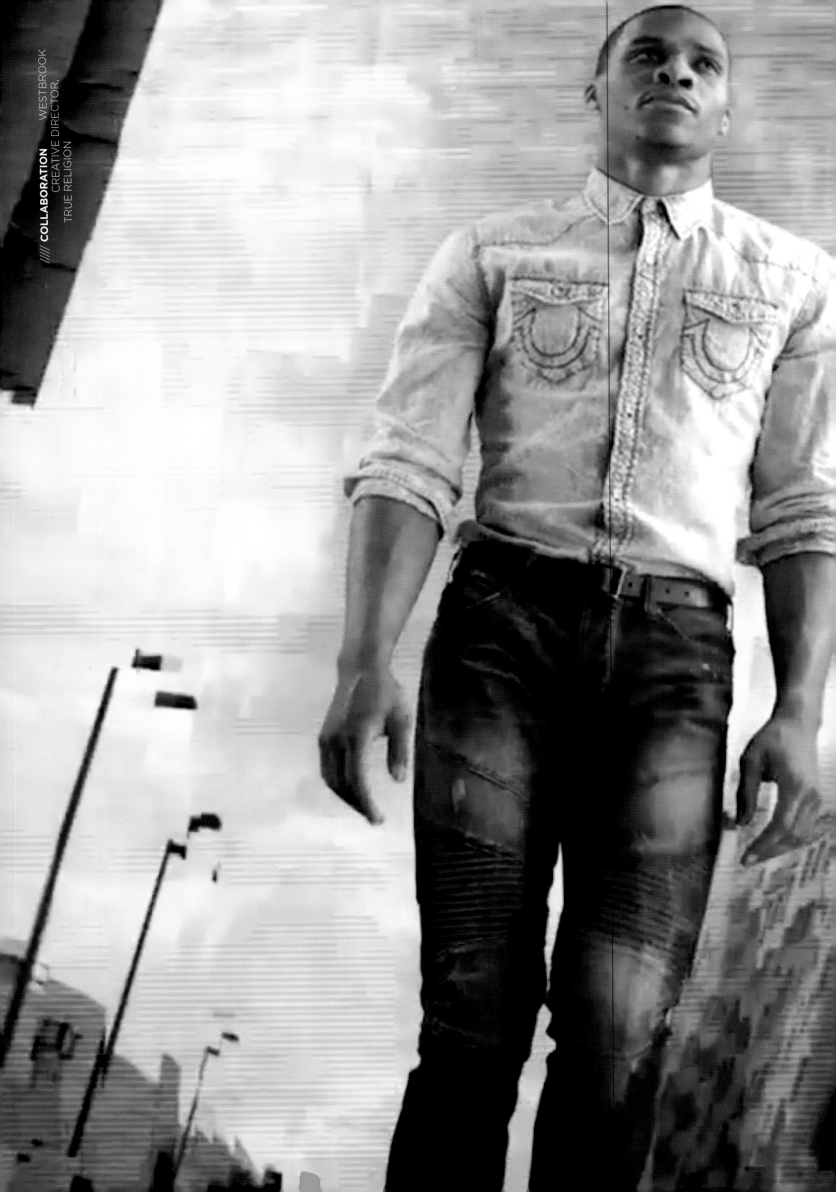

///// COLLABORATION WESTBROOK CREATIVE DIRECTOR, TRUE RELIGION

//// The key is to be yourself.
Being yourself is the most
beautiful thing in the world. ////
**DJ KHALED**

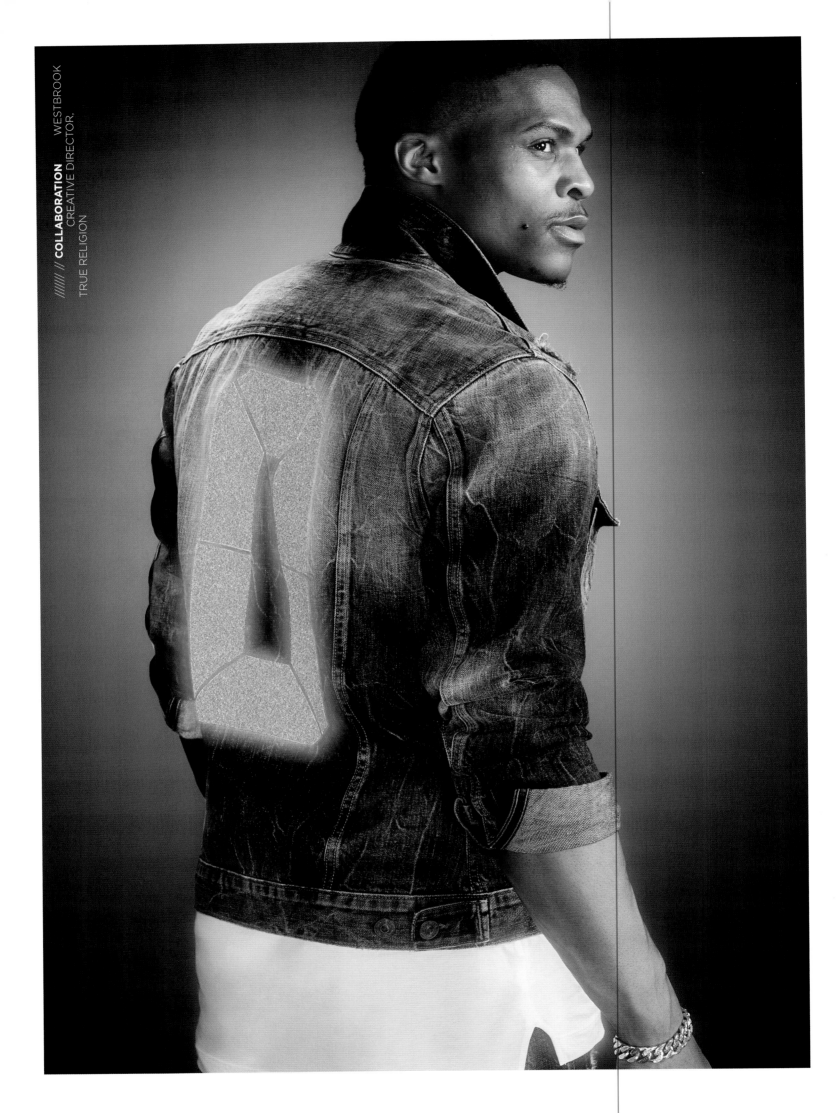

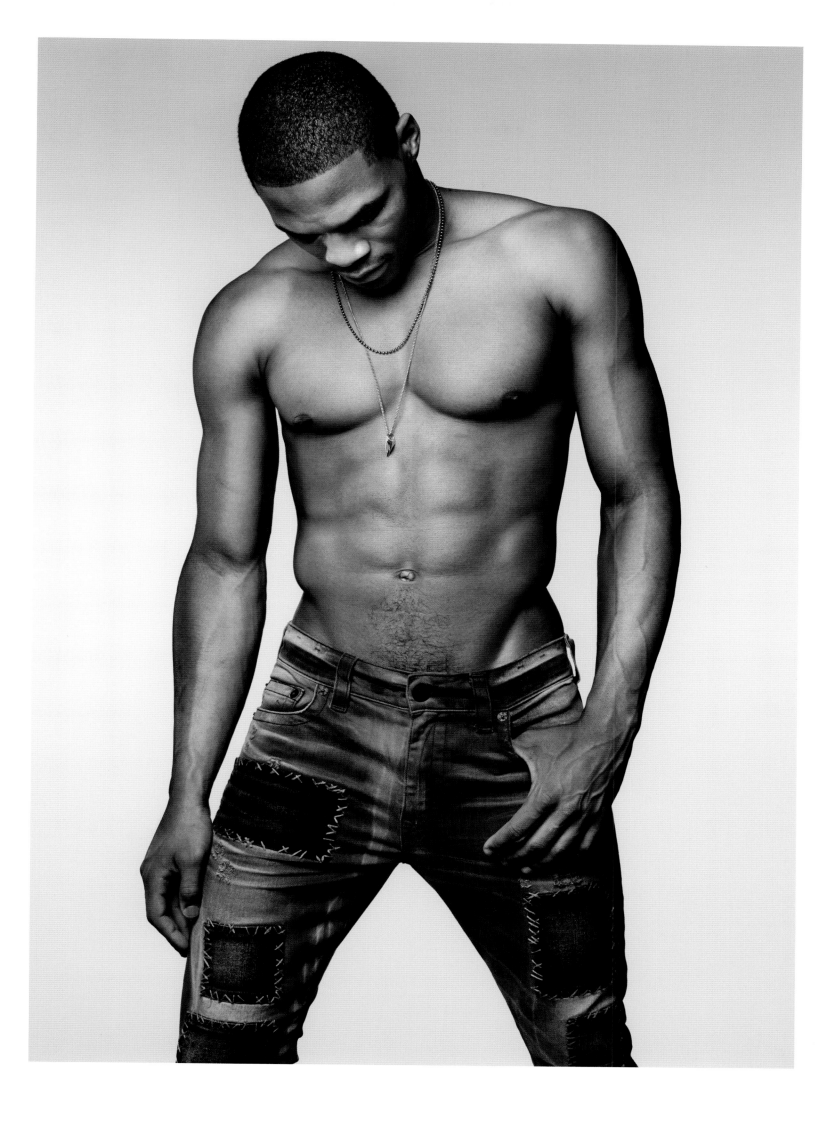

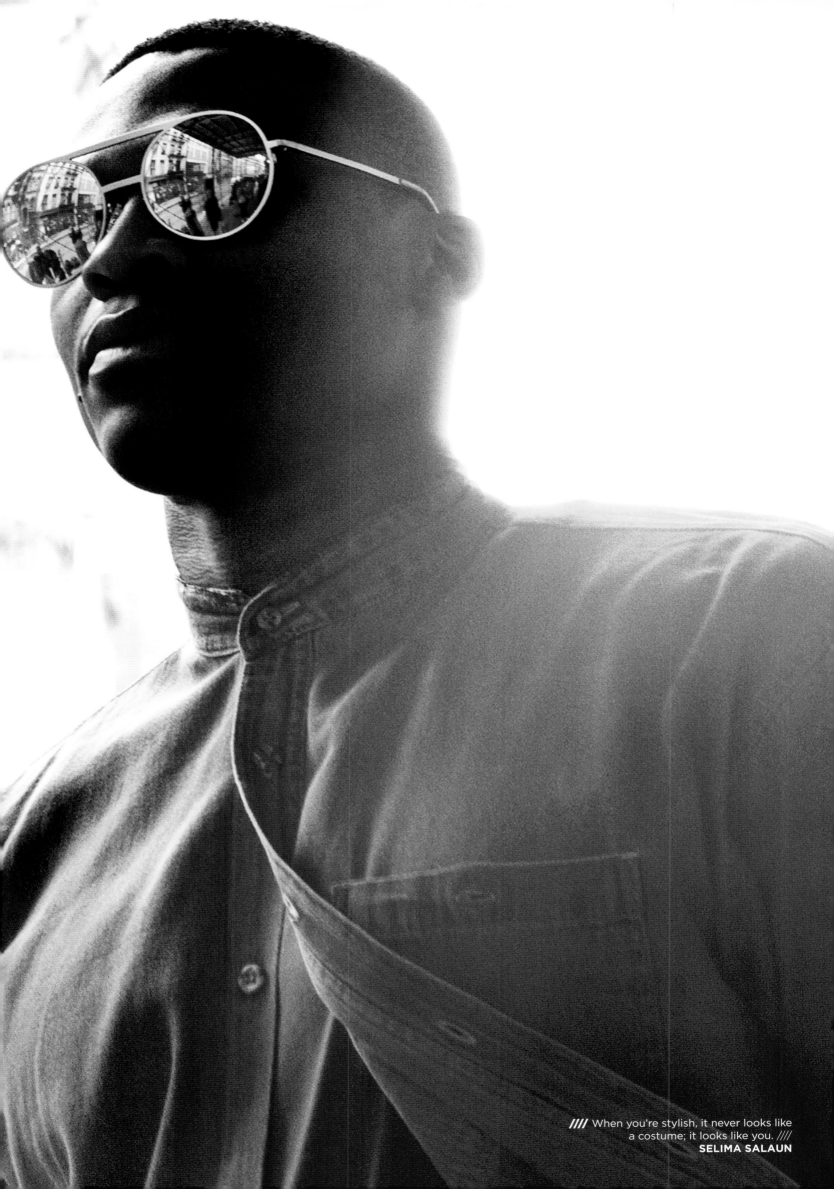

//// When you're stylish, it never looks like a costume; it looks like you. ////
**SELIMA SALAUN**

WESTBROOK FRAMES
ARE NAMED AFTER NEIGHBORHOODS IN LA:
COMPTON, BEL AIR, INGLEWOOD, HOLLYWOOD.

//////// // **COLLABORATION**

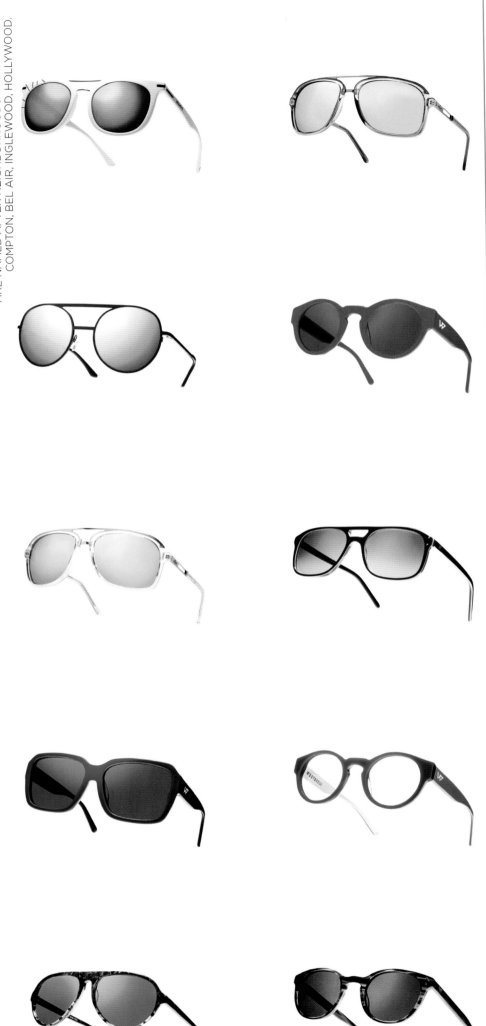

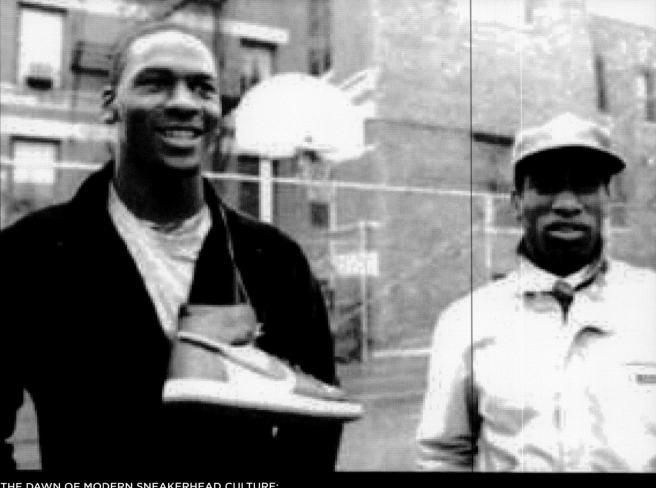

**THE DAWN OF MODERN SNEAKERHEAD CULTURE:**
HOWARD WITH MICHAEL JORDAN
AND THE OG AIR JORDAN 1.

**Truthfully, they're muses that see the world differently. I think you need that. People need those muses, because it brightens up, literally, the way they see the world. You just go back through Coco Chanel, through Tom Ford, through all the way. Those people, they just see the world differently. And then they're able to put it in a sense that other people can understand—like looking through rose-colored glasses. Other people can look and say, 'Wow, the world looks a little brighter through those.'**

"

HOWARD "H" WHITE

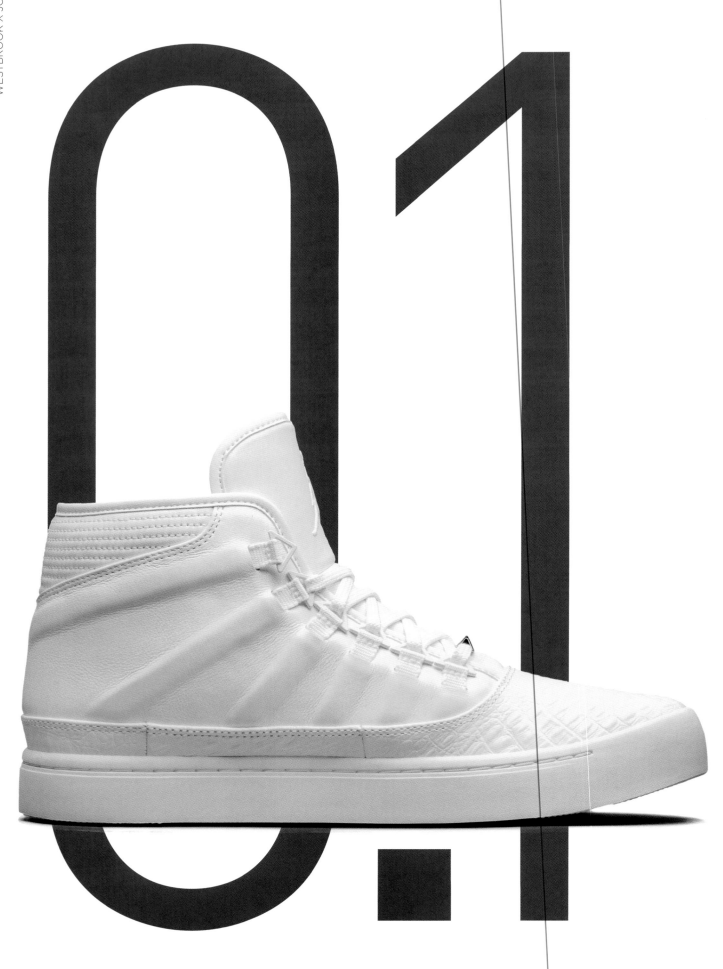

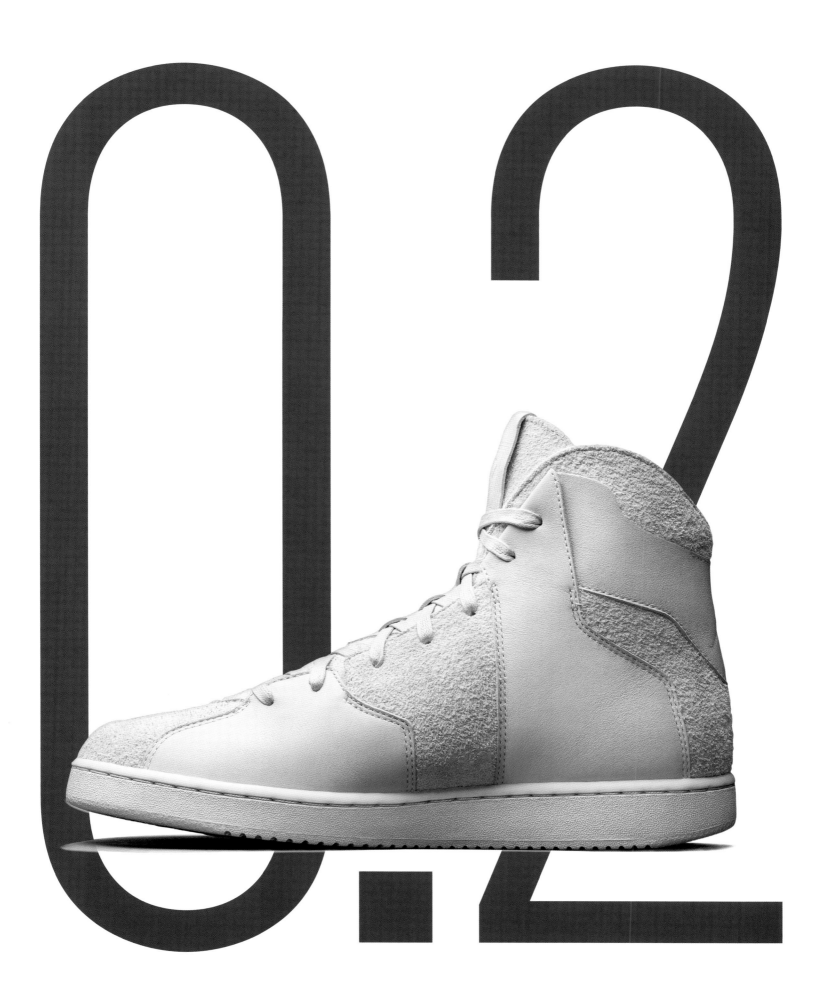

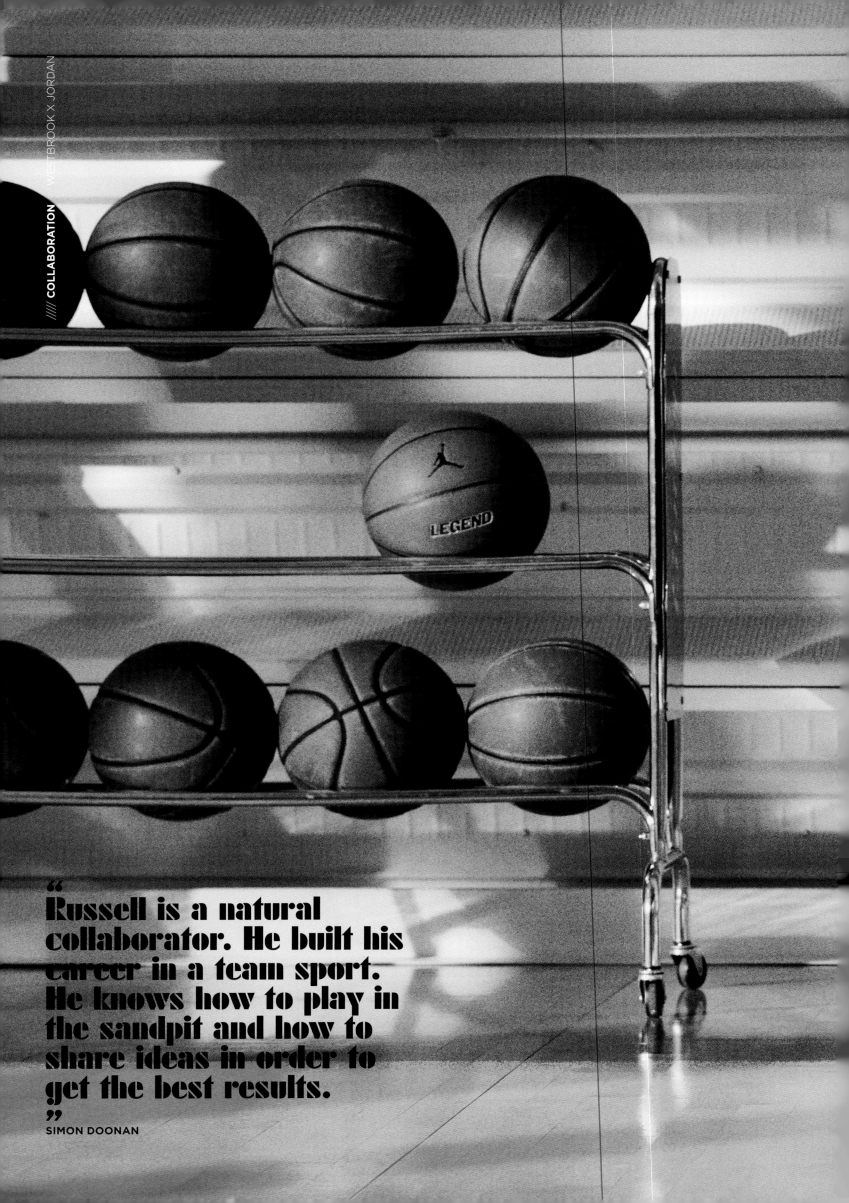

LEGEND

"Russell is a natural collaborator. He built his career in a team sport. He knows how to play in the sandpit and how to share ideas in order to get the best results."

SIMON DOONAN

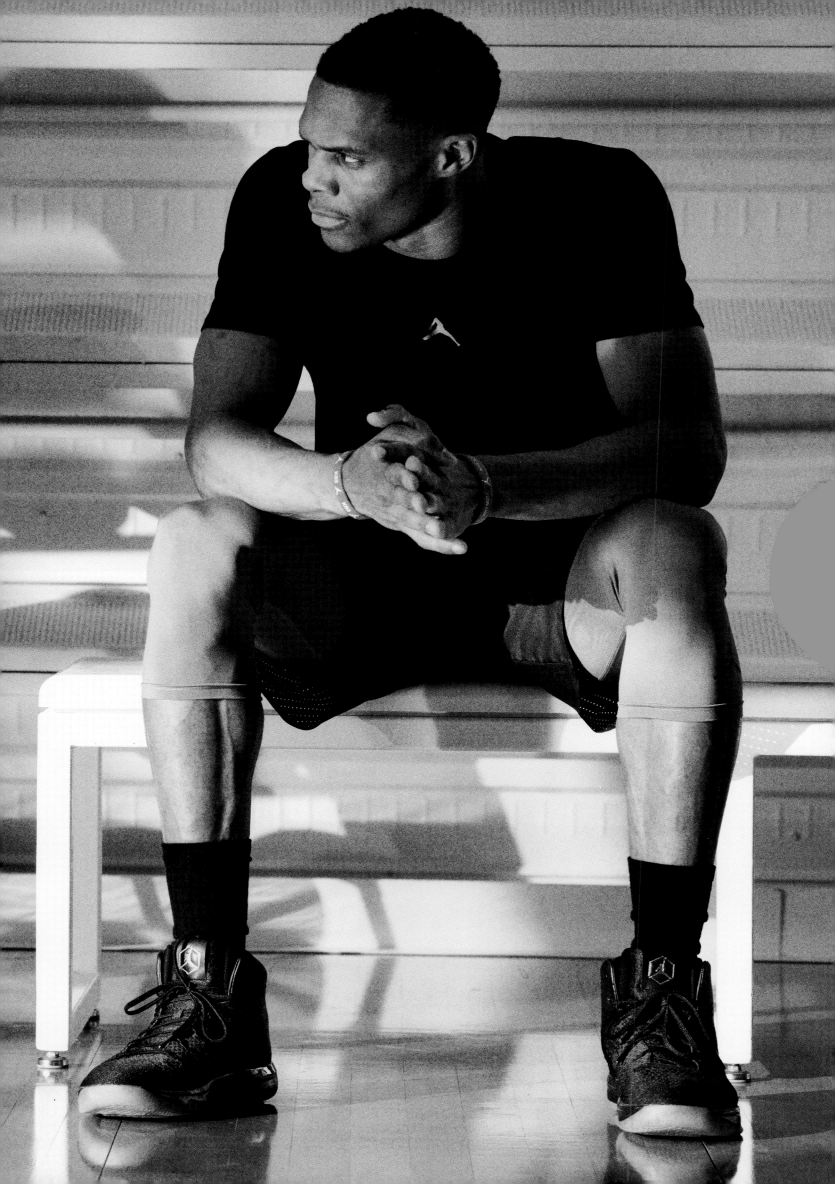

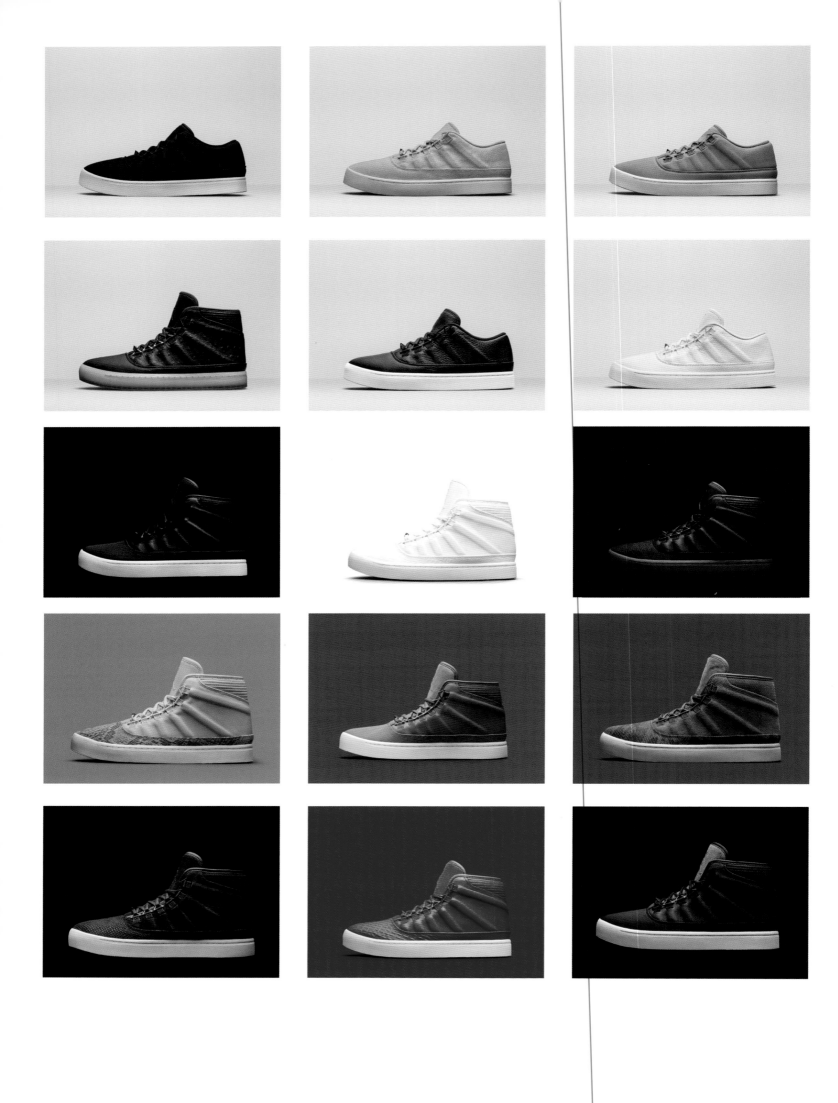

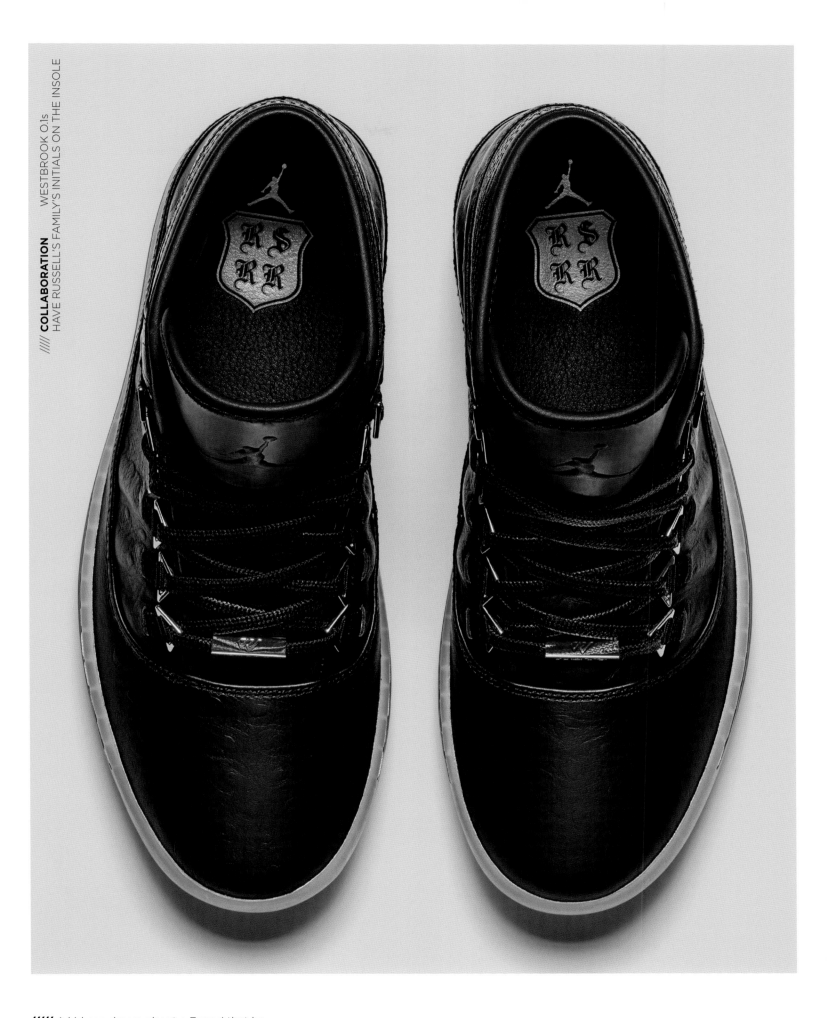

///// A kid can dream about a Ferrari that he may never in his life ever be able to get. And some who dream will get it. But you can dream about those shoes, and they are accessible. People get them and they literally feel like they had just gone out and bought a Porsche 911. And that thing, the essence of life is how something makes you feel. If you can feel a certain way, then you probably can do about anything on the planet. /////
**HOWARD "H" WHITE**

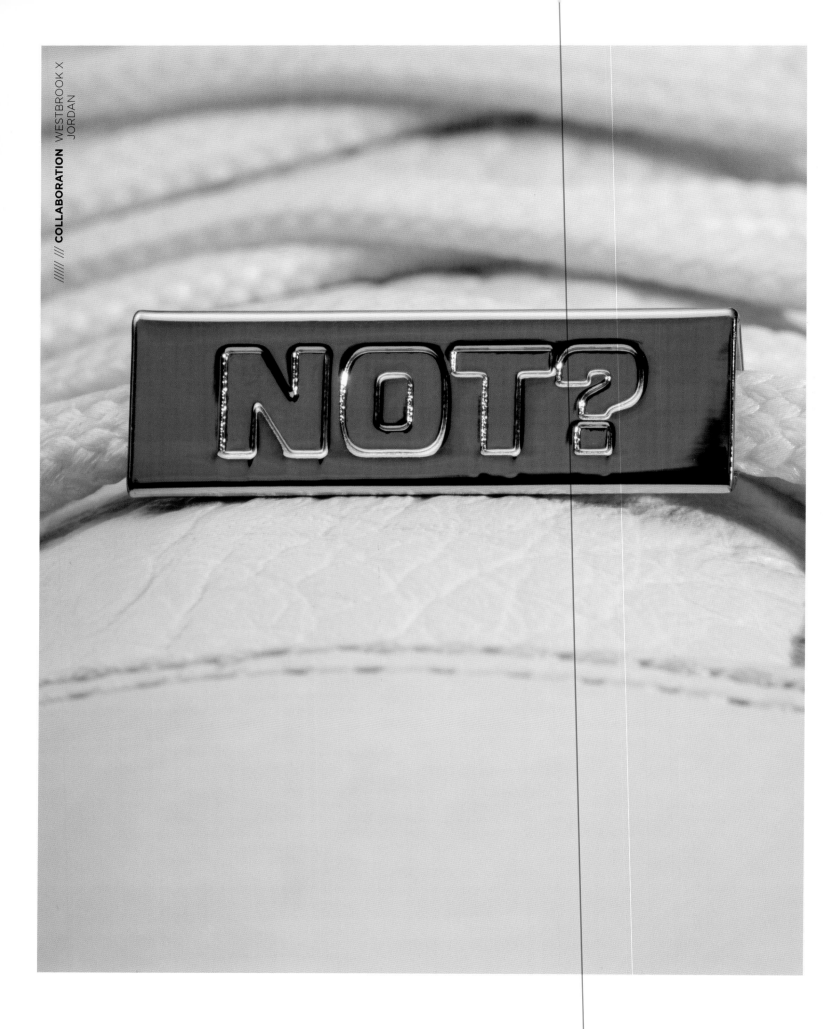

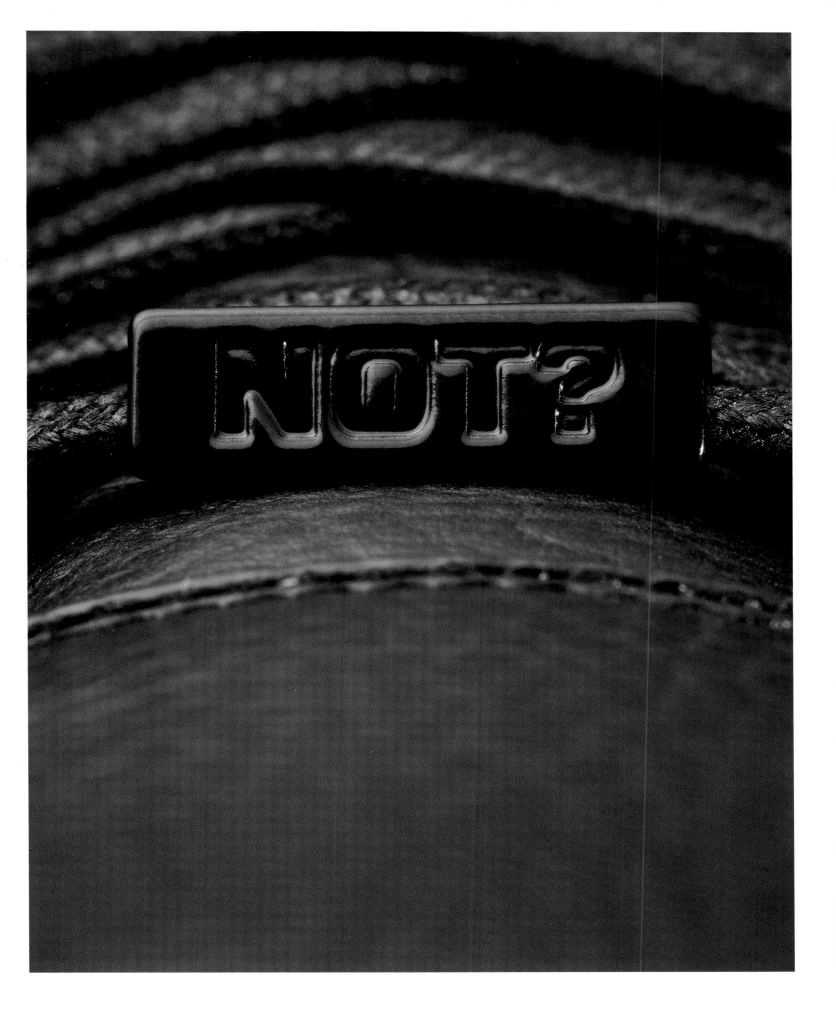

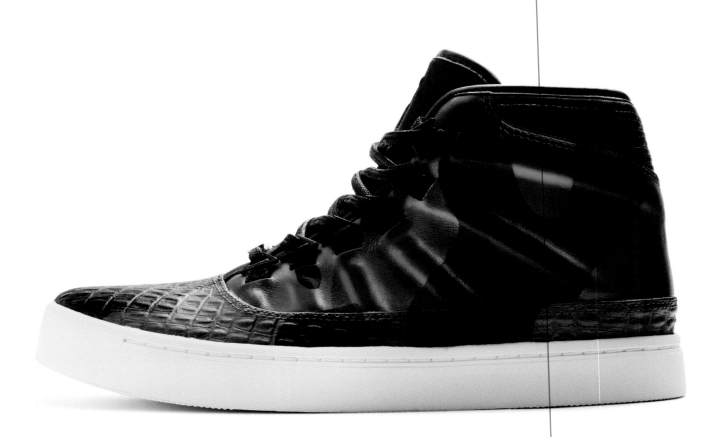

///// You have to be confident
to do what Russell does. Obviously
he's good at what he does on
court, and there's a confidence that
comes with that. And then what
he wears and how he pulls it off,
that confidence just continues off
the court. ////
**TIM COPPENS**

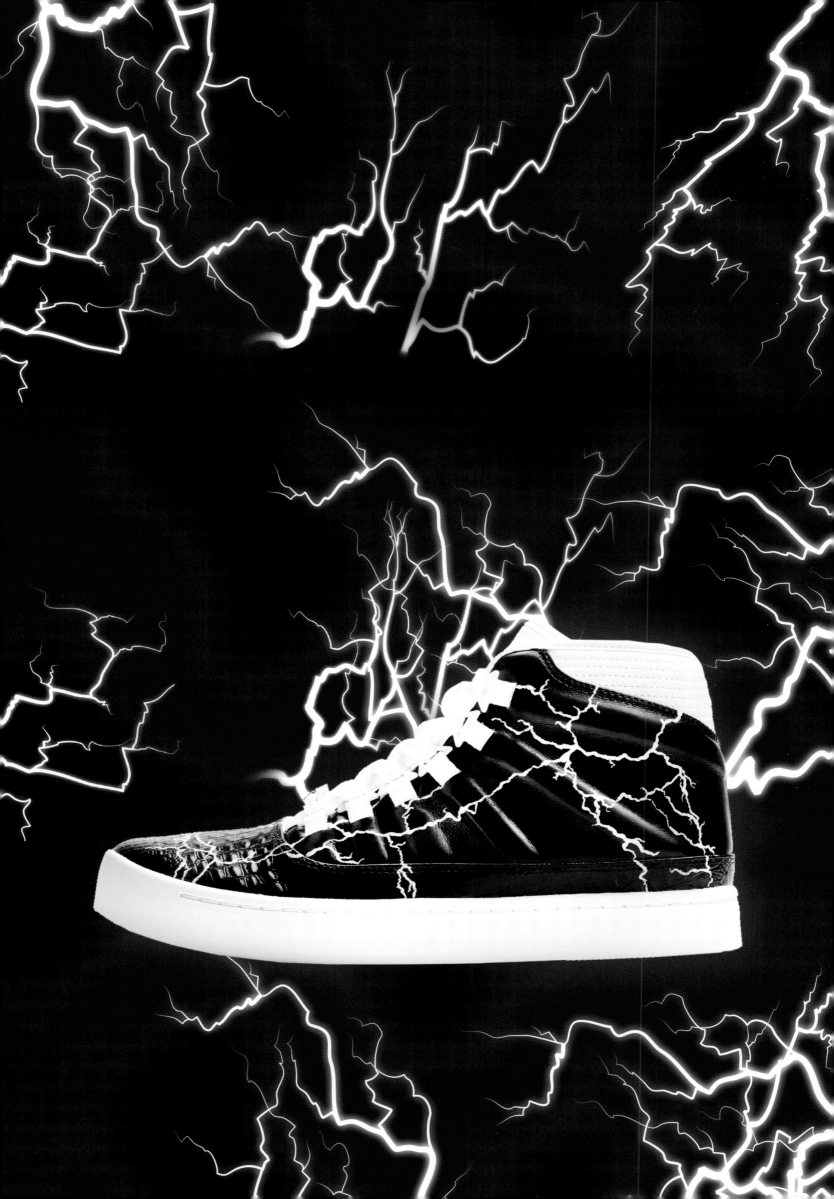

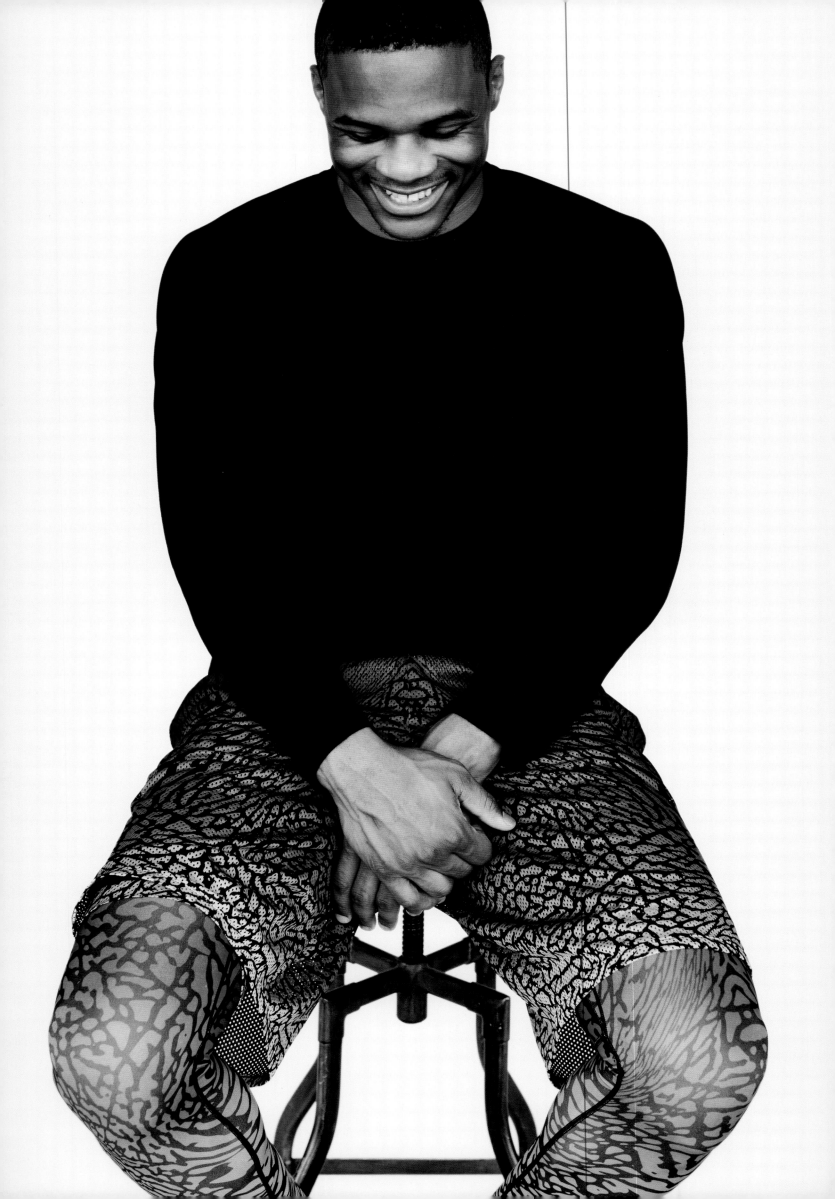

**COLLABORATION**

If there's one idea that defines the modern mode of creation, it's collaboration. Between individuals, sure—but also between companies and across industries. In an era when the multi-hyphenate creative polyglot has become not the exception but the rule, the concept of staying in your own lane when it comes to making new things has never felt more outmoded.

And with good reason. Collaboration encourages the exchange and interplay of ideas. It challenges convention and demands new modes of thinking. From music and arts to sports and fashion, it pushes its respective mediums forward into exciting—oftentimes unexpected—territories.

But there's collaborating, and there's collaborating. The distinction between the two is a whole lot bigger than it may seem.

On the one hand, you've got your pop-culture personalities looking to expand their sphere of influence and happy to slap their name on whatever might come along. Call it cynicism or marketing genius—your choice—but either way, don't call it genuine creative interplay. More often than not, the person with their name slapped on that drugstore cologne never even smelled the stuff.

On the other hand, you've got the folks who genuinely give a damn about what they're working on. "I've been blessed with the opportunity to be able to play the game of basketball and be provided this platform, so I better use it to be able to expand my ability to be able to create, and meet different people," says Russell Westbrook. "To be able to show my creative side when it comes to style." To that end, Westbrook has worked with everyone from award-winning fashion designers to specialty perfumers to one of the world's most influential department stores. And the way Barneys Creative ambassador-at-large Simon Doonan sees it, the intersection between style and sport is no coincidence.

"Russell is a natural collaborator," Doonan says. "He built his career in a team sport. He knows how to play in the sandpit and how to share ideas in order to get the best results." That give-and-take between complementary—sometimes competing—perspectives isn't just key to the vitality of a team, it's an essential element of crafting and refining new ideas.

Well, that and a decent attitude.

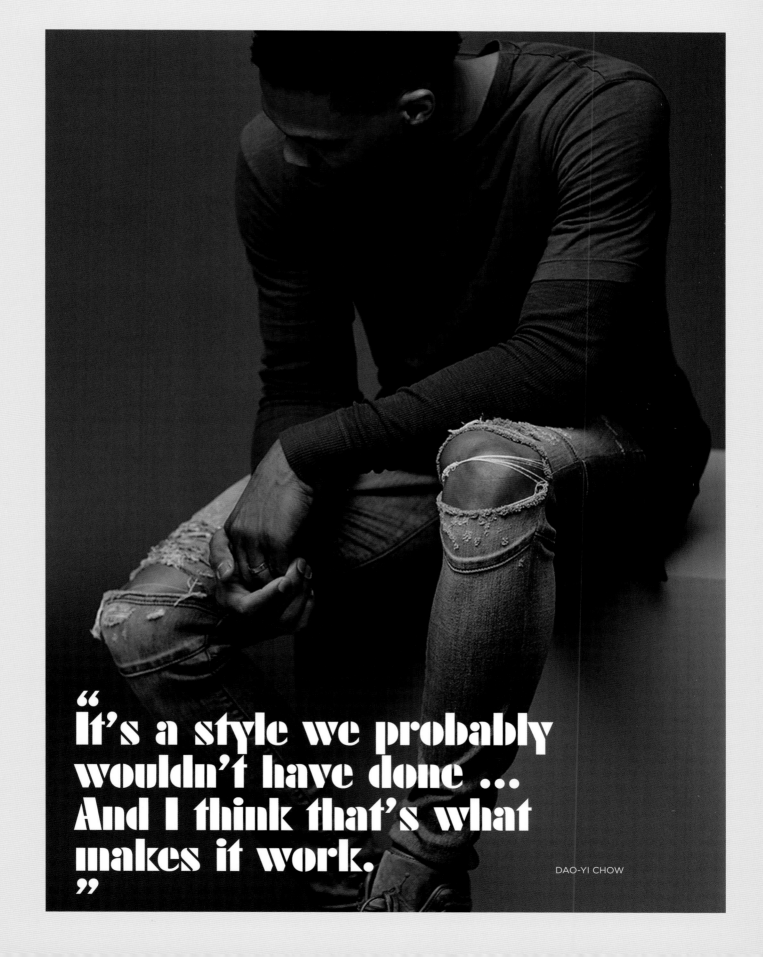

"It's a style we probably wouldn't have done ... And I think that's what makes it work."

DAO-YI CHOW

"Unlike so many professional athletes, Russell doesn't exude a big ego," says Brandon Svarc, whose Montreal-based denim brand Naked & Famous worked with Westbrook on his collaborative Russell Westbrook XO Barneys New York capsule collection, along with labels like WANT Les Essentiels, Byredo, Tim Coppens, Public School, and Jordan Brand. "He's confident and polite," Svarc continues. "He has solid ideas and, more importantly, is decisive enough to know if he likes something or not right away."

Selima Salaun of boutique eyewear line Selima Optique echoes that sentiment. "He's extremely particular," she says of Westbrook. "He knows exactly what he wants and doesn't want." According to Tim Coppens—the winner of the 2014 CFDA Swarovski Award for Menswear and the featured designer at the seminal men's tradeshow Pitti Uomo in early 2017—that has a lot to do with simple business chops. "He's educated like most people in the industry aren't always educated," the Belgian-born designer explains. That translates to not only a sense of direction when it comes to materials and fabrication, but to a belief in his distinctive point of view.

"The minute you see him, you know it's him," says friend and fellow fashion fan Victor Cruz, who's done his share of collaborations with lines like denim brand 3x1 and Nike. "You know it's his personal style. You know that's exactly what he loves to wear and how he loves to wear it."

"He completely grasps that his own style is about experimenting with different things," says Long Nguyen, cofounder and style director of *Flaunt* magazine, and a longtime friend of Westbrook's. What that means, for the brands that collaborate with Westbrook, is that boundaries are going to be pushed. This is a good thing.

"We got this opportunity to work with Russell, and we were like, 'This is so cool, because now we're going to start looking at other fabrics or finishes or prints.' It took us out of our wheelhouse, and it was interesting because he was able to bring us along," says Byron

Peart, who designs for the accessories and footwear label WANT Les Essentiels along with his brother Dexter. Both tend toward minimalism, and the brand's bags and shoes tend to slip—exceedingly stylishly—under any radar attuned to louder, streetwear-inspired pieces. Not so with the twins' work with Russell, which swung from understated backpacks to bold, leopard-print portfolios.

For Maxwell Osborne, who heads up New York based brand Public School along with Dao-Yi Chow, the story was much the same. Working with Russell led to the creation of pieces that the *Vogue*/CFDA Fashion Fund winning label may have otherwise left on the cutting room floor. Speaking about a particular top—mesh, and done up in a brand new silhouette—he lays out the value of a new perspective: "It's a style we probably wouldn't have done if it weren't a collaboration with Russell. And I think that's what makes it work."

Of course, it's not just about pushing boundaries. Sometimes, when it comes to collaboration, it all comes down to compatibility. Ben Gorham, the mind behind the luxury fragrance and accessory line Byredo, describes Westbrook as "receptive, and very curious. He has a perspective and an idea about things like fragrance and fashion and so on." Asked what it's like to work with the man who's name has become an official Byredo scent, he responds simply: "Easy."

The respect, for Westbrook's collaborators, goes both ways. "I really appreciate what he does, and I guess it's mutual," says Milanese fashion designer Marcelo Burlon, who summarizes what so many designers and creative types have said of their relationship—working and otherwise—with Westrbook. "I'm very happy I have met him, and looking forward to developing even more projects together in the future."

That give-and-take between complementary—sometimes competing—perspectives isn't just key to the vitality of a team, it's an essential element of crafting and refining new ideas.

IT DOES NOT FIND, BUT BRING.

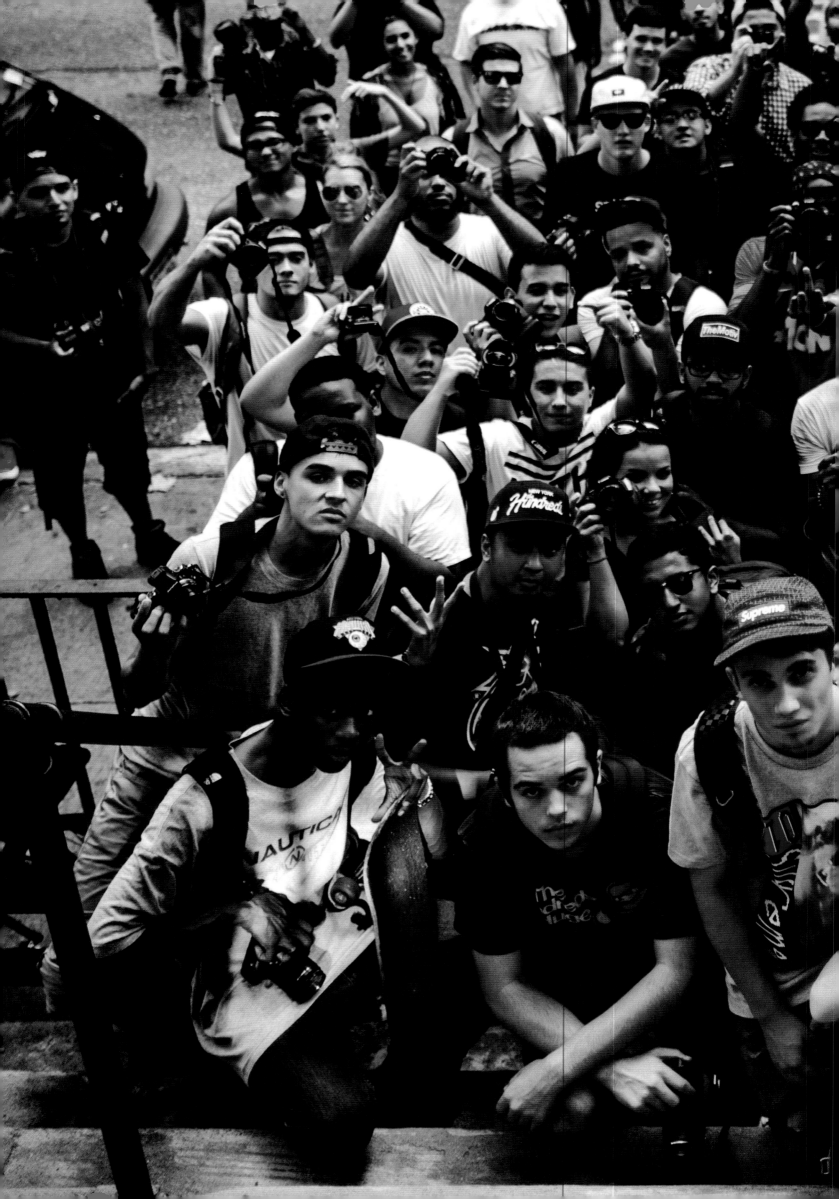

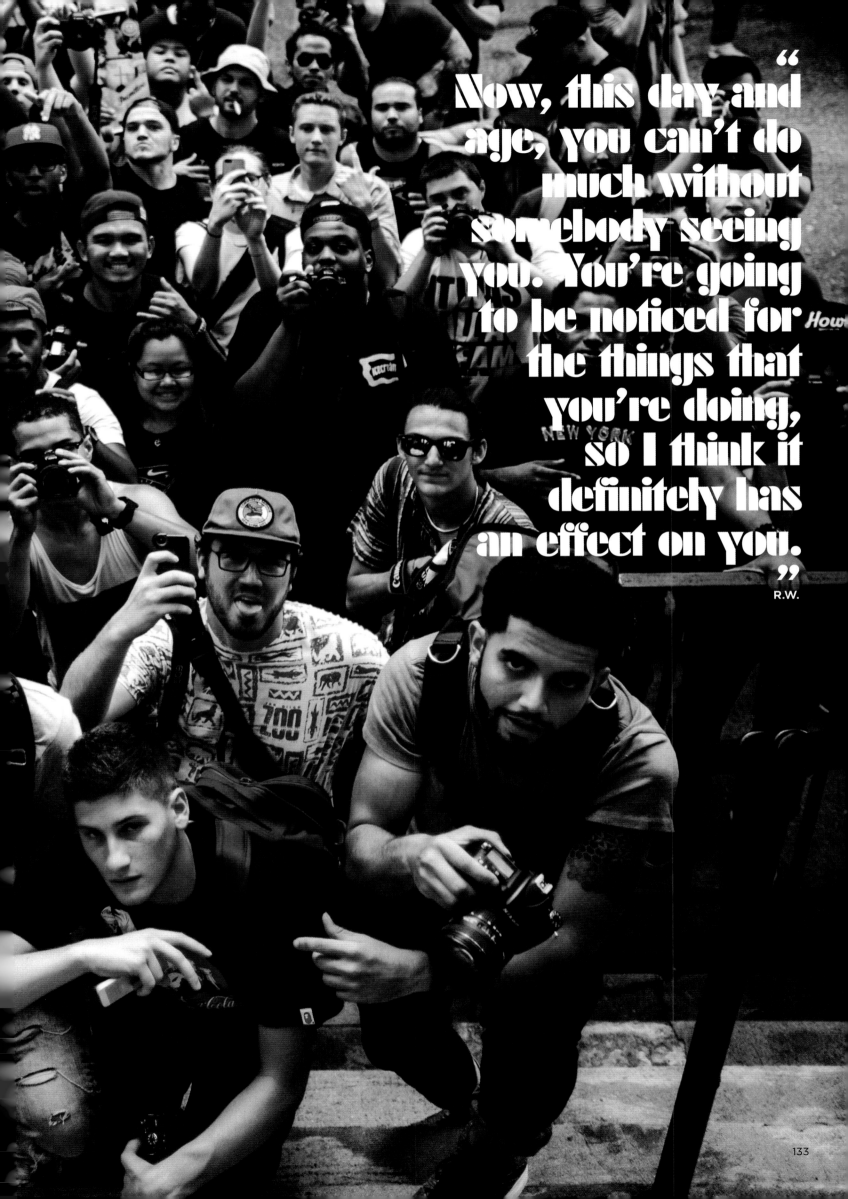

"Now, this day and age, you can't do much without somebody seeing you. You're going to be noticed for the things that you're doing, so I think it definitely has an effect on you."

R.W.

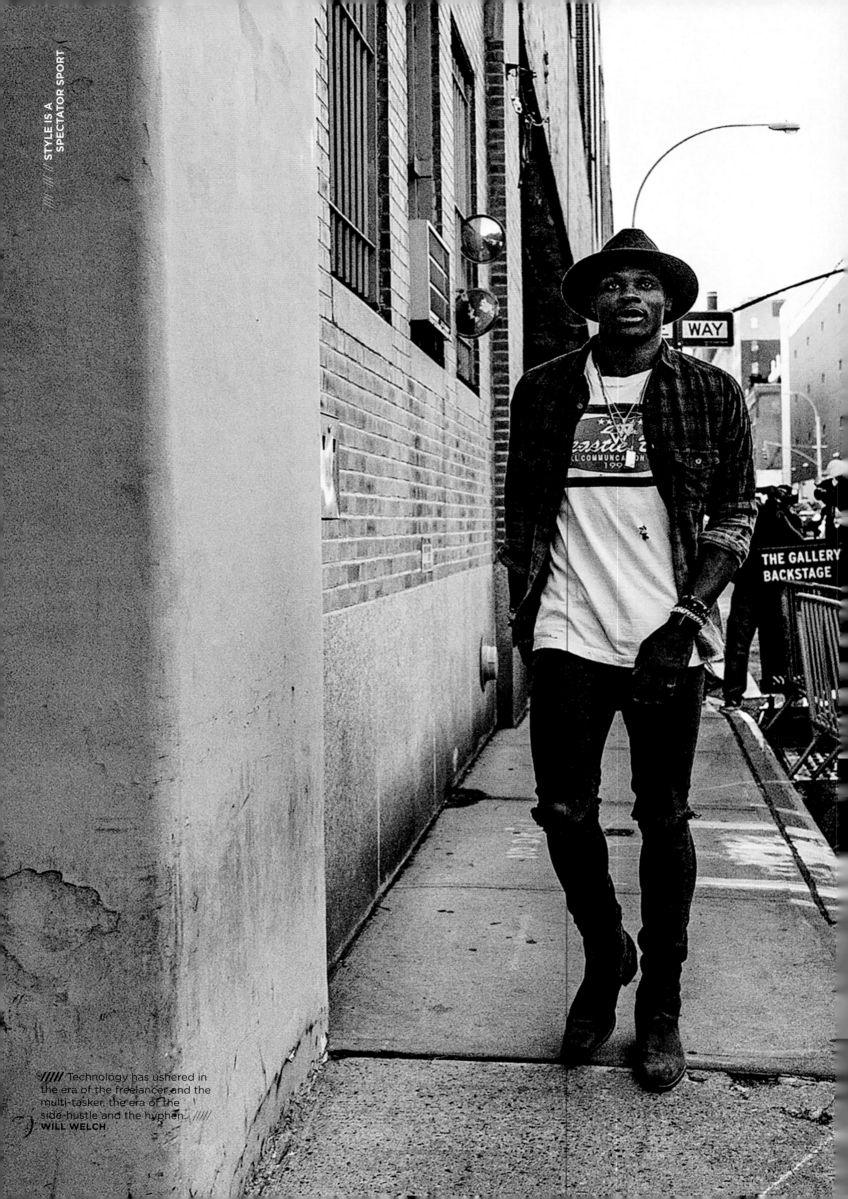

Technology has ushered in
the era of the freelancer and the
multi-tasker, the era of the
side-hustle and the hyphen. /////
**WILL WELCH**

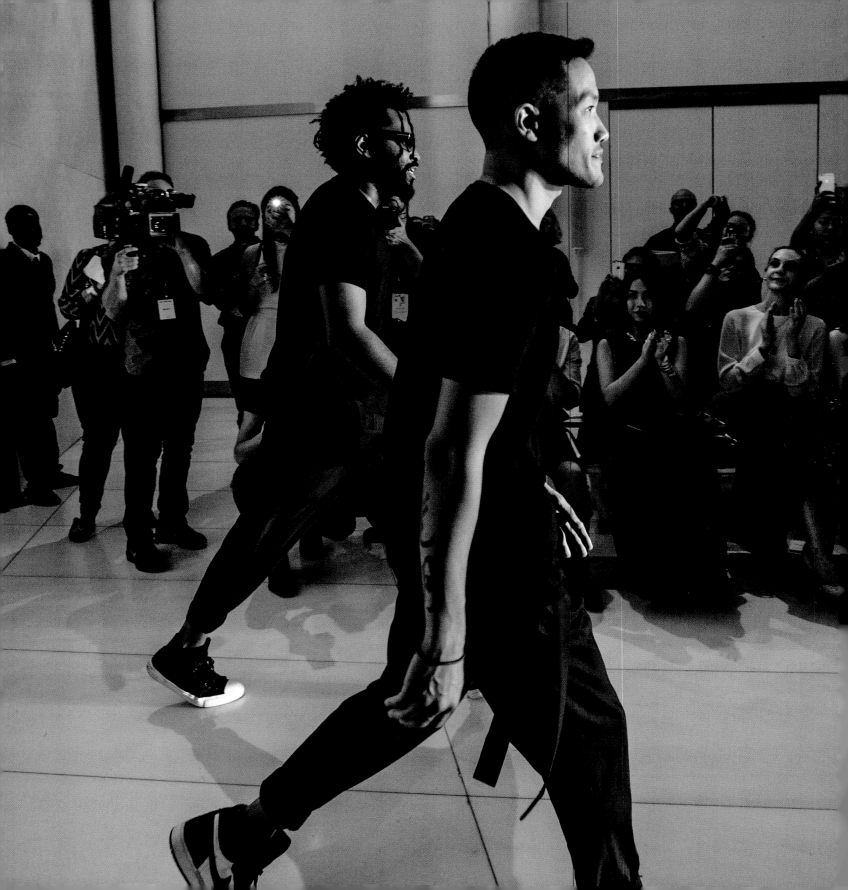

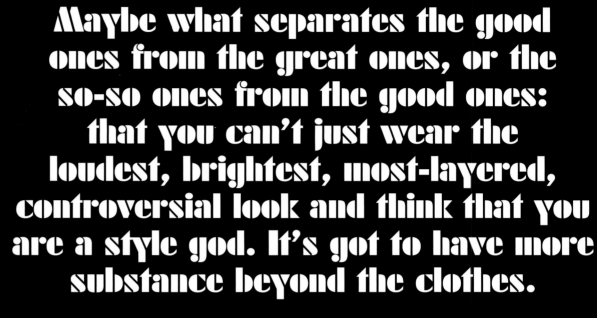

"
**Maybe what separates the good ones from the great ones, or the so-so ones from the good ones: that you can't just wear the loudest, brightest, most-layered, controversial look and think that you are a style god. It's got to have more substance beyond the clothes.**
"

DAO-YI CHOW

"
**Style is just being yourself and being comfortable. Starting off at that point and from then on, understanding yourself. Style is unique. Style is true to yourself. Style is not really a trend; it's just being creative and being you in your own skin.**
"

MAXWELL OSBORNE

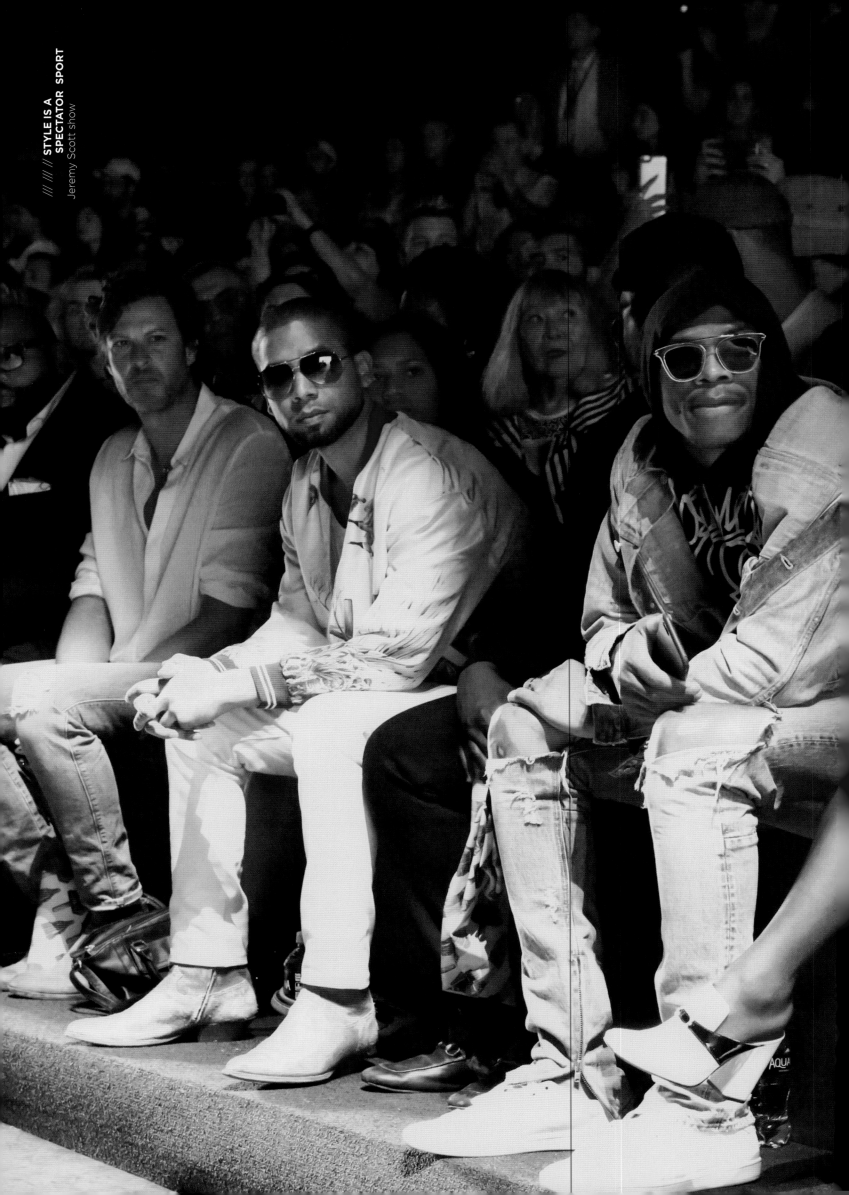

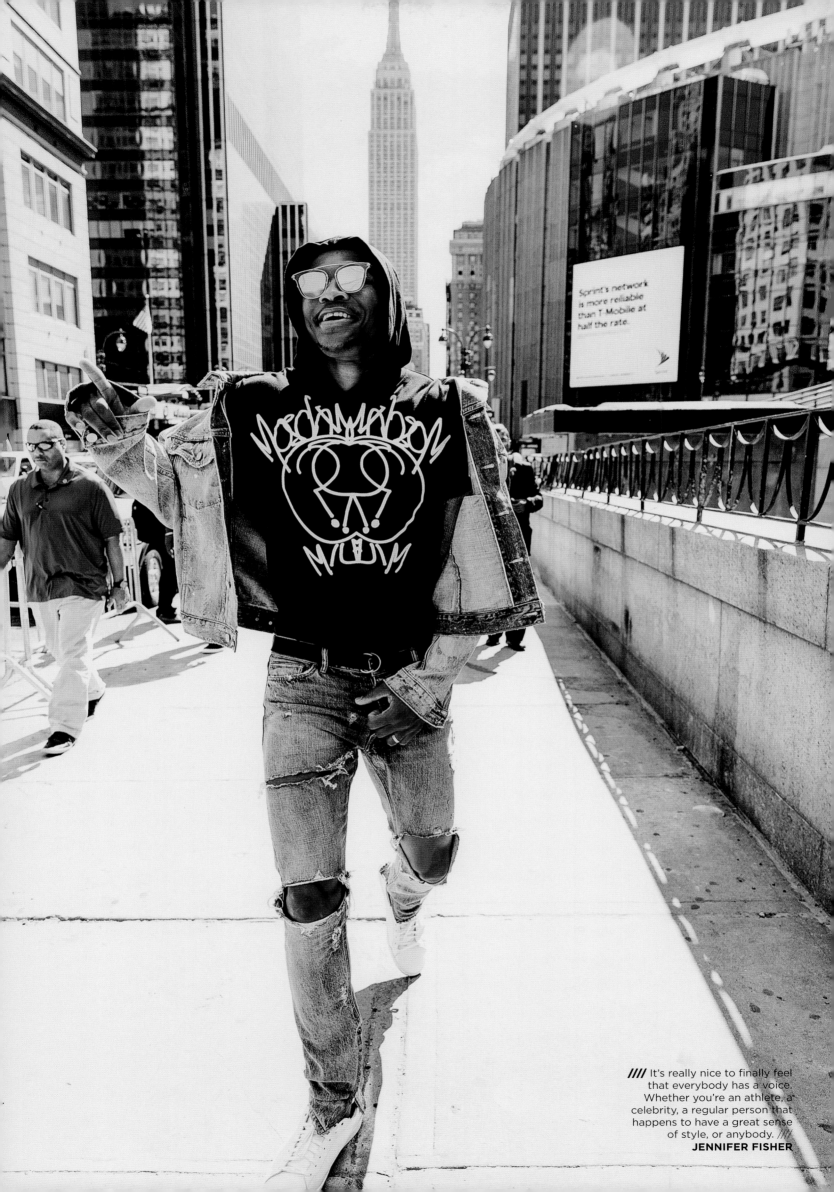

//// It's really nice to finally feel that everybody has a voice. Whether you're an athlete, a celebrity, a regular person that happens to have a great sense of style, or anybody. ////
**JENNIFER FISHER**

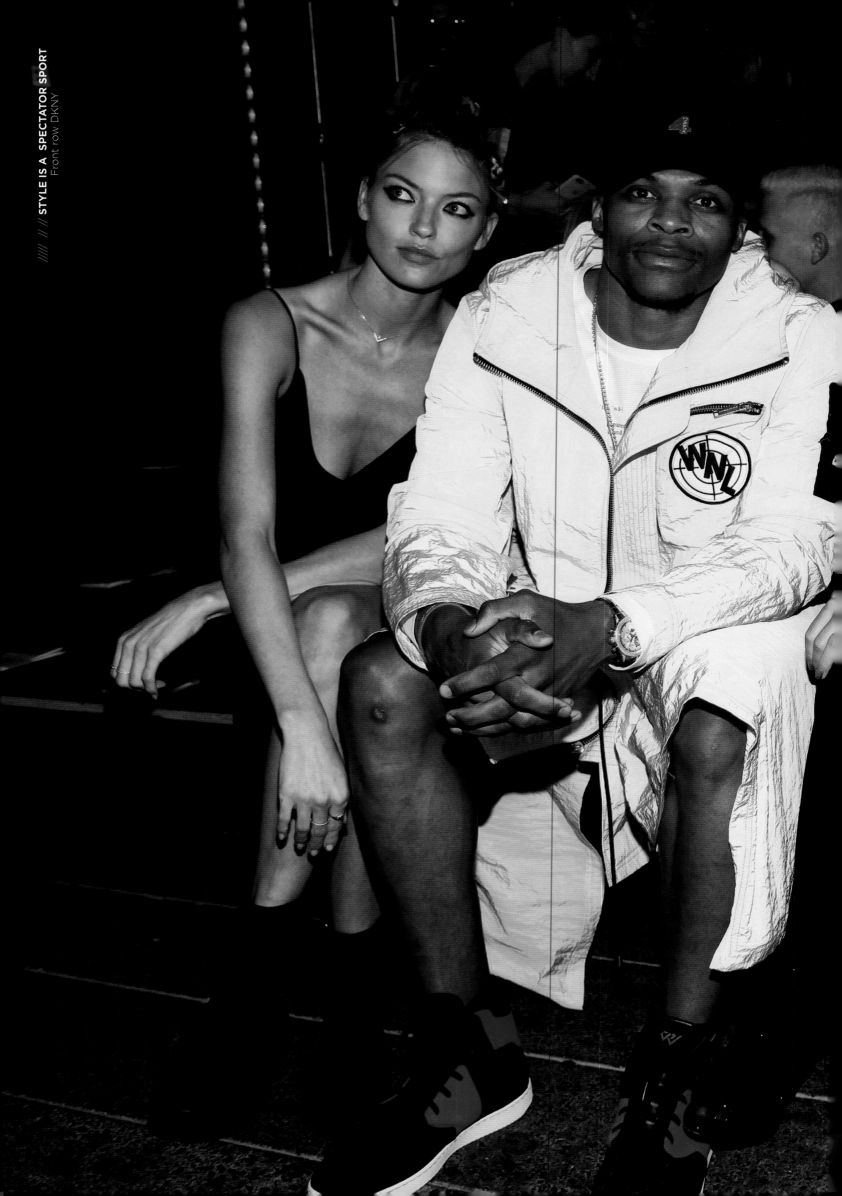

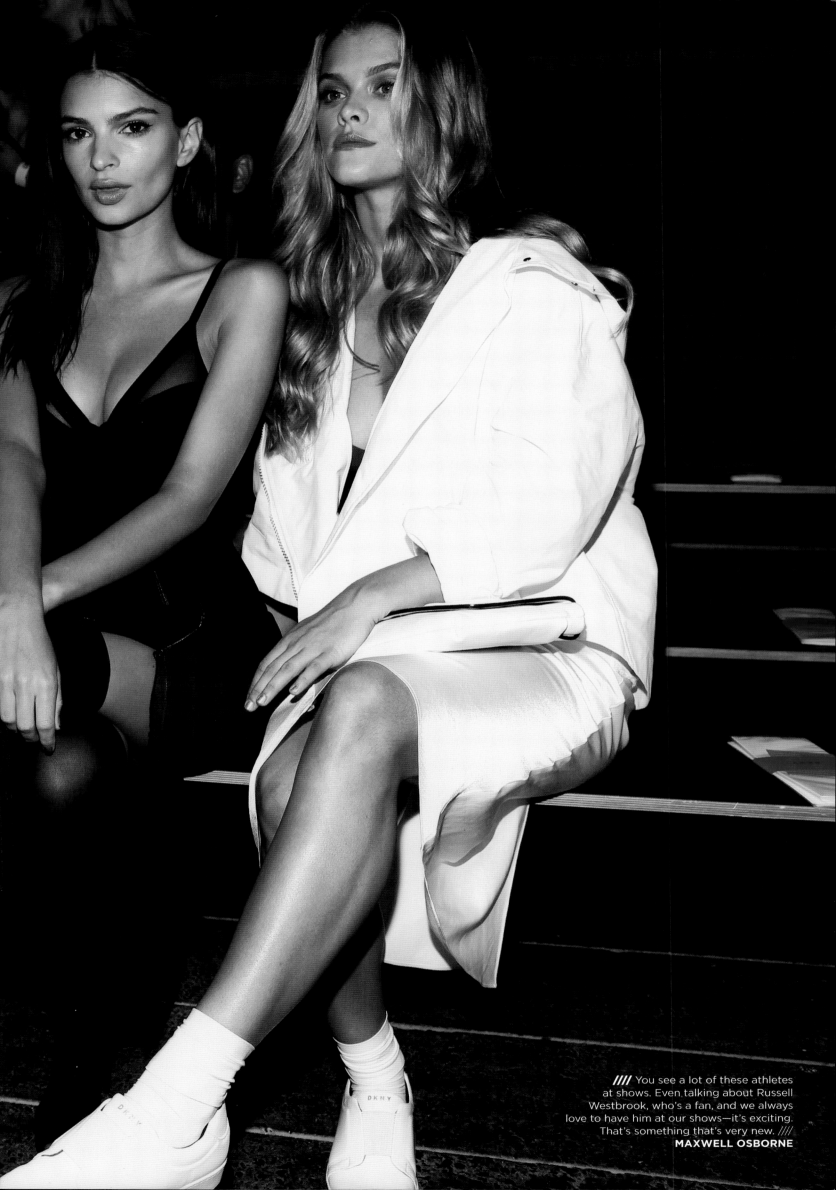

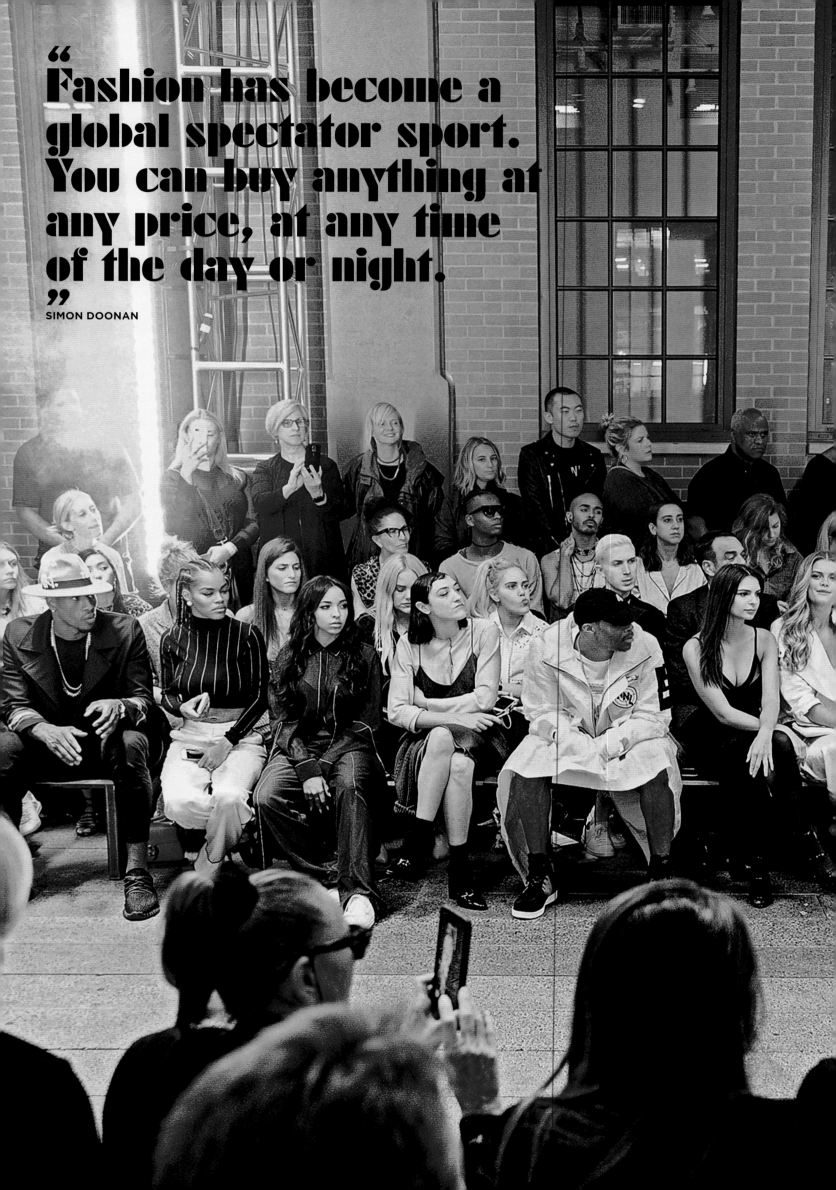

"Fashion has become a global spectator sport. You can buy anything at any price, at any time of the day or night."

SIMON DOONAN

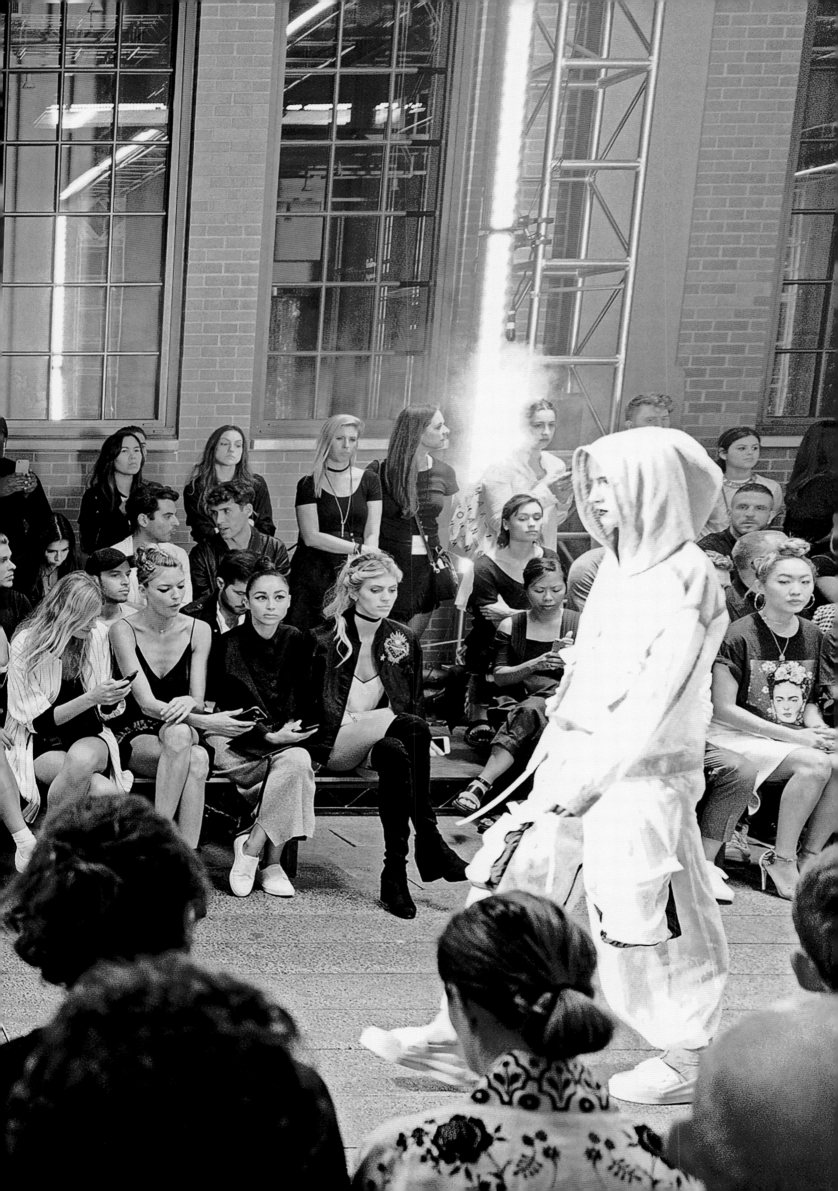

# "I've been blessed with the opportunity,

# so I better use it to expand my ability to create."

R.W.

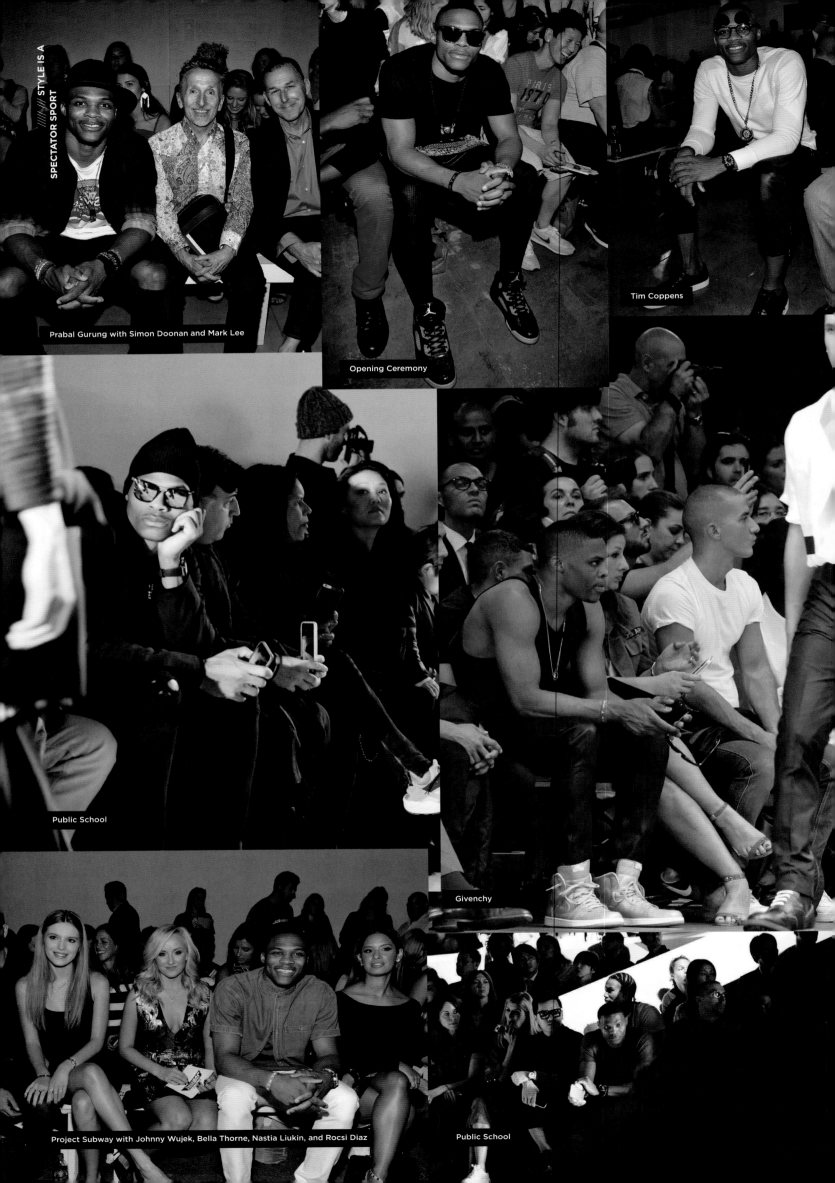

Prabal Gurung with Simon Doonan and Mark Lee

Opening Ceremony

Tim Coppens

Public School

Givenchy

Project Subway with Johnny Wujek, Bella Thorne, Nastia Liukin, and Rocsi Diaz

Public School

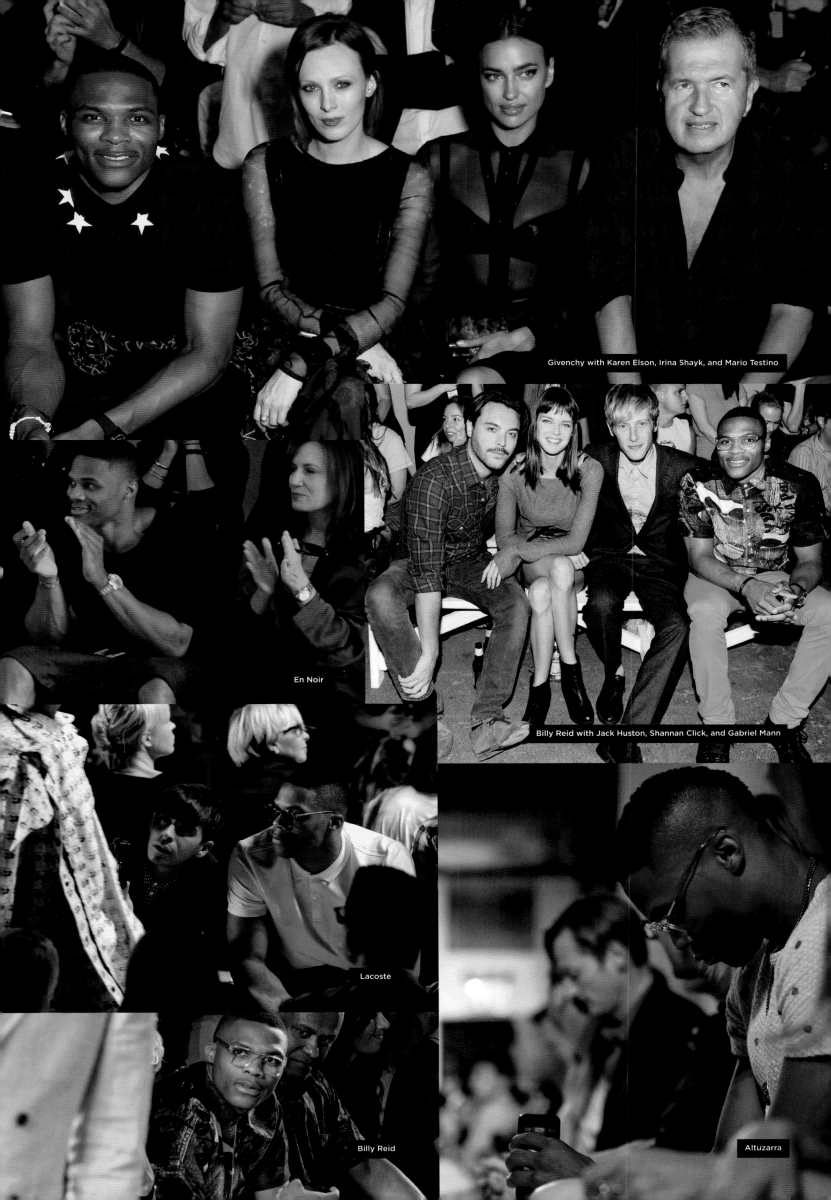

Givenchy with Karen Elson, Irina Shayk, and Mario Testino

En Noir

Billy Reid with Jack Huston, Shannan Click, and Gabriel Mann

Lacoste

Billy Reid

Altuzarra

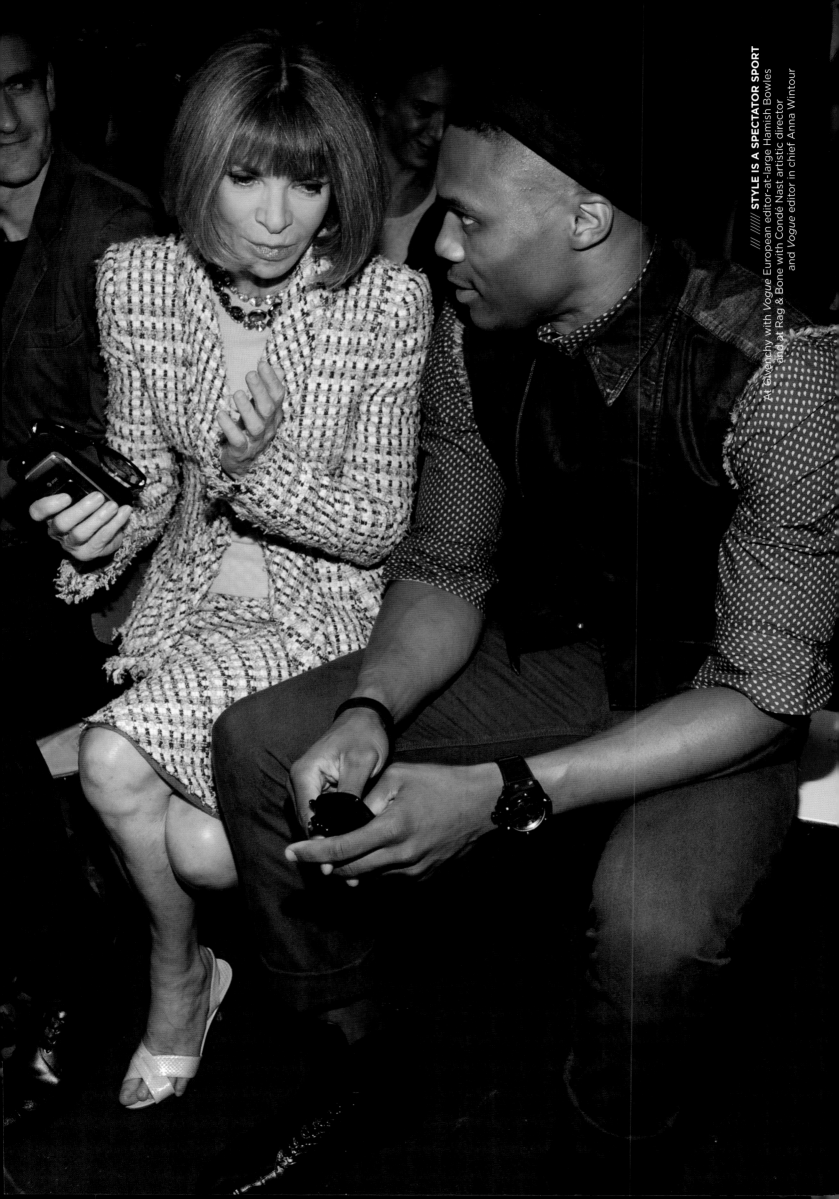

At Givenchy with *Vogue* European editor-at-large Hamish Bowles and at Rag & Bone with Condé Nast artistic director and *Vogue* editor in chief Anna Wintour

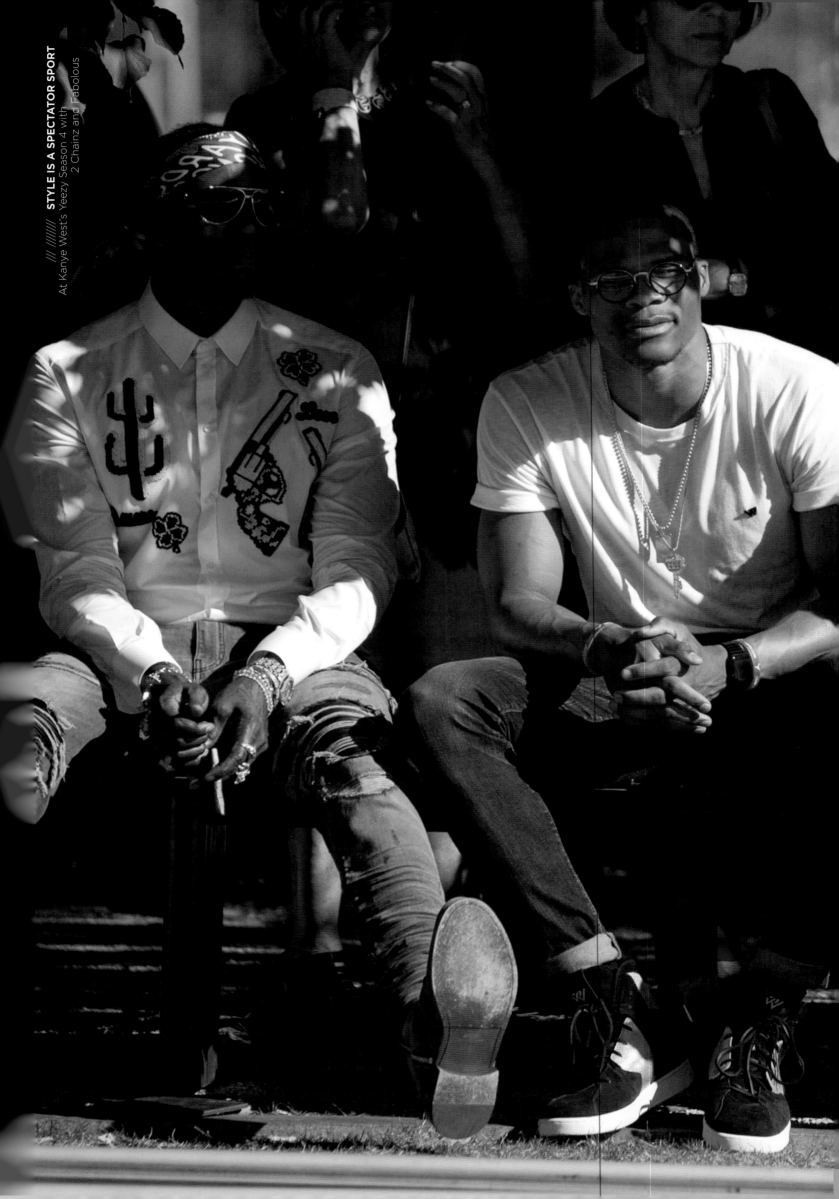

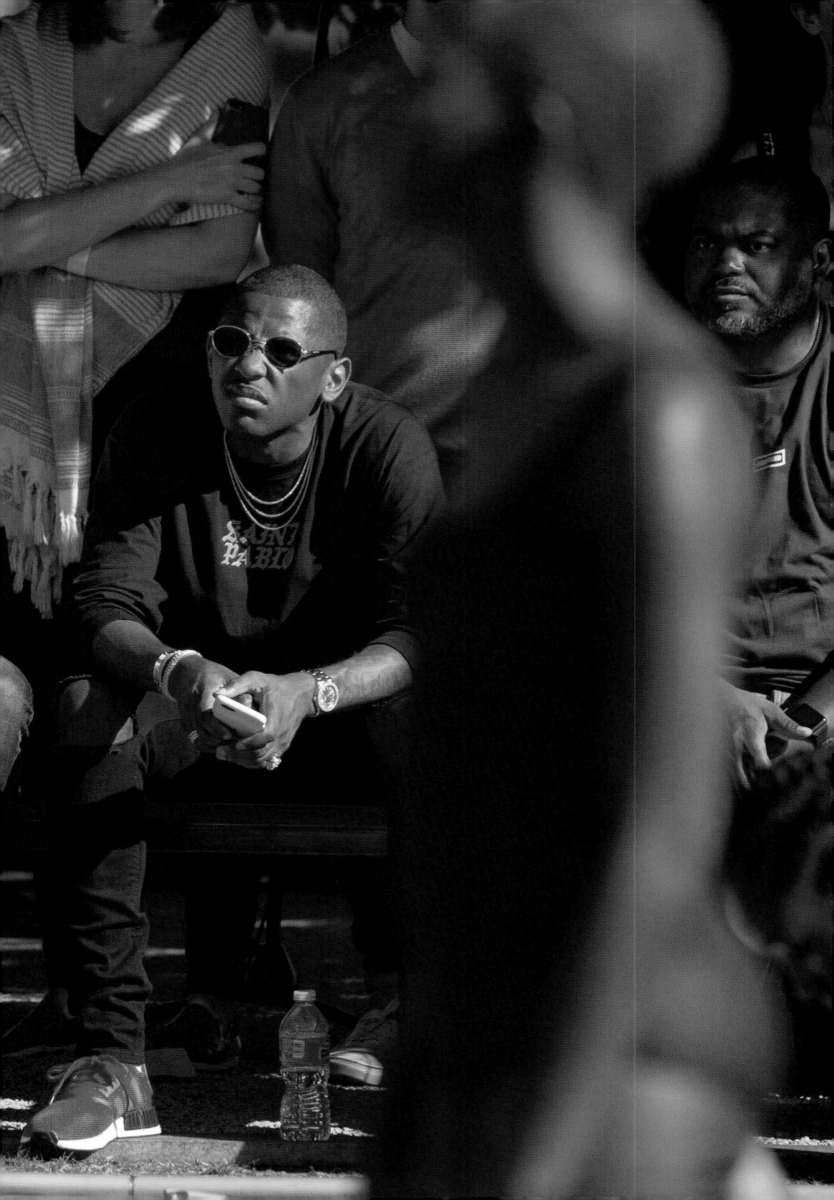

"

When we talk about fashion, I like the conversation because it's a cultural conversation that's not only tied into a garment and a zipper. It's something that lives, and it's part of a bigger picture. I was born in a small village, and it was very hard to express yourself because people were watching you and you were the outsider or whatever. And now—

I'm not saying that every problem in the world is solved—but there's a connection that can be created with people that are very far away from you but actually very close, because we have different outlets to connect with.

"

**TIM COPPENS**

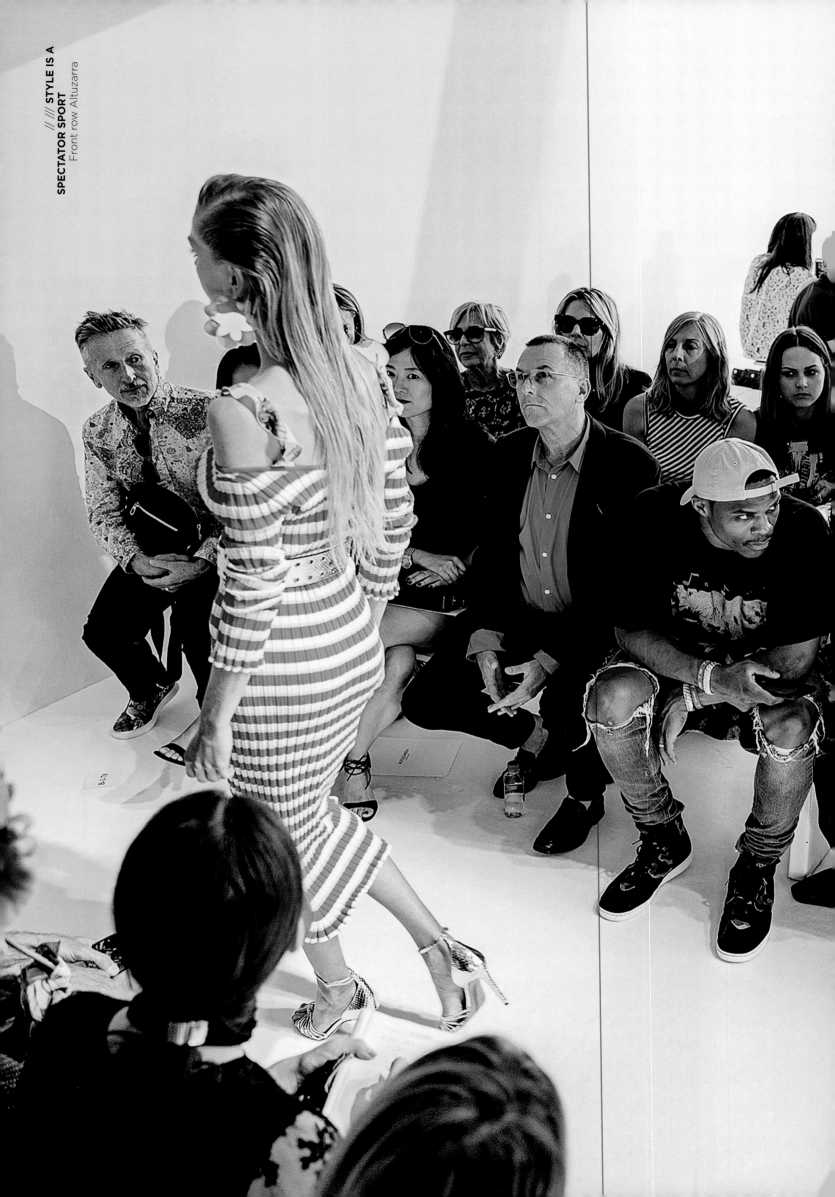

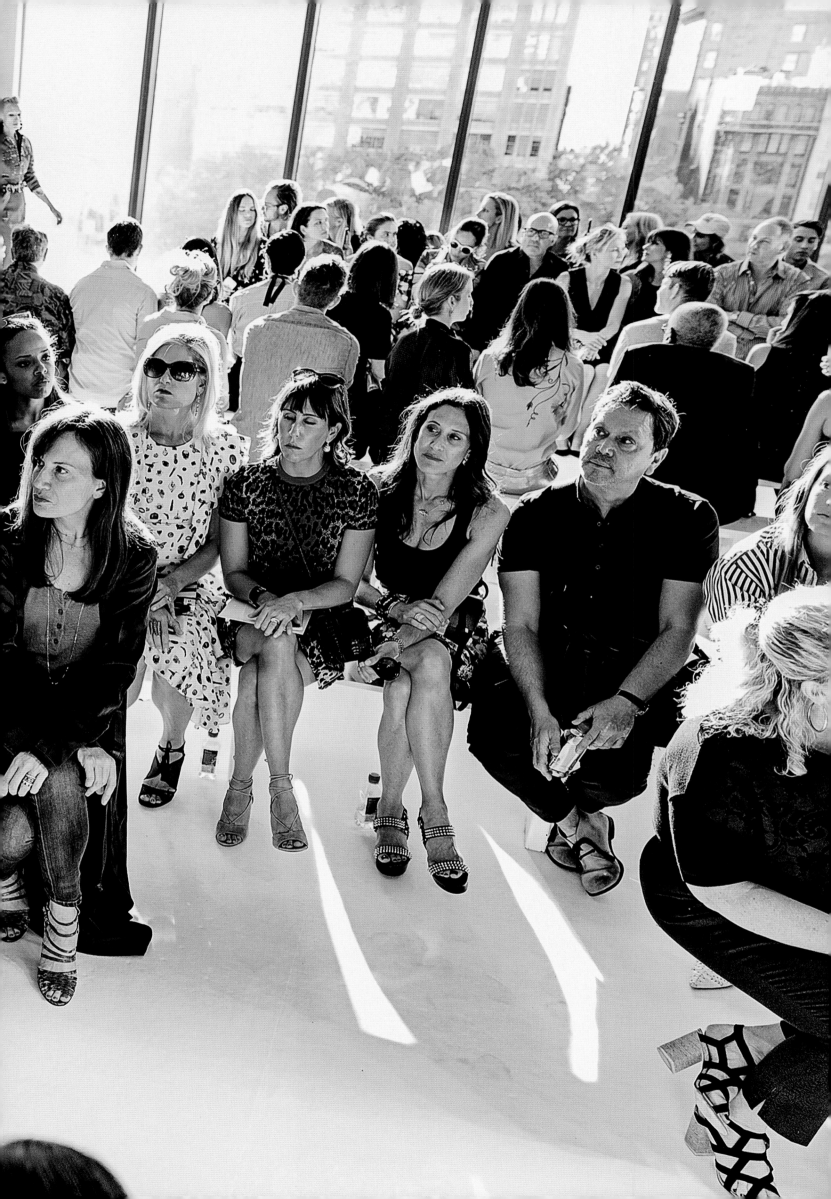

///// People who are stylish have their own
style, whether it's Kanye—whoever it is.
"OK, that's their style. That's what they do."
I think now I'm at a place where people are
like, "OK, that's a Westbrook style.
That's what he does." /////
**R.W.**

"I think the more and more I see fashion, a lot more people are deciding to step out of their comfort zones. That makes me more excited, because that means people are being themselves, people are being more outside of the box and want to expand, and I think that's the best part about it."

R.W.

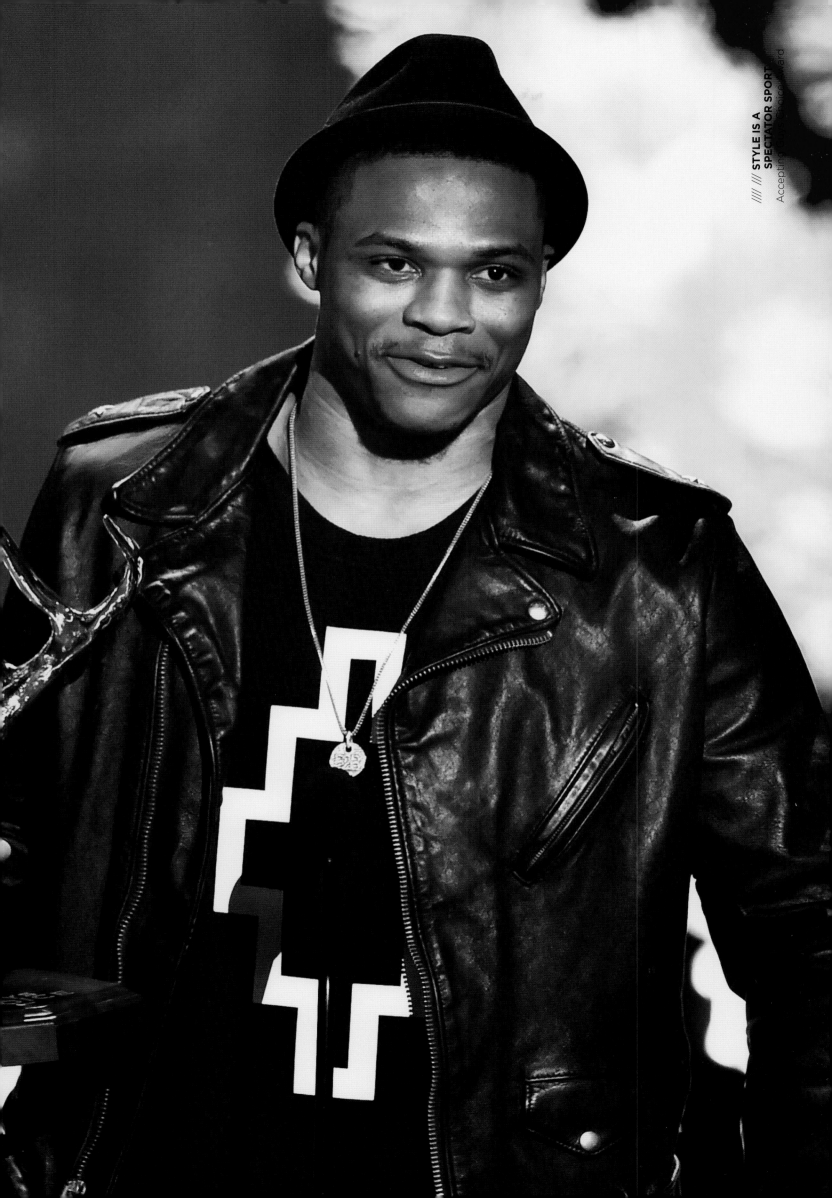

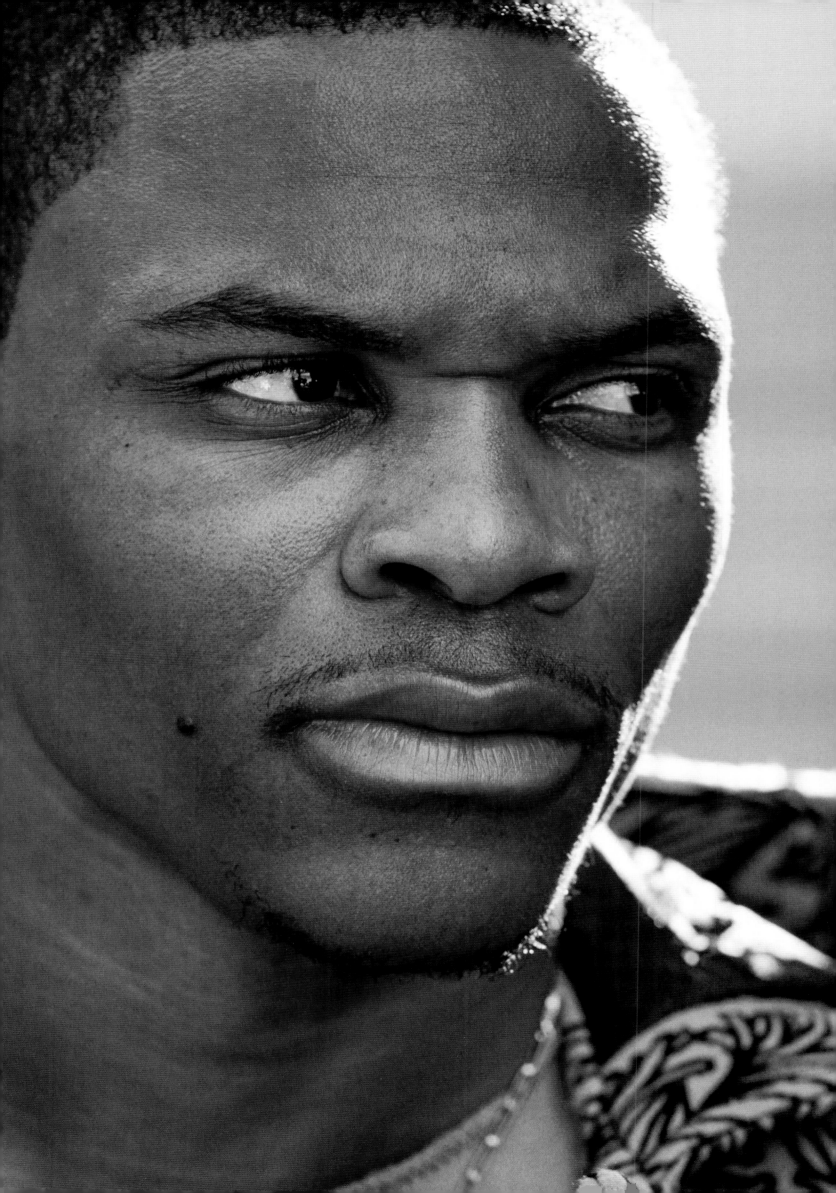

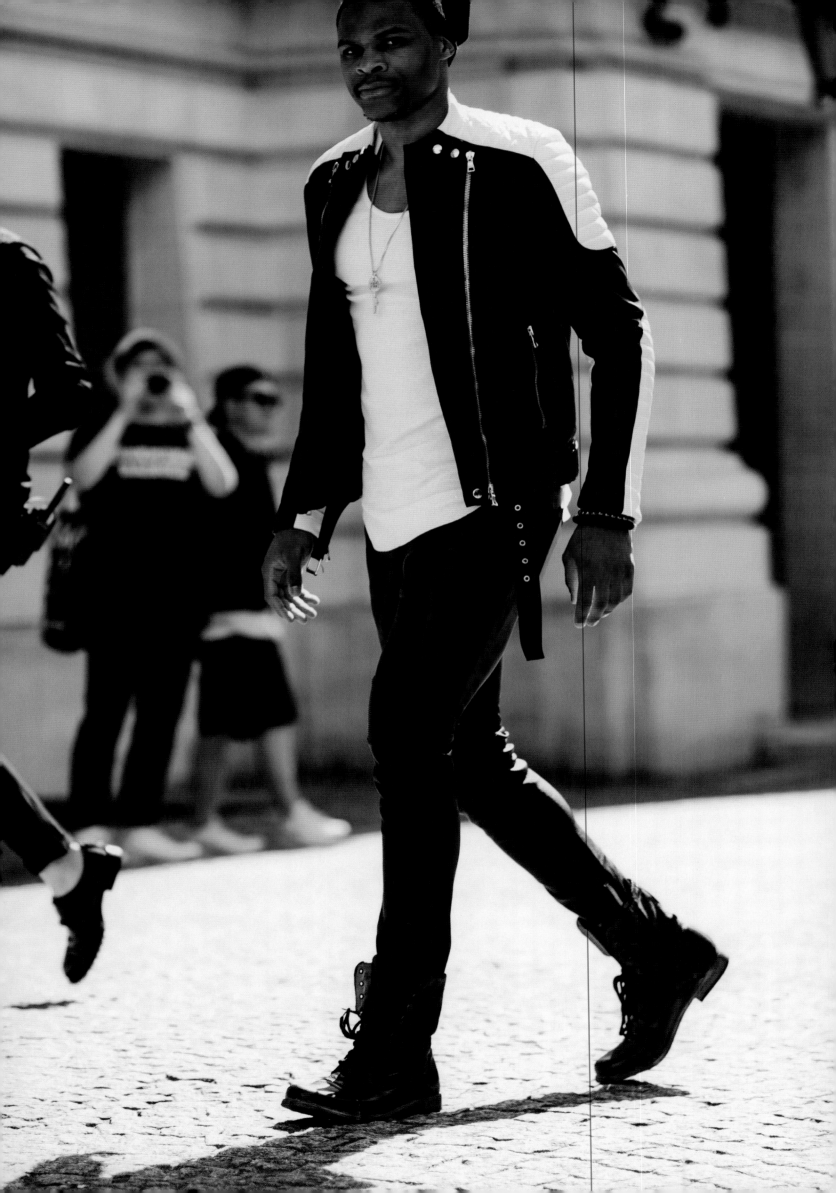

# STYLE SPECTATOR SPORT IS A

Saying that social media has drastically shifted the landscape of men's style is like saying that water is wet and sneakerheads like Air Jordans: painfully obvious. But that doesn't make it any less true. In a world where a single photo of a single outfit can go from your camera roll to millions of screens across the world, the question of what it means to be stylish has never been more open to personal interpretation.

"There's no longer an intermediary," says *Flaunt* magazine's Long Nguyen. "You don't need a magazine to tell you what is fashionable anymore." In place of a few arbiters of taste and style, we've thrown open doors to a whole slew of new perspectives and opinions. And while a few holdouts may balk at the loss of exclusivity, most forward-thinkers will agree that this democratization is incredibly valuable.

"Everyone has the ability right now to be their own style icon for themselves and however many people follow them on whatever social platform they're using," says Dexter Peart of WANT Les Essentiels. "And I think that's an amazing opportunity for men's fashion." It's the individual as influencer, not simply consumer—a sea change in how the fashion world functions.

His twin brother Byron lays out what that means in terms of giving voice to previously unheard or underrepresented ideas: "Now people are finding their references from so many different people, different ethnic backgrounds, different shapes and sizes, and everything else like that. So anything goes, to a certain degree." In other words, the choice is yours. The floodgates are fully open.

But that's not the only element at play. Credit Hedi Slimane and his rise to fashion royalty. Or the change in the NBA dress code. Or Instagram or H&M or Kanye. Or, probably, all of that and more. Whatever the reason, the fact is, men's fashion is more visible now than it has been since Beau Brummel and his band of dandies became the proto style icons of Regency England. "Fashion has become a global spectator sport," says Barneys New York creative ambassador-at-large Simon Doonan. "Fashion is now more democratic than ever. You can buy anything at any price, at any time of the day or night." Here's to overnight shipping and free returns. And to clothes that people from across the economic spectrum can appreciate and acquire. But it's more than simply a supply-side issue. Because for them to mean anything, someone has to buy those clothes— and guys are lining up to do just that.

"Men, I think, genuinely do care more about how they look and how they dress now," says Dao-Yi Chow of New York based label Public School. It's something he and cofounder Maxwell Osborne credit, in part, to the intersection of sports and style. While guys like Walt "Clyde" Frazier were luminaries in their own time, they were also men apart. That's all changed.

"Now," says Osborne, "kids look up to these athletes as style icons. And you see a lot of these athletes at shows." It's not a fluke; it's a shift in culture. And it's driven by platforms that didn't even seem possible in

# I understand why a regular person has the world as an audience. "

BEN GORHAM "

# " Fashion is now more democratic than ever. "

SIMON DOONAN

the days when "Clyde" first threw on his wide-brimmed hat and earned his nickname.

"Social media's probably changed the way we think about everything," says Howard "H" White, founding father and current VP of Brand at Jordan. He should know; he's been doing this gig for a while. "I'm from a completely different generation," he explains, but nowadays, "someone sees something and they take a picture and send it out to a million people. That never happened before. And so, it's good and bad. People scrutinize, and then have something to add in, take away, whatever. Social media is just . . .Well, it's a new day. It's just huge."

It's also a double-edged sword. "I think that social media can be a great opportunity. But there is also a lot of bullshit in social media," says Lapo Elkann. For all the opportunity—all the new and interesting ways of rein-terpreting the world of style—there's also the danger of losing yourself in the feedback loop.

"Social media has made kids too self-critical and mas-ochistic," Doonan says. "They seem hardwired to care too much about their peers." And still, we persist in posting and commenting and liking. It comes with the territory when the individual supplants the institution as the driving force in fashion.

And despite the thorns along the path, Byredo's Ben Gorham sees the value in forging on. "I understand why people do it," he says. "I understand why a regular person has the world as an audience in relation to what they're wearing. It changes the stakes for a lot of people, I think."

"Sometimes you get dressed to take a picture," says rapper Nipsey Hussle. Why? Because we want to. Be-cause we have to. Because we can. And because people will notice.

For better or for worse—most likely, for both—the way we create and consume style is fundamentally different now. We're all defining this moment, and what comes next. What that means is up to us.

# "Social media has made kids too self-critical and masochistic. They seem hardwired to care too much about their peers."

SIMON DOONAN

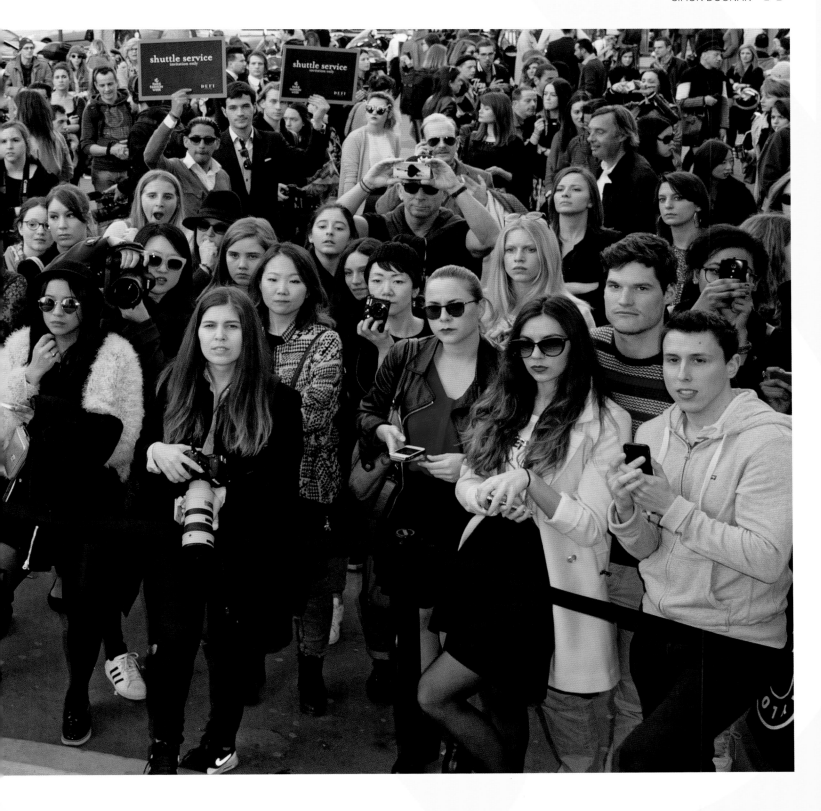

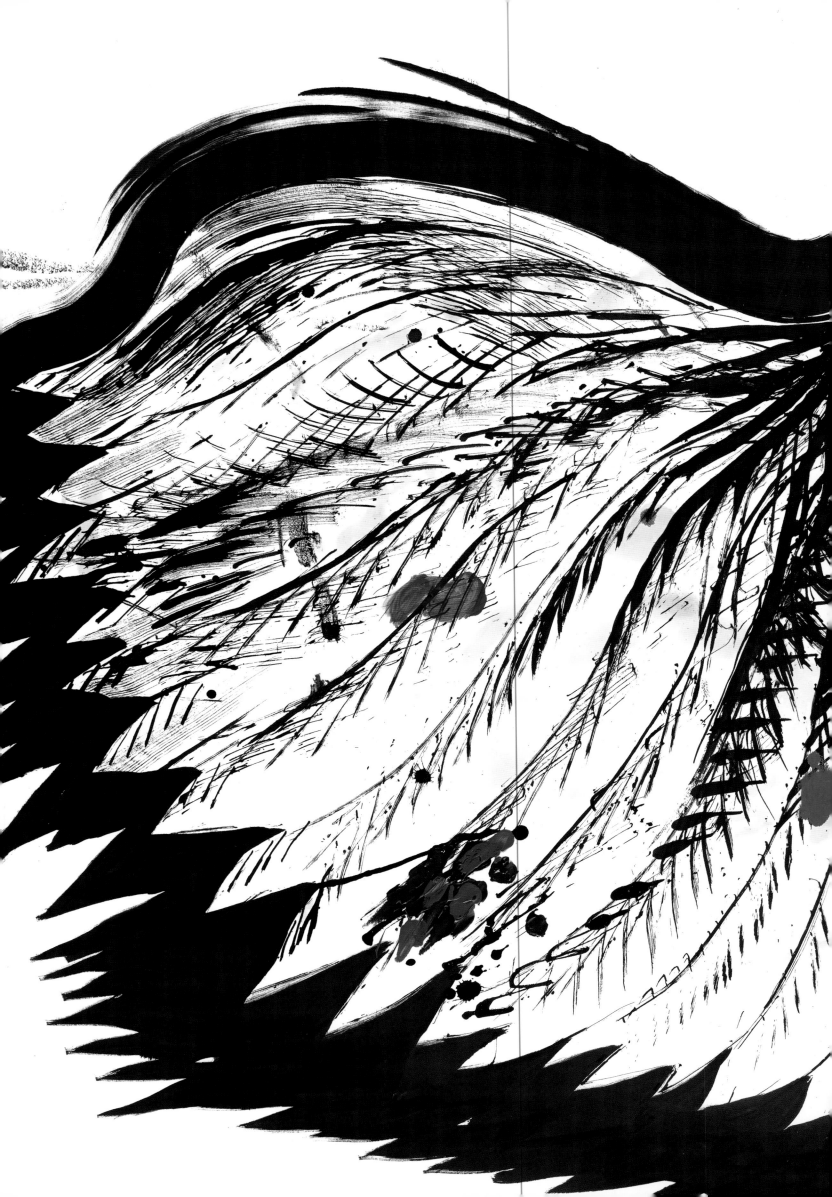

WHY NOT ?

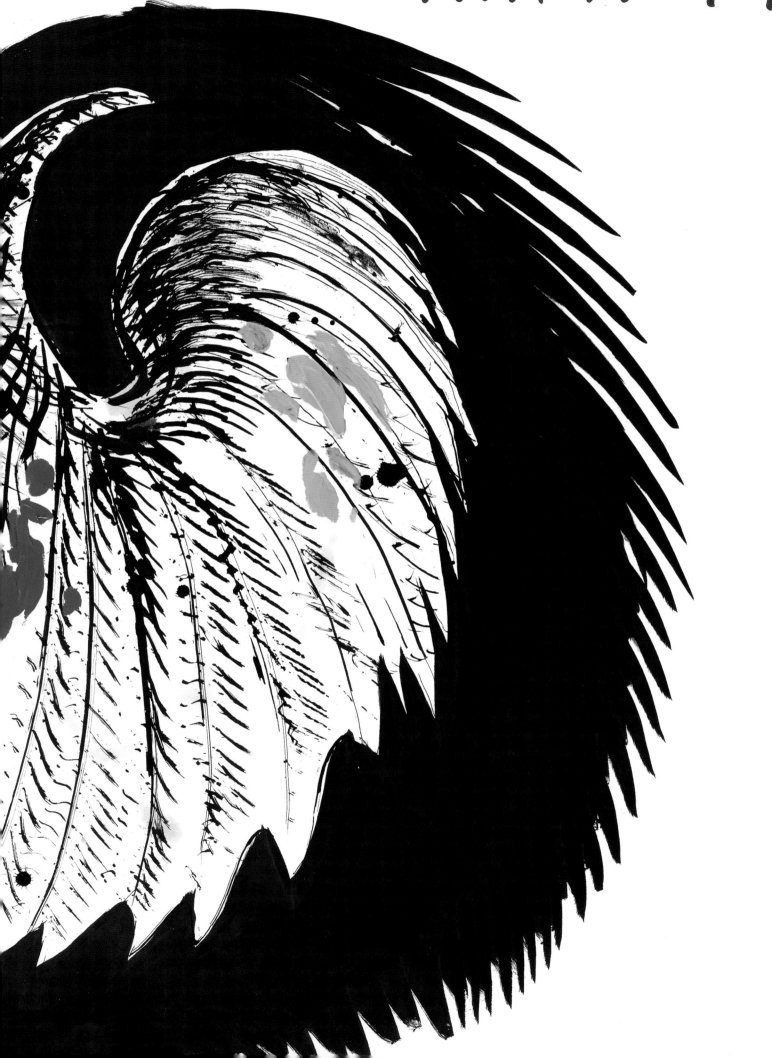

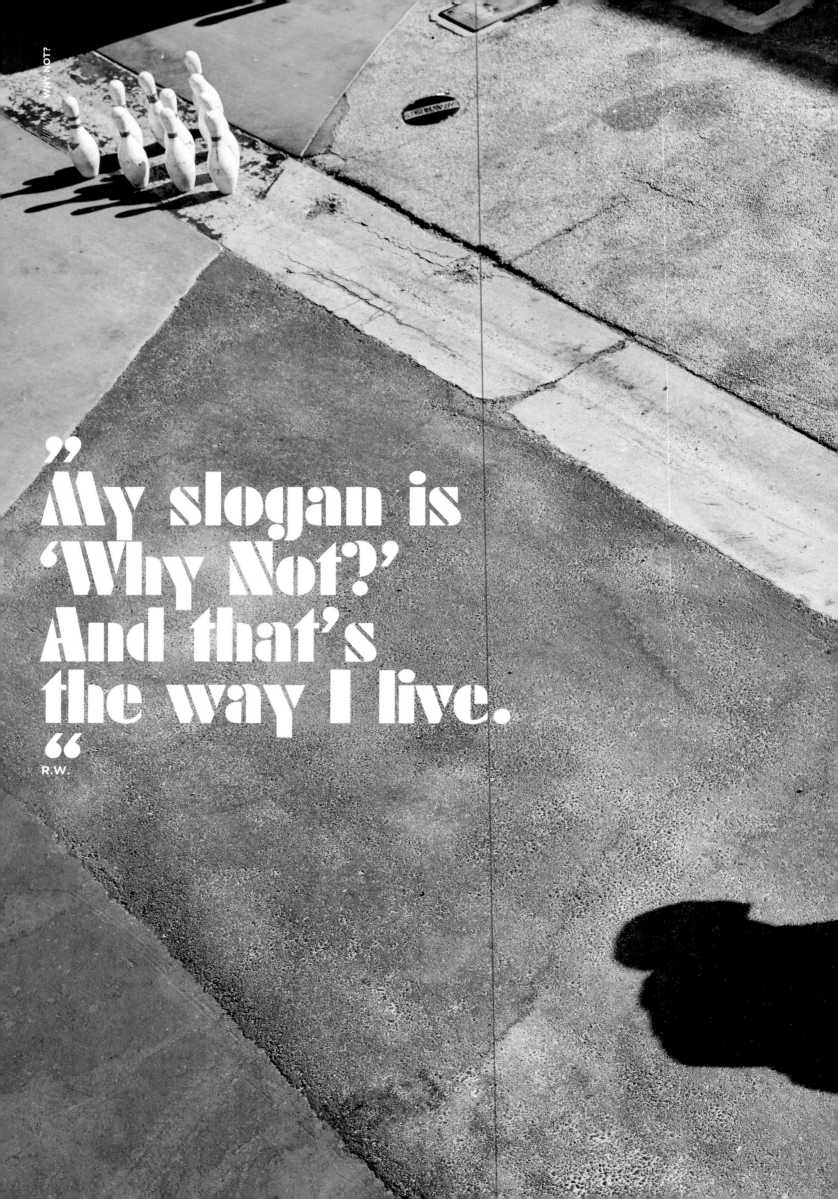

"**My slogan is 'Why Not?' And that's the way I live.**"

R.W.

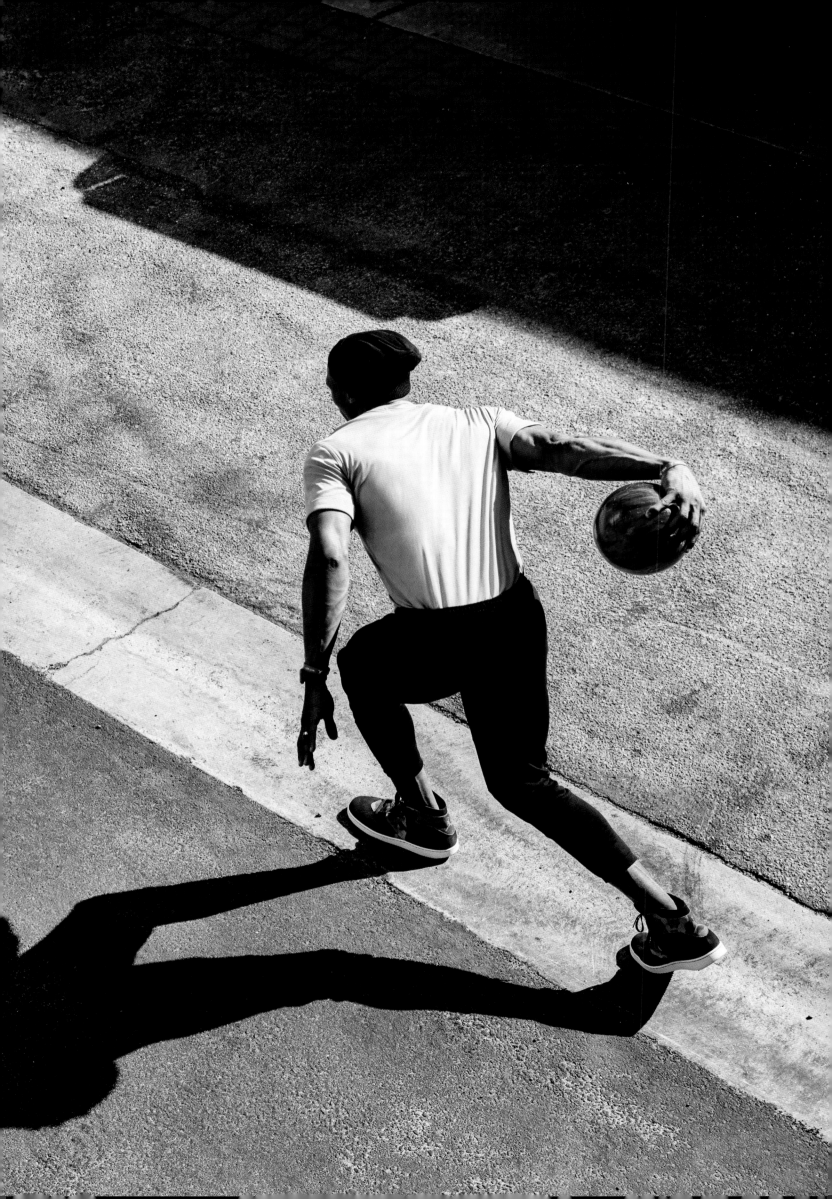

WHY

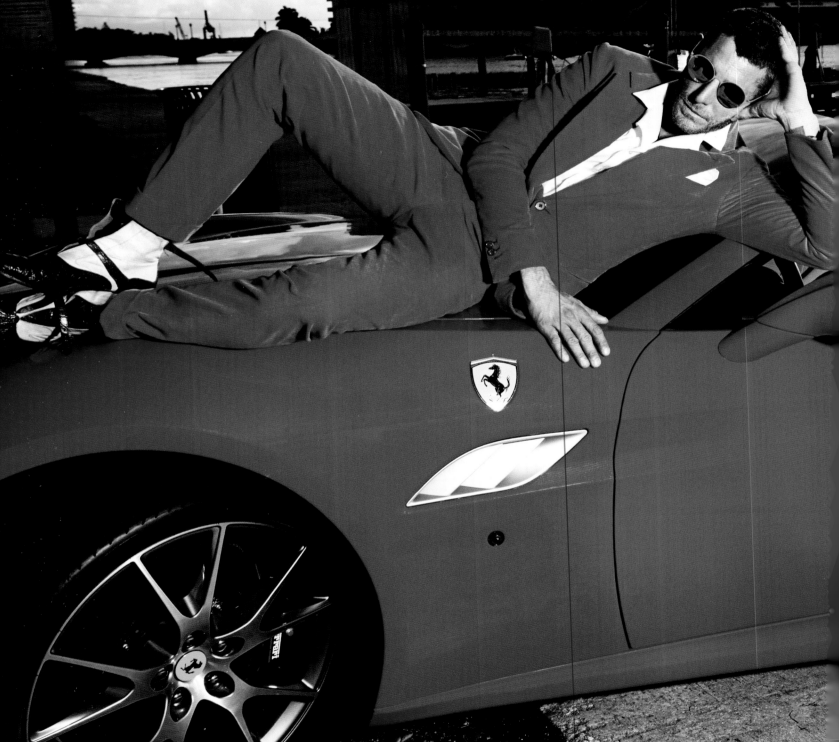

"
# The reality is that style is something that you build or that you create on your own, while fashion is something that you follow. Fashion is something that doesn't last, and style is something that does last. So the reality, to me, is that style is far more precious than fashion.
"

**LAPO ELKANN**

"
# As long as you feel comfortable and confident in what you're doing, I think you should be fine with wearing or doing whatever, as long as it's positive.
"

R.W.

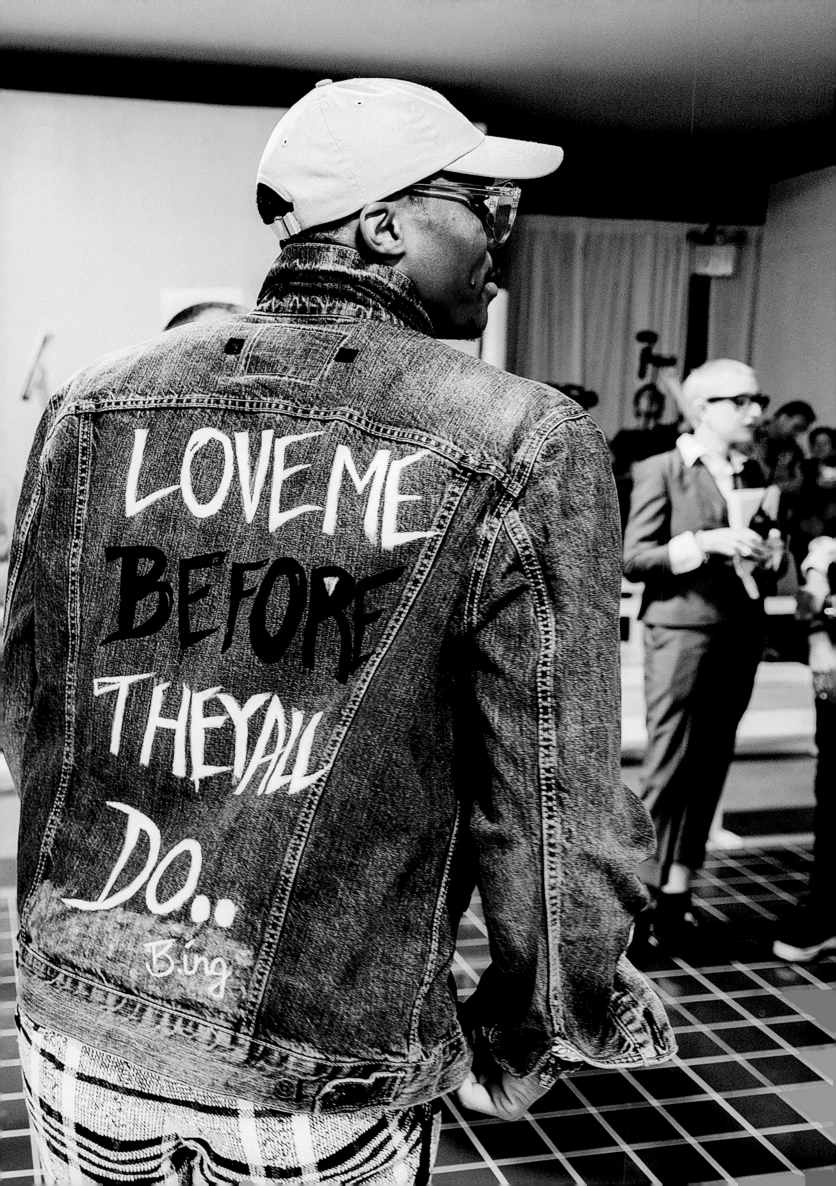

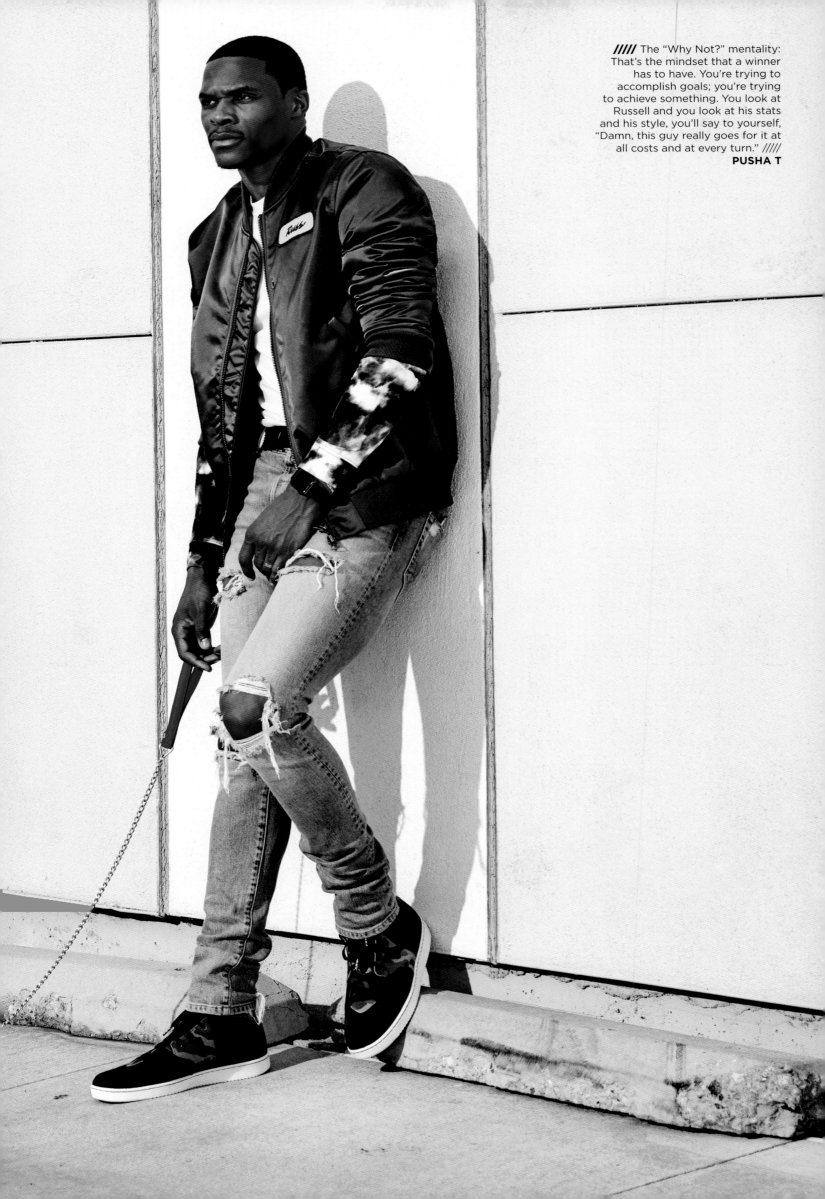

"

# I try to create some things that are crazy and different and that push the envelope. But I do it because that's who I am. I'm a bit crazy and I love being unique and different. I made glow-in-the-dark jeans because it reminds me of my childhood room full of glow-in-the-dark stickers. I made scratch-and-sniff denim jeans because . . . well, because I thought it would be fun!

"

BRANDON SVARC

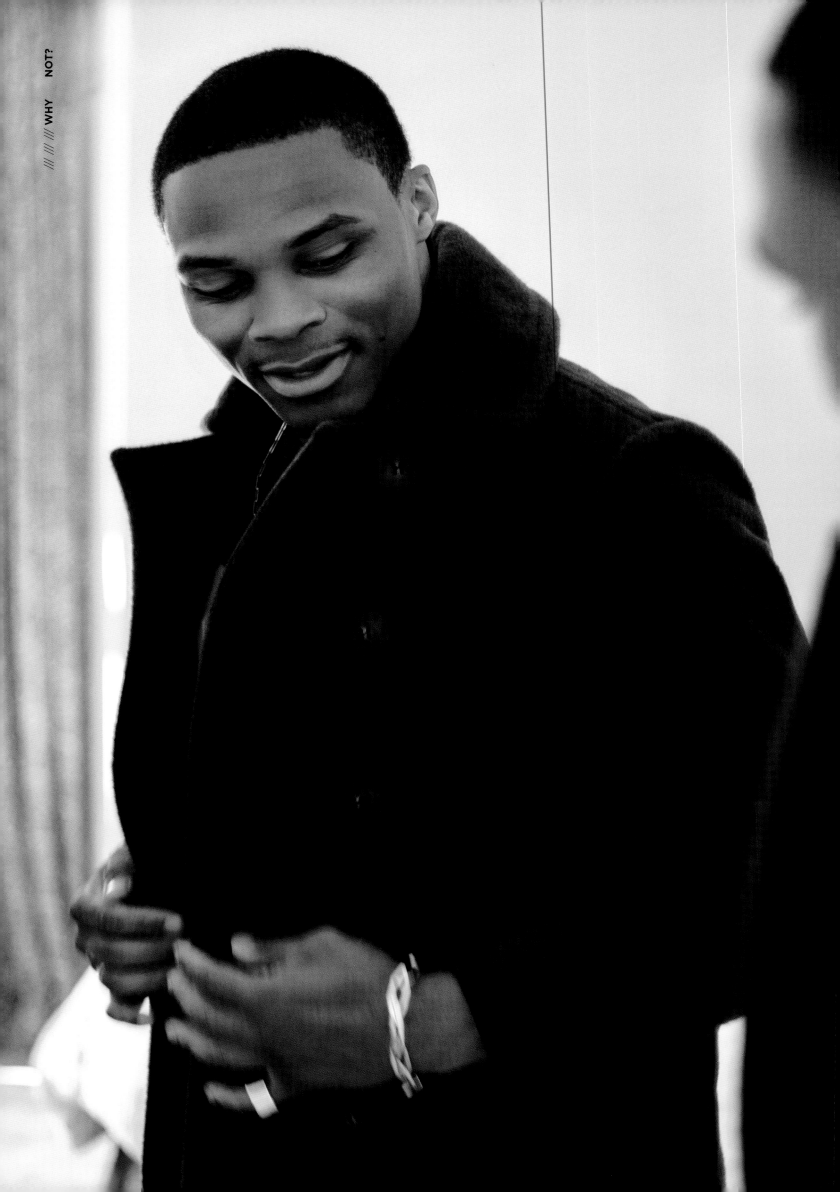

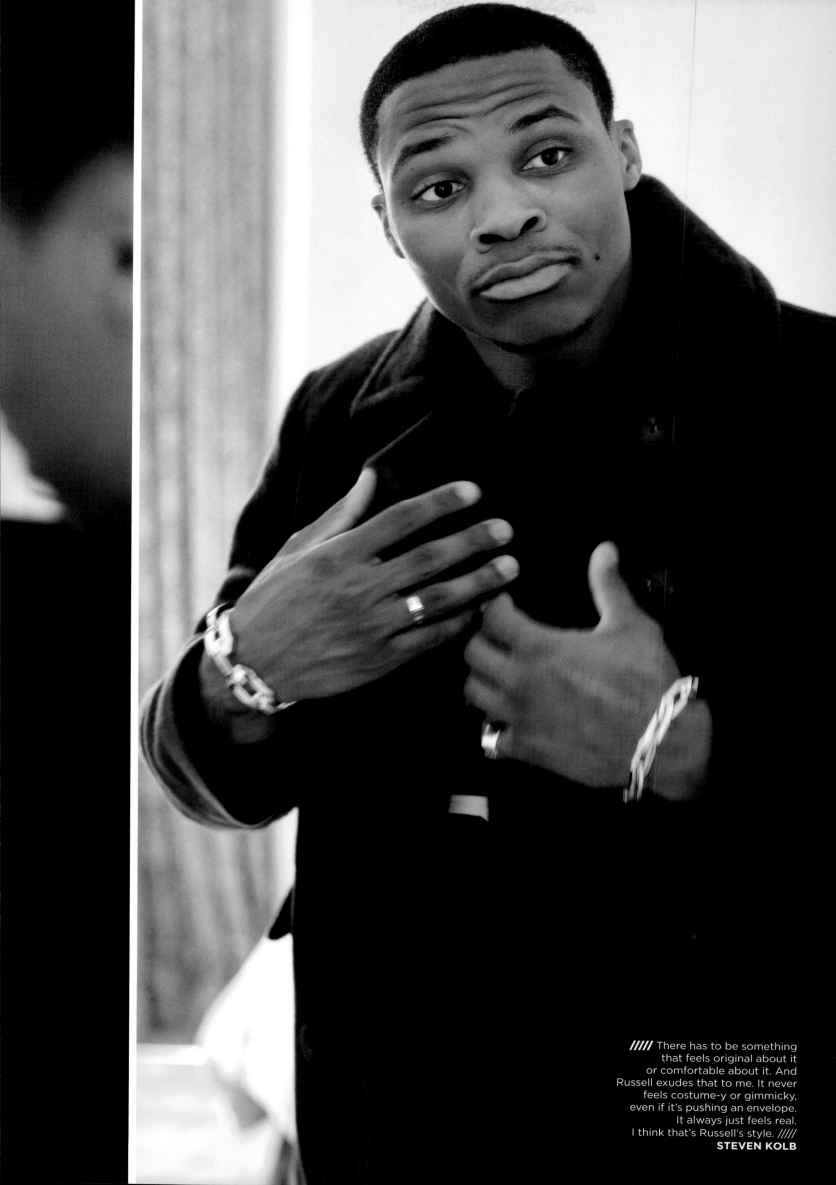

///// There has to be something that feels original about it or comfortable about it. And Russell exudes that to me. It never feels costume-y or gimmicky, even if it's pushing an envelope. It always just feels real. I think that's Russell's style. /////
**STEVEN KOLB**

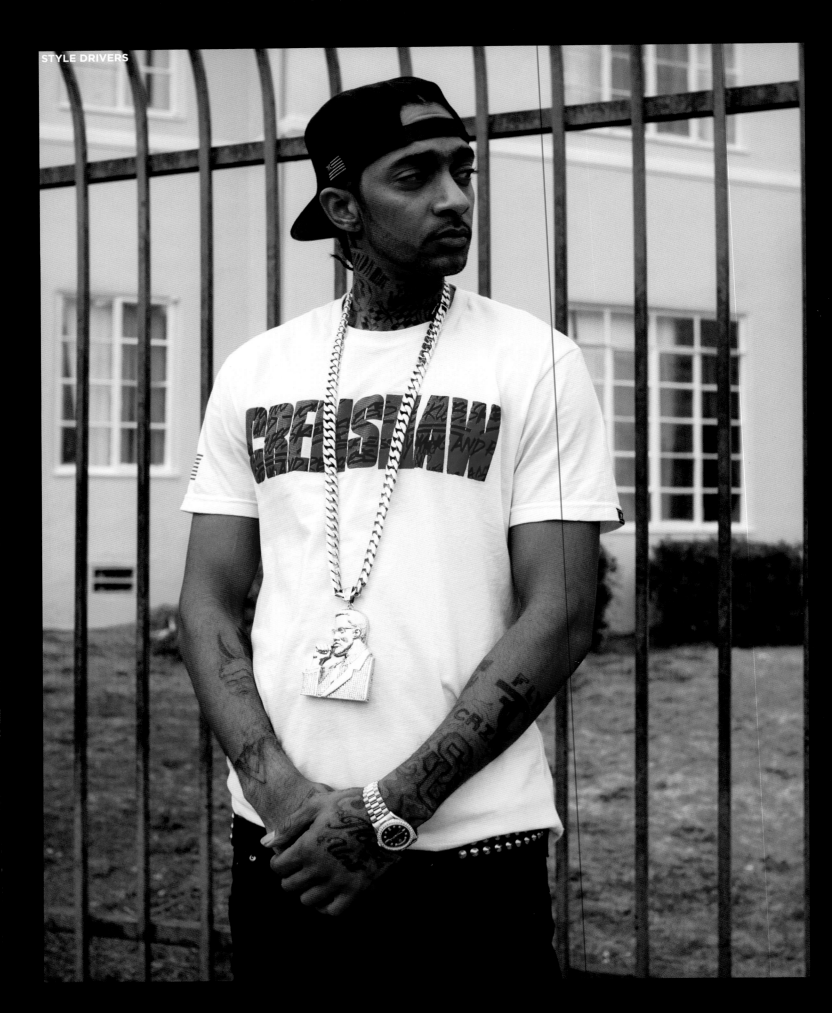

"

I think to thrive in a creative space, you have to be pure. You gotta know how to maintain the thing that gives you access, which, as an artist, is the integrity of the art and the intention being pure. That's what gives you continuous access to that space where all the good art is. The shit you have to tap into, I think you have to be worthy to tap in.

"

**NIPSEY HUSSLE**

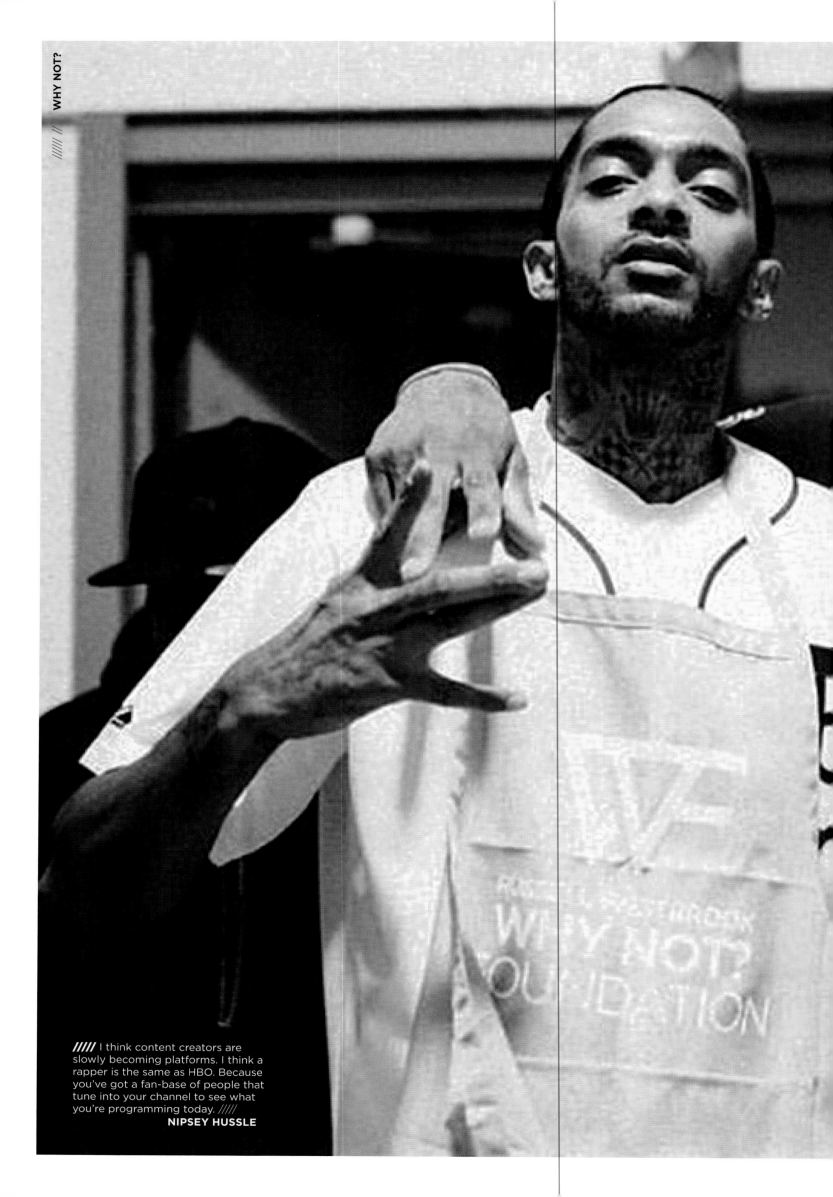

///// I think content creators are slowly becoming platforms. I think a rapper is the same as HBO. Because you've got a fan-base of people that tune into your channel to see what you're programming today. /////
**NIPSEY HUSSLE**

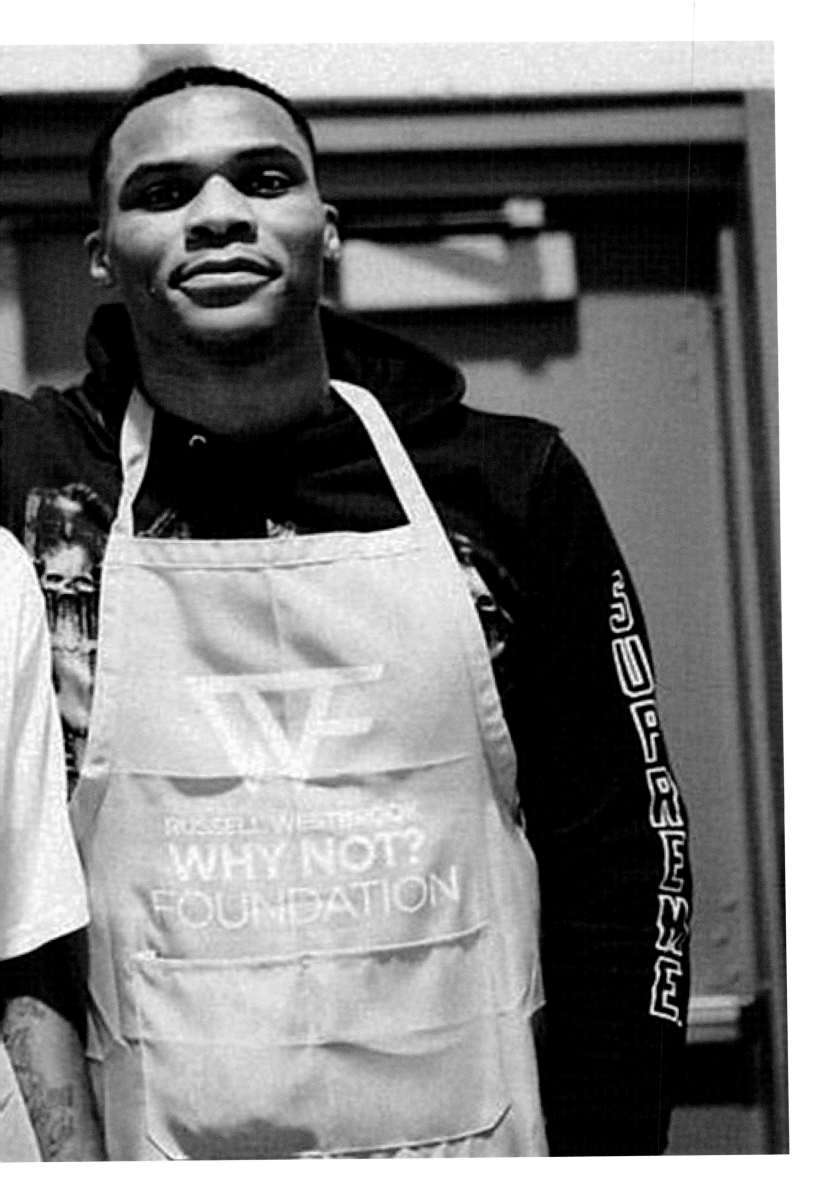

" Now one can wear basically anything without being perceived as transgressive or outrageous.

# You're only outrageous

# "when you're not wearing enough."

MARCELO BURLON

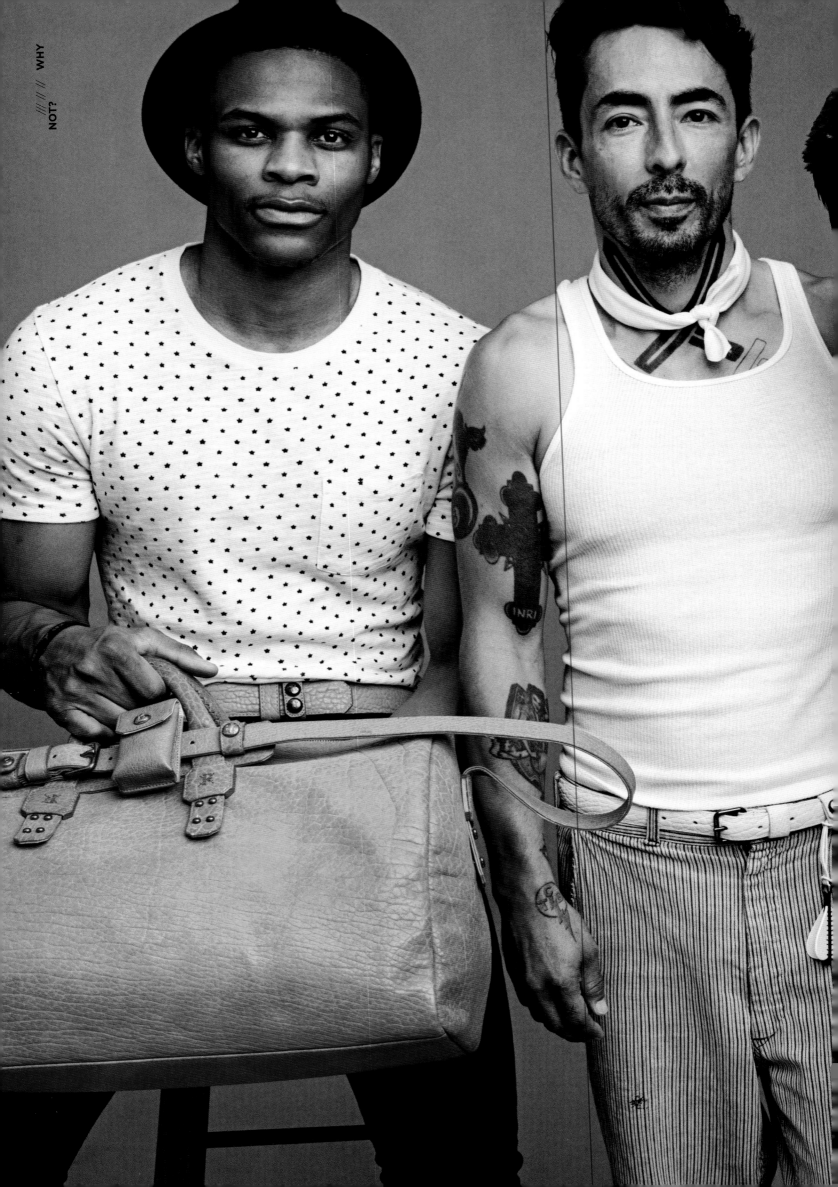

"**If someone looks at something and says, 'Oh, that's nice,' that's the worst thing they can say. Because that's neutral. That's almost like not having an opinion. That's the worst. I'd rather someone say they hate the outfit. Then they're reacting to something.**"

**LONG NGUYEN**

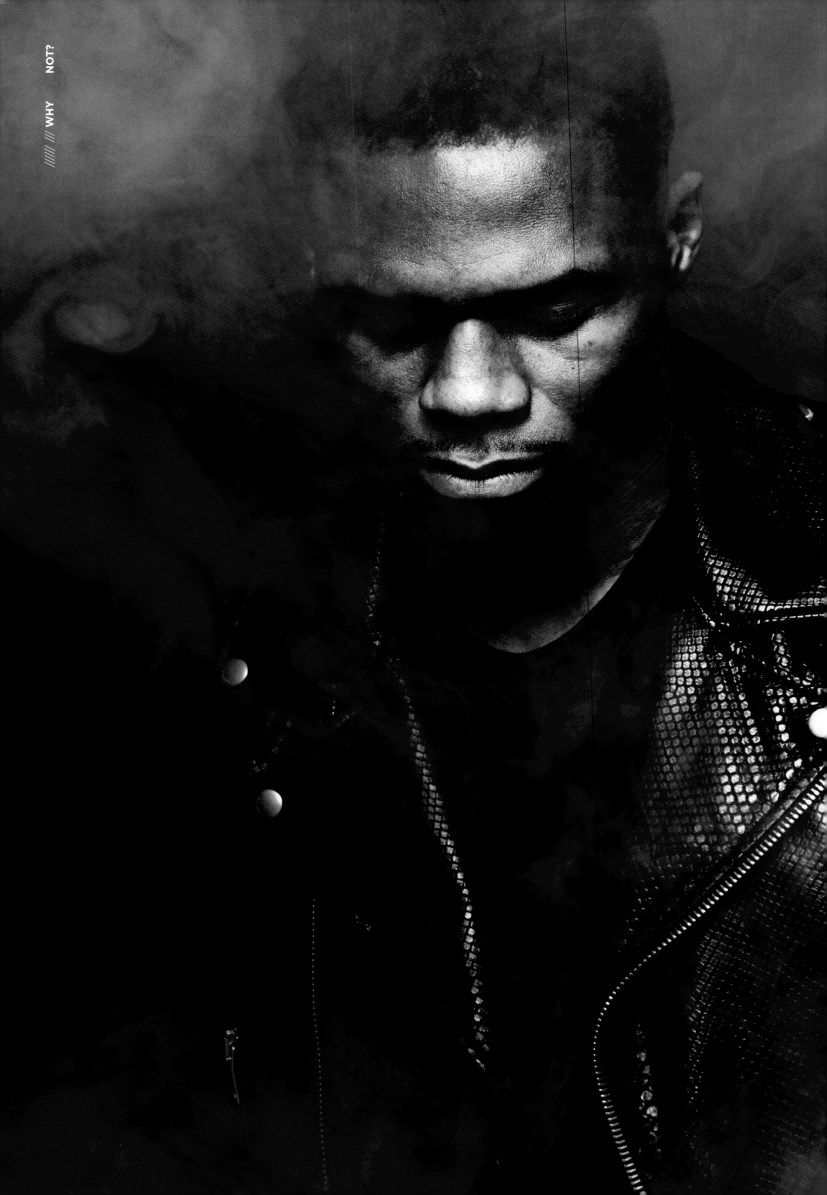

"True wild men are rare, but when you've got one in the culture, they're so valuable. They really push things forward."

WILL WELCH

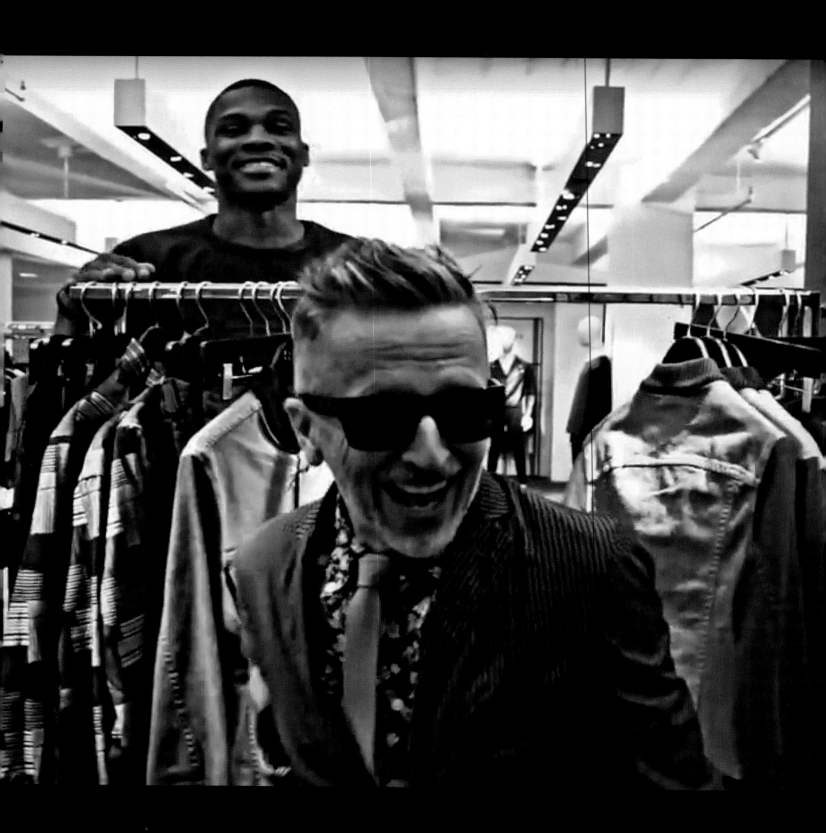

"
**There is no such thing as a mistake. As long as you have conviction, you can wear anything you want. You just have to mean it. Think about all the great style icons of the last half-century: James Brown, Bowie, Prince, Michael Jackson. They wore crazy shit, but they had total conviction.**
"

SIMON DOONAN

/////  I'm not afraid of nothing,
so I love just having fun
with fashion. /////
**DJ KHALED**

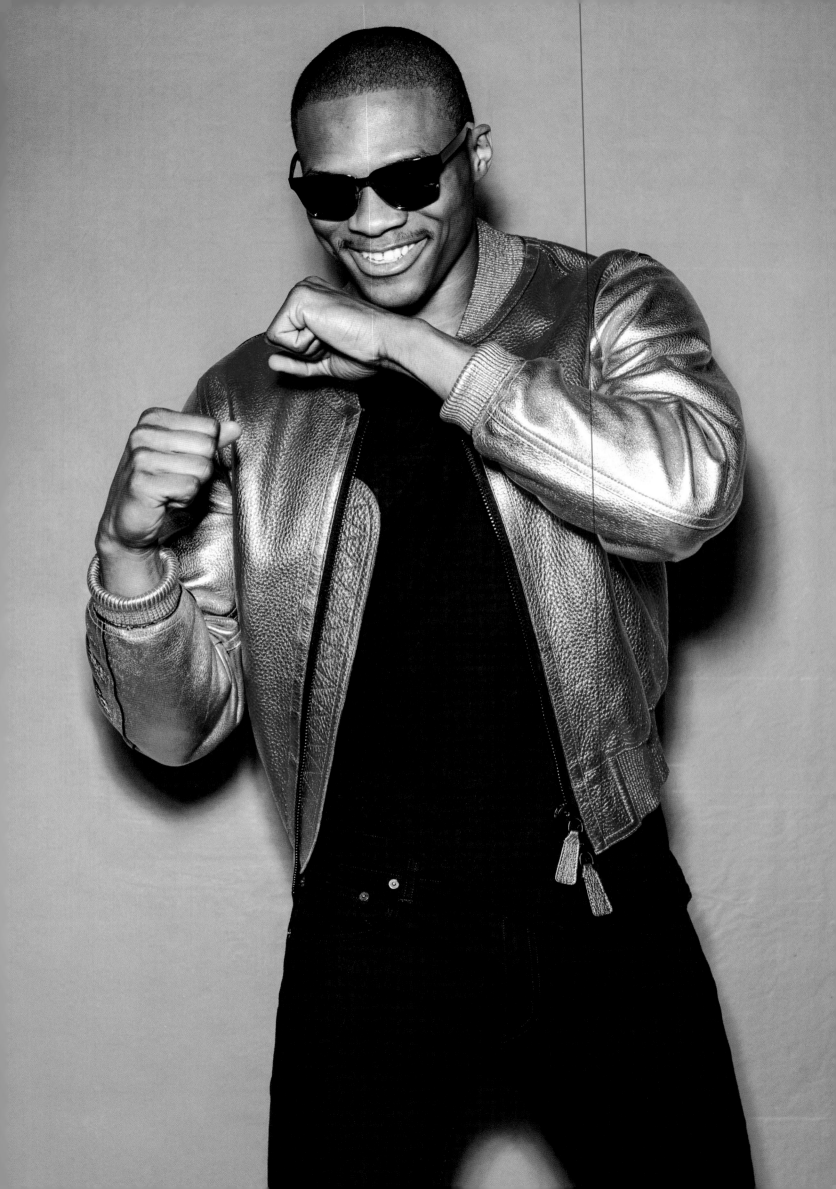

# WHY NOT?

Call it what you want.
Boldness.
Confidence.
Simply not giving a fuck. In the long run, the words themselves aren't important. Because no matter what you call it, the thread that connects one style driver to the next—the connective tissue that gave rise to this entire group of people who are shaping and reshaping culture as we know it—is rooted in one thing: **fearlessness.**

# "Everyone can become or do or achieve or overcome, if you simply change the way you look at things."

HOWARD "H" WHITE

"Some people are scared to make mistakes," Russell Westbrook says. "Some people are scared to mess up." It's an understandable impulse, at least to most of us. But the way Westbrook sees it, that's exactly what's standing in the way of forging new (and better) path: "Me believing in not worrying about messing up or making mistakes, that makes me be more fearless to do anything that I want to put my mind to."

It all comes down, he says, to a simple question: why not? Why not make a mistake? Why not take a risk? Why not dress exactly how you want to dress or do exactly what you want to do?

**Why not?**

"It connects everything," Westbrook says. From sports to style, it's how he lives his life. Turn back the tongues on his signature Jordans and you'll see those very words embroidered on the interior: "Why not?" And he's not the only one who believes in the power of questioning convention and going your own way.

Howard "H" White of Jordan Brand knows a thing or two about working with extraordinary personalities; he's been with the company since before Michael even had his first championship ring. And he sees the value of breaking out on your own, especially when it comes to taking a risk—and, more importantly, believing in your ability to rise above. Playing it safe is simply something that "most conformists go along with." On the other hand, though, we have the style drivers.

"These people, they kind of break the mold," H says. They see things differently, and that has a certain kind of power. "I think Russ's vantage point is, 'Everyone can become or do or achieve or overcome, if you simply change the way you look at things. So why not look at them as I do?'"

It's that optimism that Victor Cruz connects to. "I love it," he says. "I think that motto should go across all platforms to everyone in whatever people do. Why not you? Why not be the one to do what you need to do to get to where you want to go? Why not have a triple-double every night? Why not score touchdowns every weekend?

# "Why not you? Why not be the one to do what you need to do to get to where you want to go?"

VICTOR CRUZ

Why not excel at your job each and every day?"

Westbrook collaborator Ben Gorham of Byredo also sees the value of the "Why not?" mantra as a kind of ethos for living life in general. "I think more people should adopt that beyond style," he says, "just in terms of how they live their life. Russ, I think, exemplifies that: in sports, in fashion, even in the charity work and those components of his life," he explains. "So I think it's very much about the person he is."

Of course, style is still a crucial part of the conversation. From his infamous fish lure shirt—arguably the moment that first defined him as a style driver—to the curated looks he wears down the concrete runway each night before a game, it's

Westbrook's style as well as his masterful gameplay that's catapulted him into the upper stratosphere of sports celebrity.

"Some people think it may be crazy if you look at it," he says. "But it all depends on your personal style and what you believe in or if you care what other people think about it. When I'm getting dressed, I'm not getting dressed for anybody else. I get dressed because I like it. That's how it is."

Or, as Brandon Svarc of Naked & Famous Denim puts it, "What's the point of life without individualism?" Fellow designer Marcelo Burlon expounds upon that confluence of personal style and unflinching confidence: "Nothing is embarrassing if you're not embarrassed. Looking good is also about feeling good, so if you think you're playing it right, and if you're feeling it's right to you, then it can't be a mistake."

Of course, if you do stumble along the way, rapper Nipsey Hussle finds some comfort in the "Why not?" credo, even though he's got his own version. "It's a marathon," he says. "It's about your cumulative performance. I think looking at it like that makes us a little less hard on ourselves when we make mistakes or when we have rough patches, because it's about continuing to push forward. It is what it is, and we ain't tripping over slip-ups and we're not second-guessing ourselves."

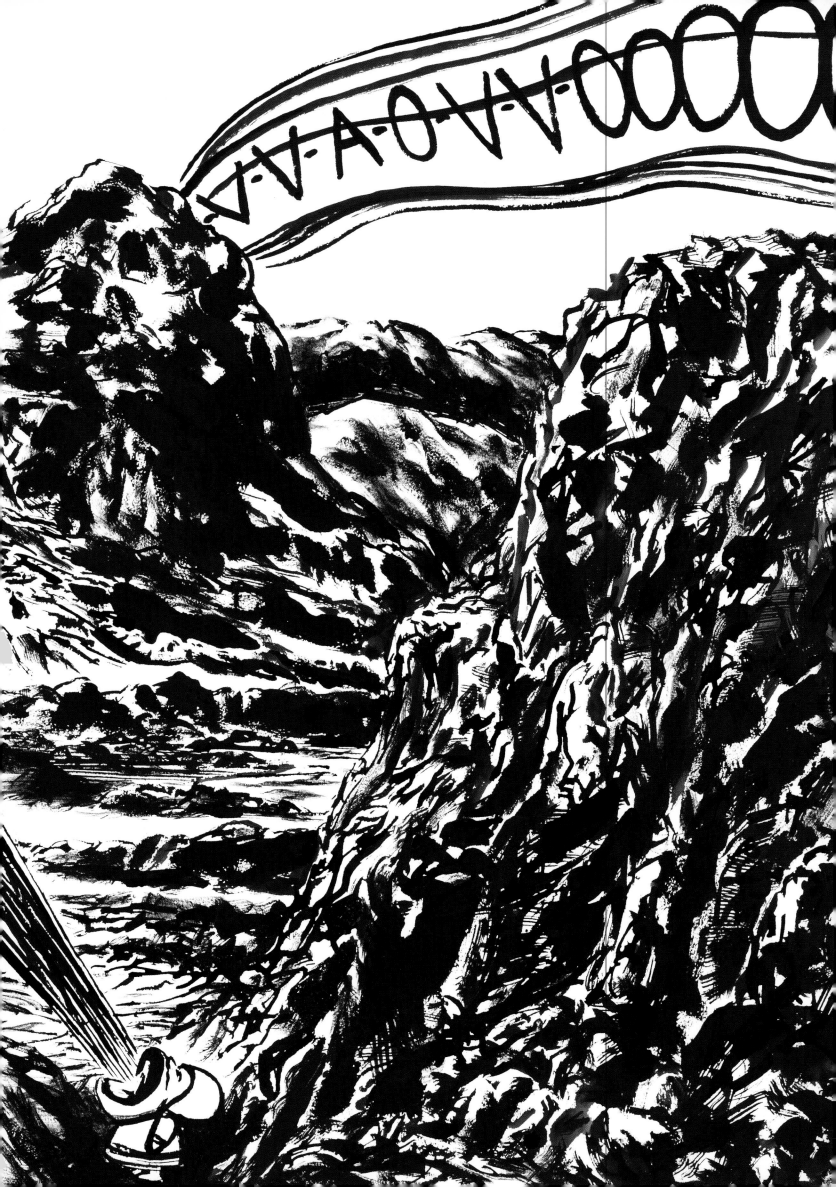

# PLAYING THE GAME

# " Style is a psychological weapon, so use it. "

SIMON DOONAN

Style

Yohji Yamamoto

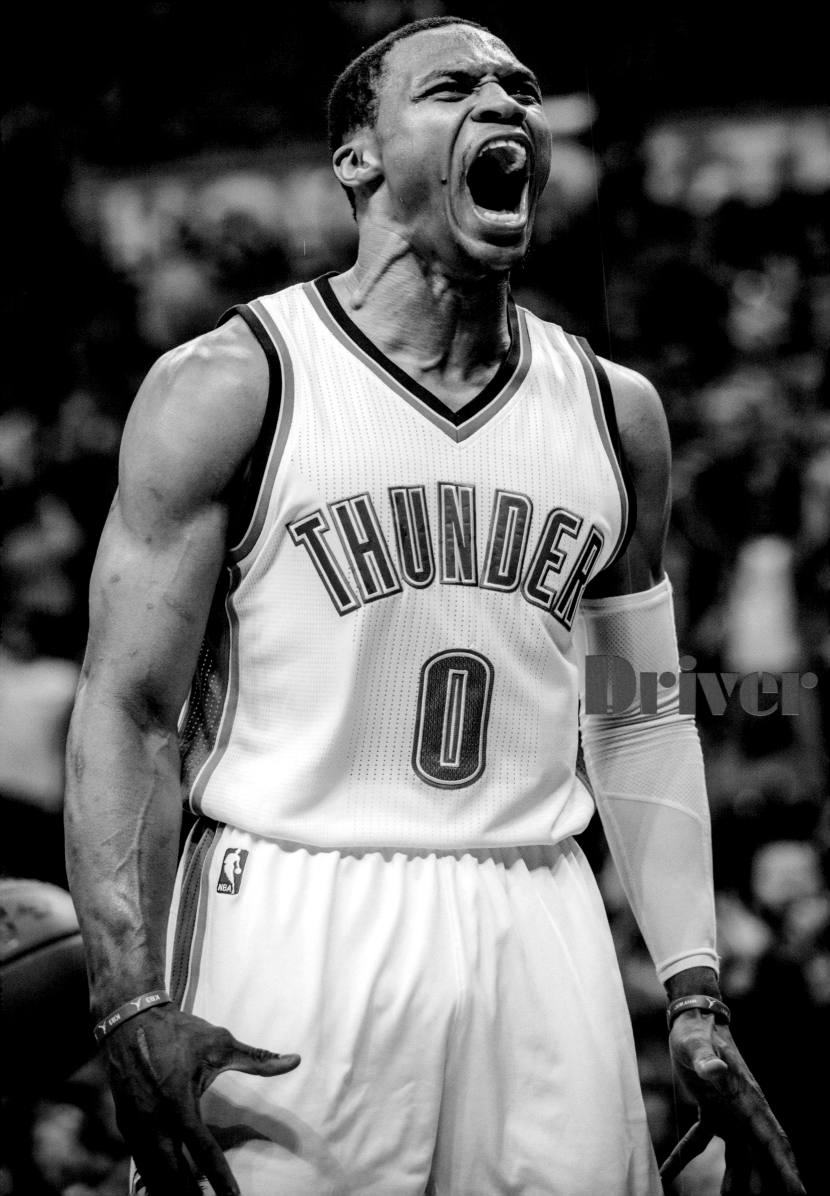

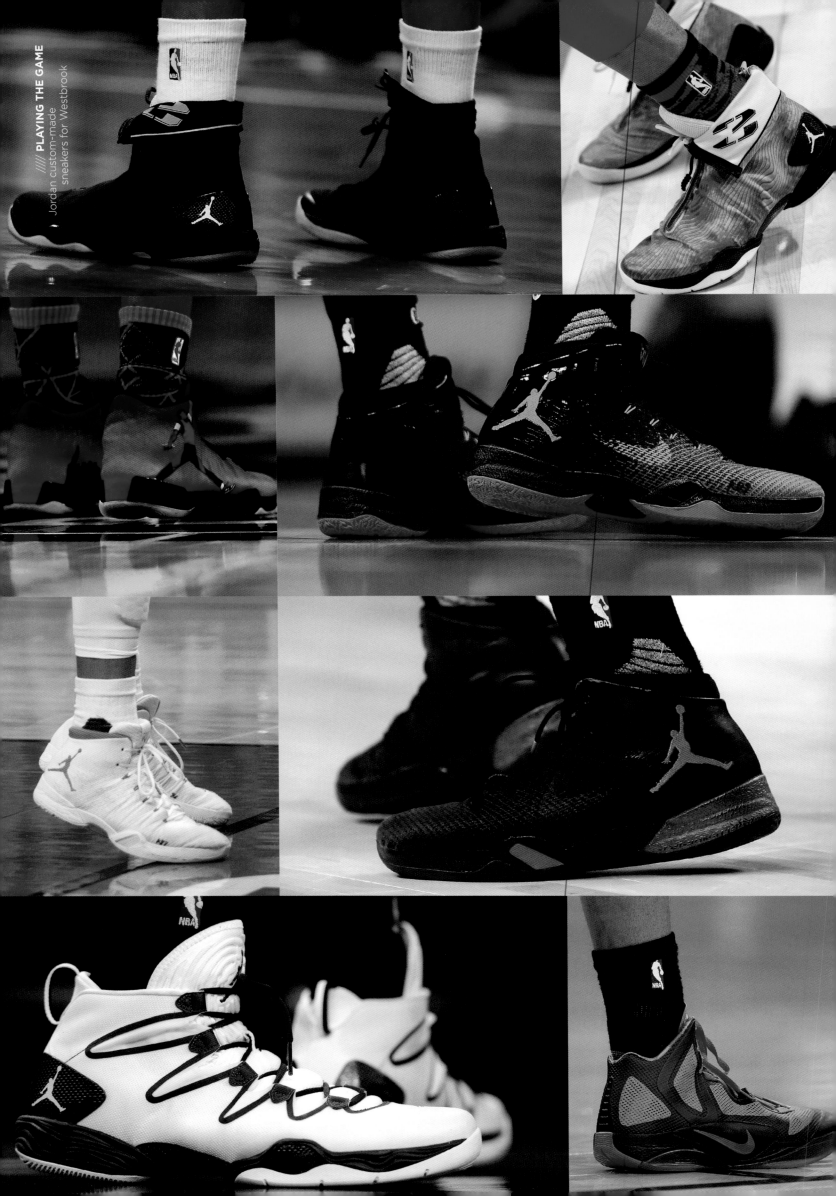

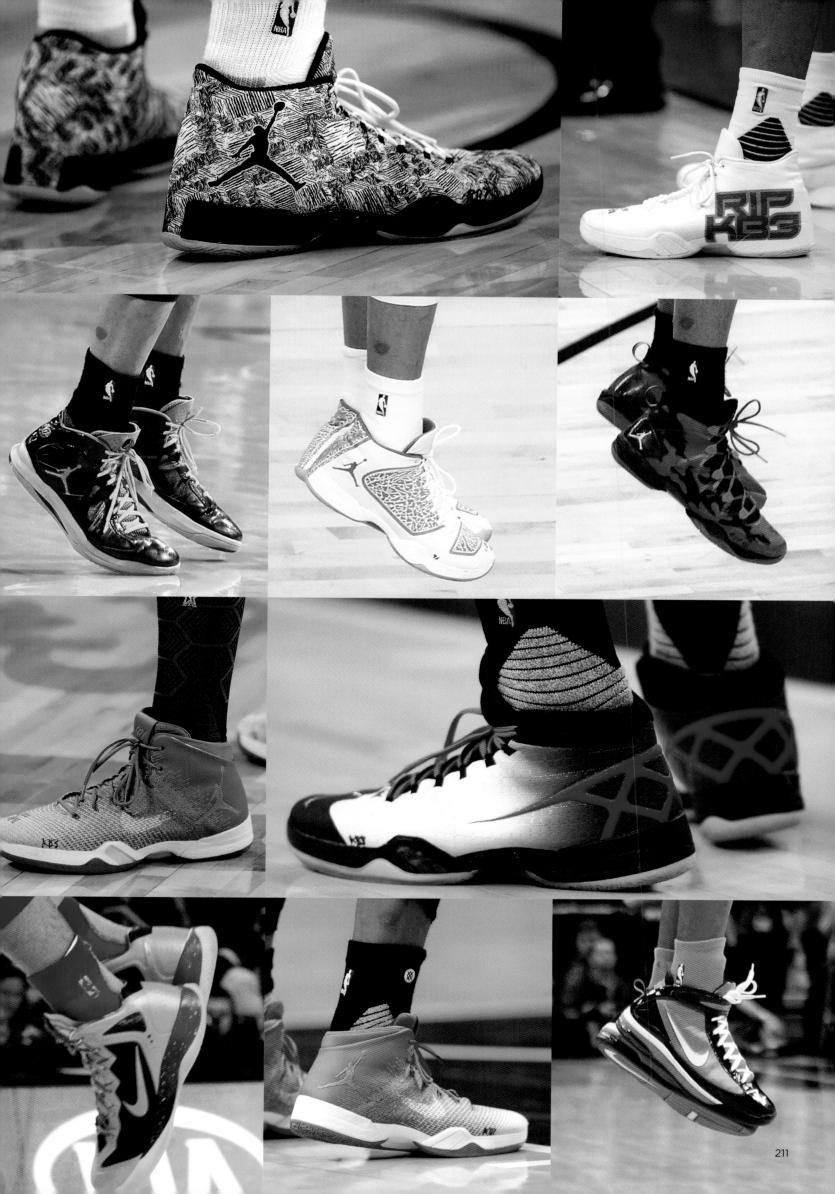

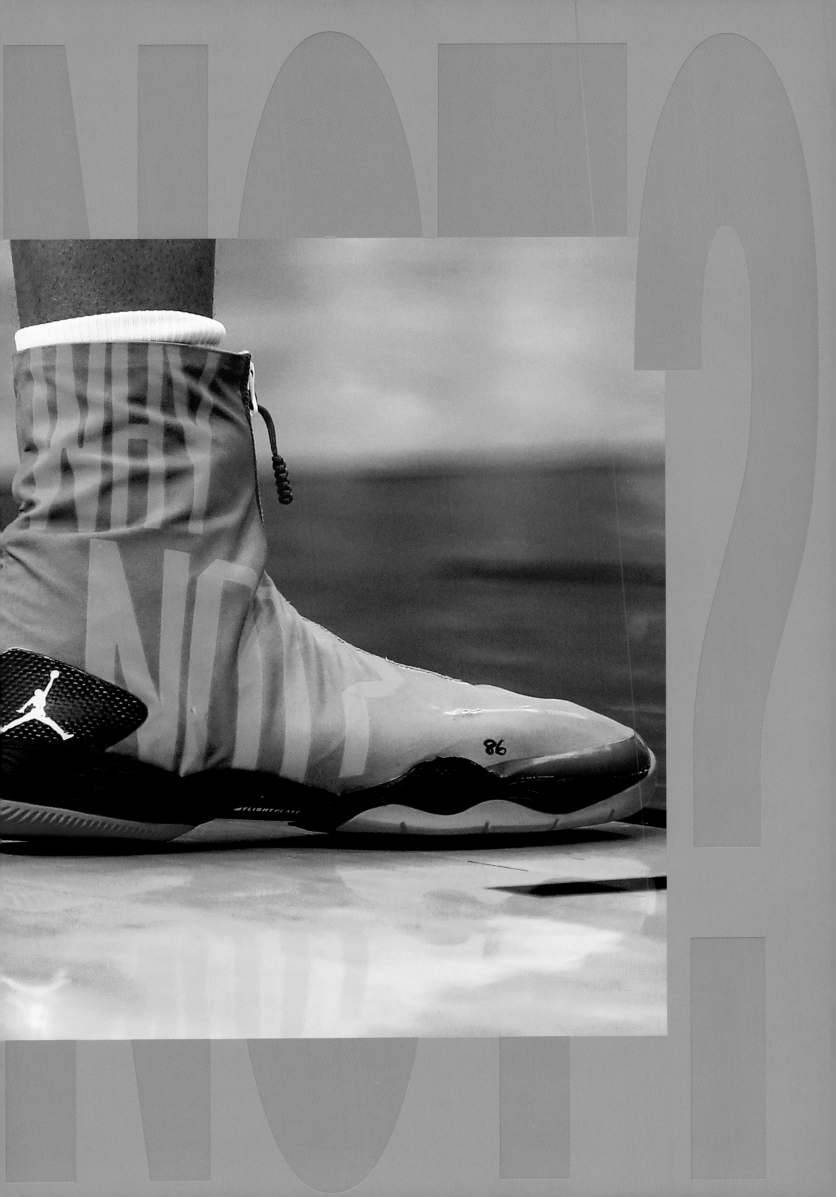

"
It's always interesting to speak
with people who have leadership.
Who have vision.
Who have talent.
By confronting yourself with
them you grow. Personally,
professionally, emotionally.
"
**LAPO ELKANN**

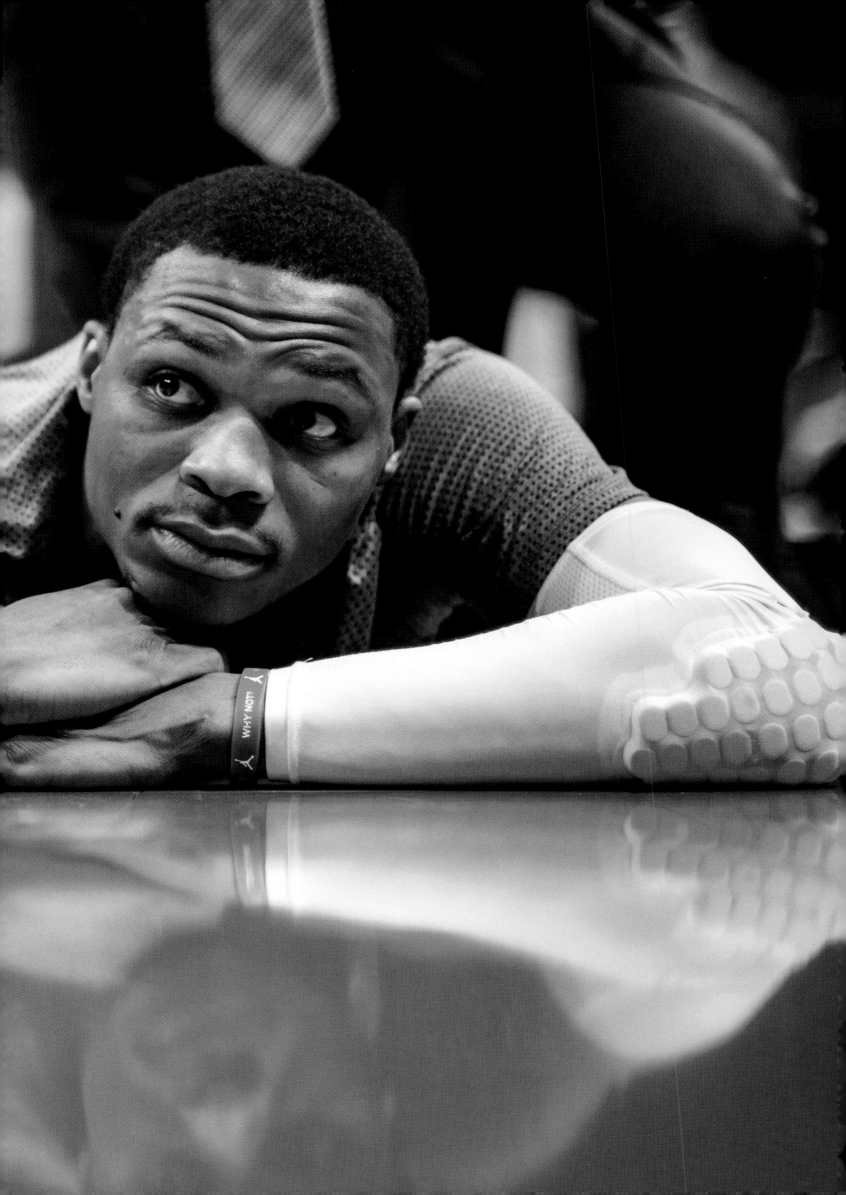

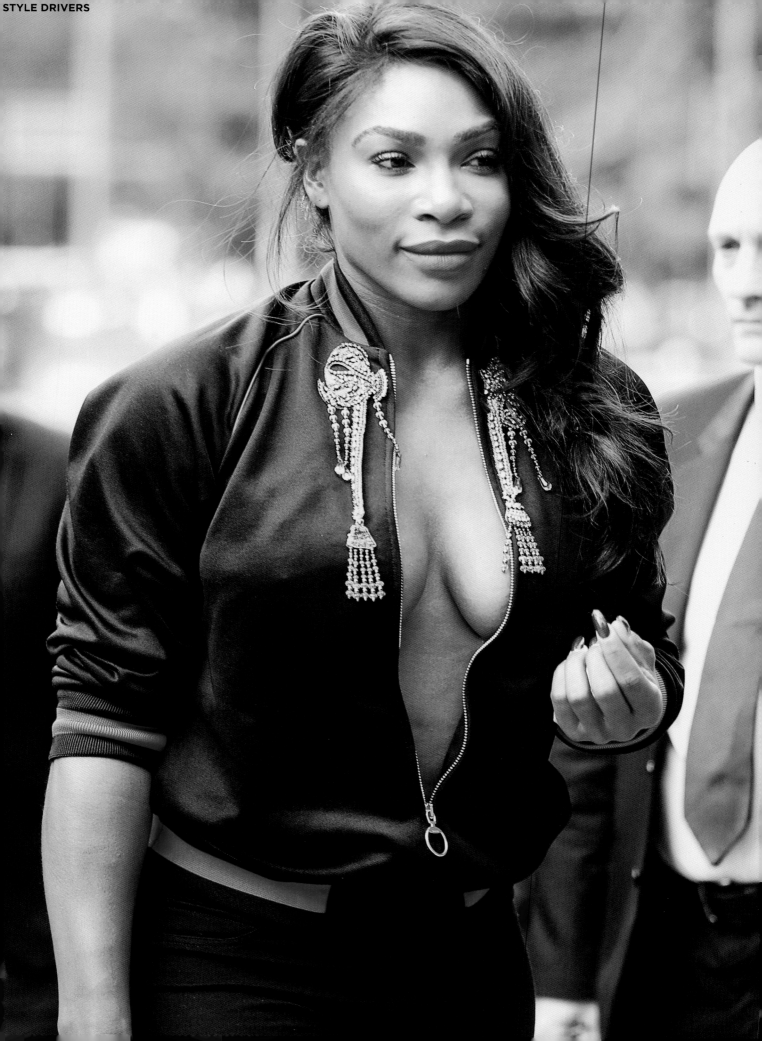

Serena Williams on what it takes to get to the top of the game:

# "Dedication, hard work, and most importantly you have to be willing to make incredible sacrifices."

**SERENA WILLIAMS**

///// Every day I try to find ways to keep expanding my brand—expanding my brand in the style world, in the fashion world—and try to find ways to be successful. /////
**R.W.**

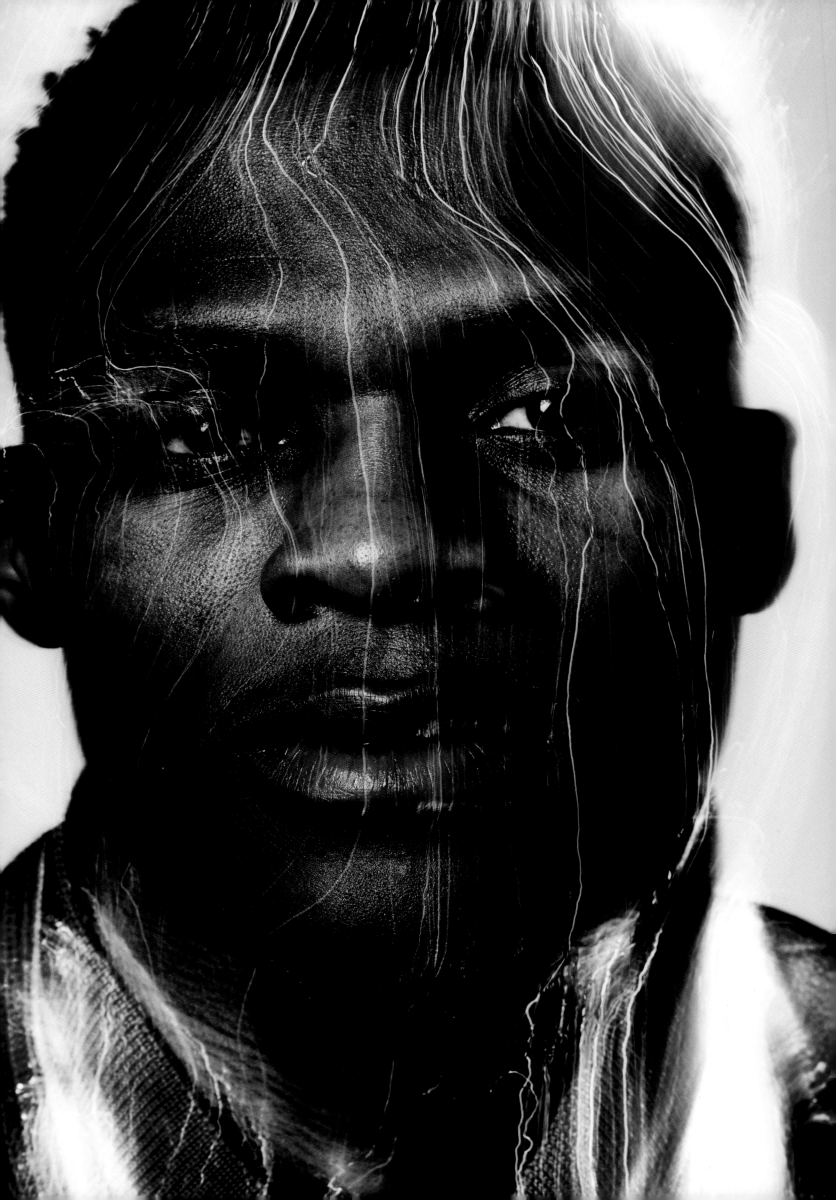

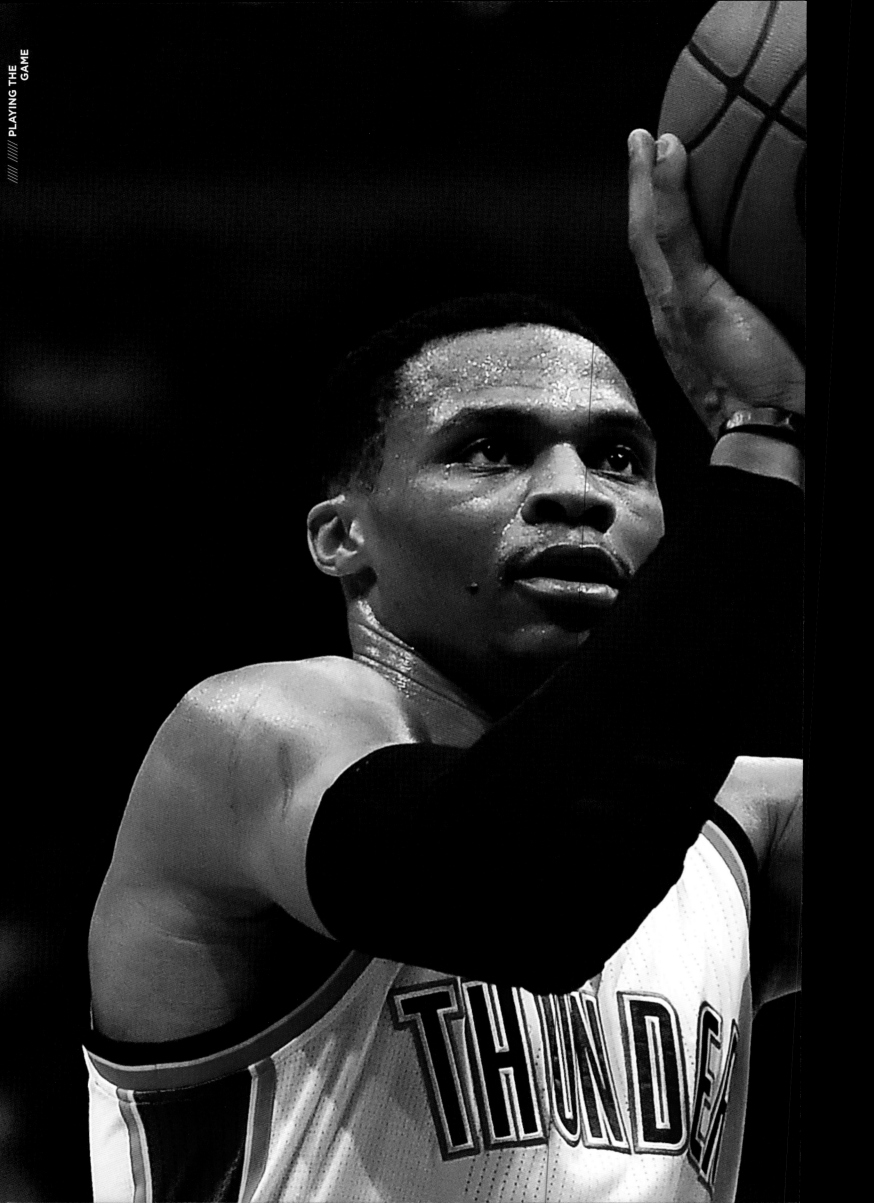

///// Russell is such a perfect example, because you see him—whether he's stepping into an NBA arena or he's going to a fashion show—you know exactly who it is. I think that speaks to his personality as well as his own personal style. /////
**VICTOR CRUZ**

"
**Since style is a great way to paint the picture, you're able to use it as a way to project an image of success, or creativity, or confidence.**
"

BEN GORHAM

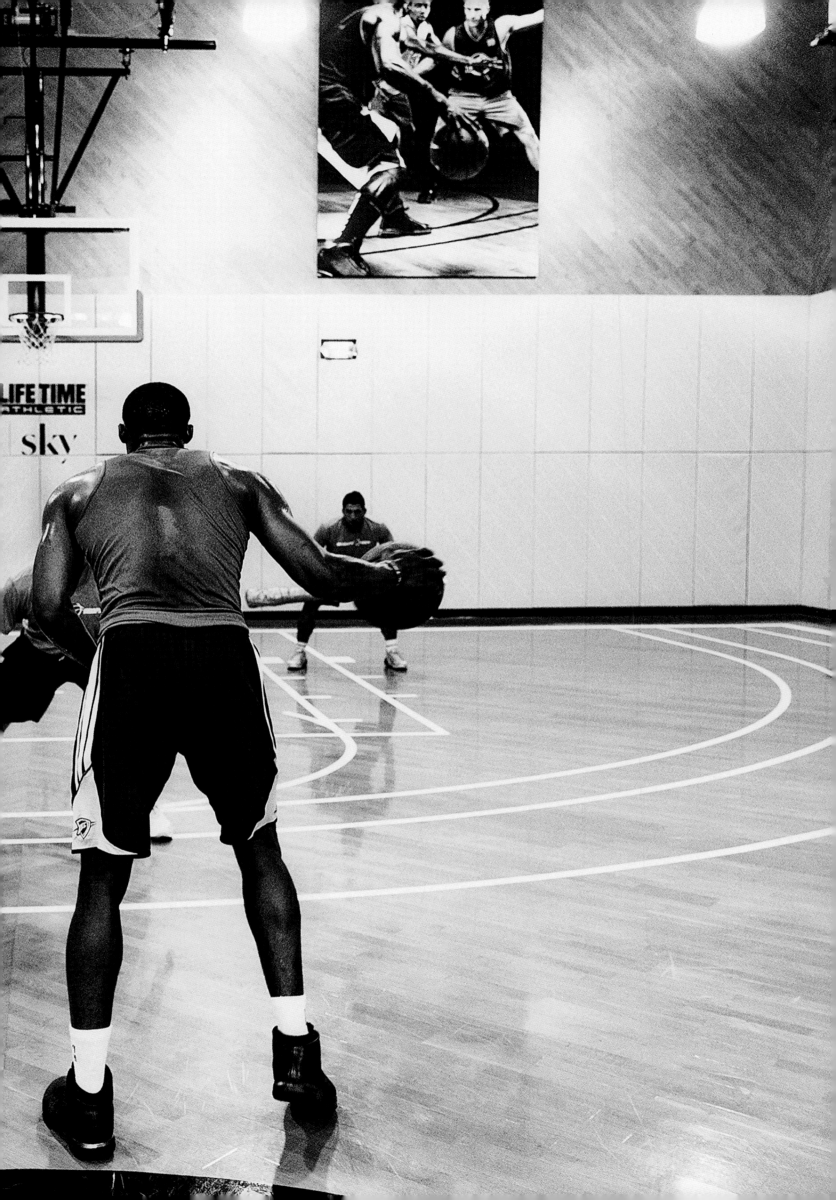

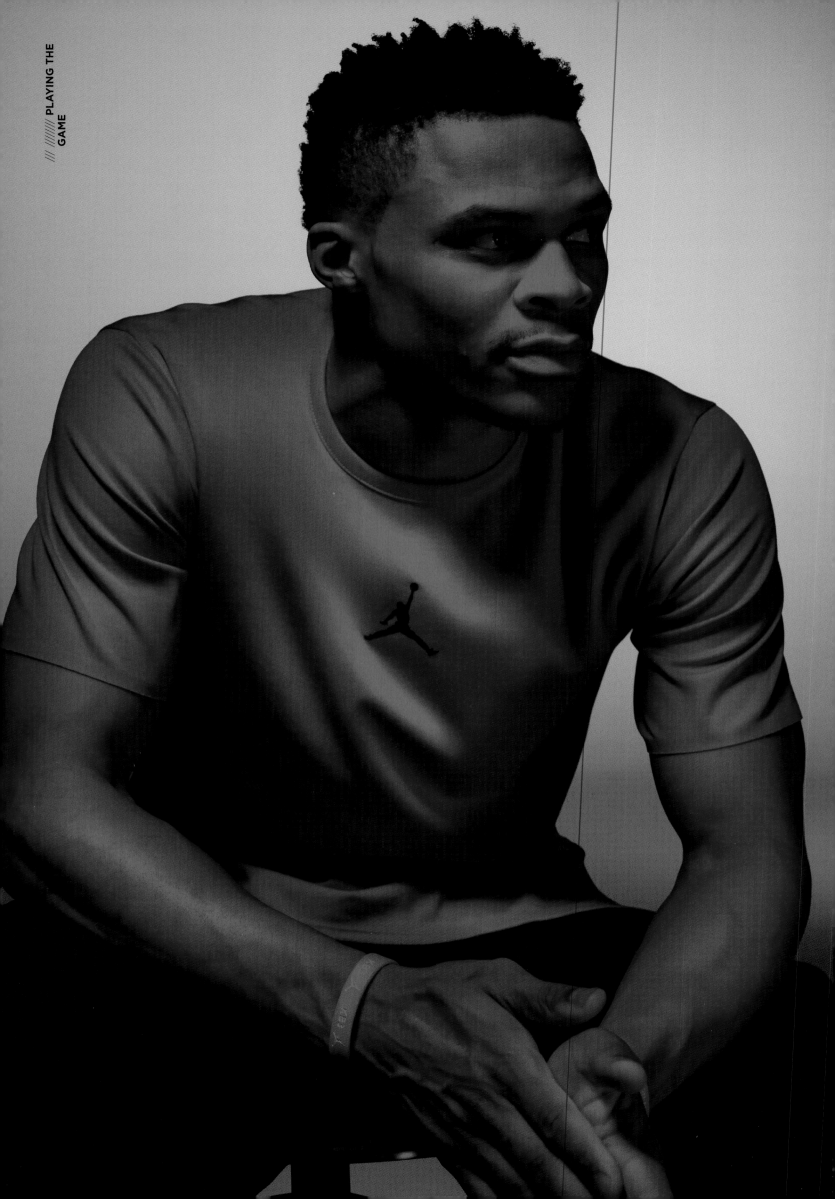

///// For me there's no true definition of what it means to be stylish. It just goes on how you feel it. The state of mind you're in. The confidence and swagger that you want to portray during those times. /////
**R.W.**

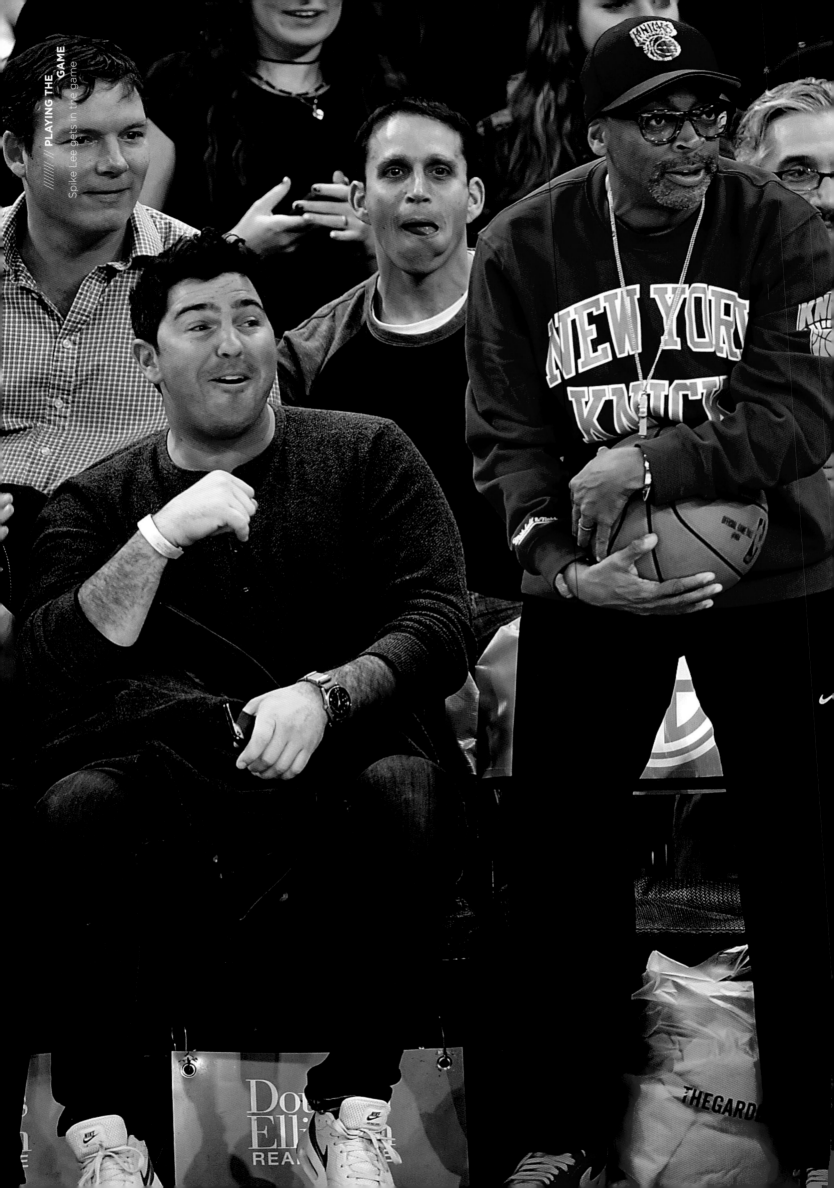

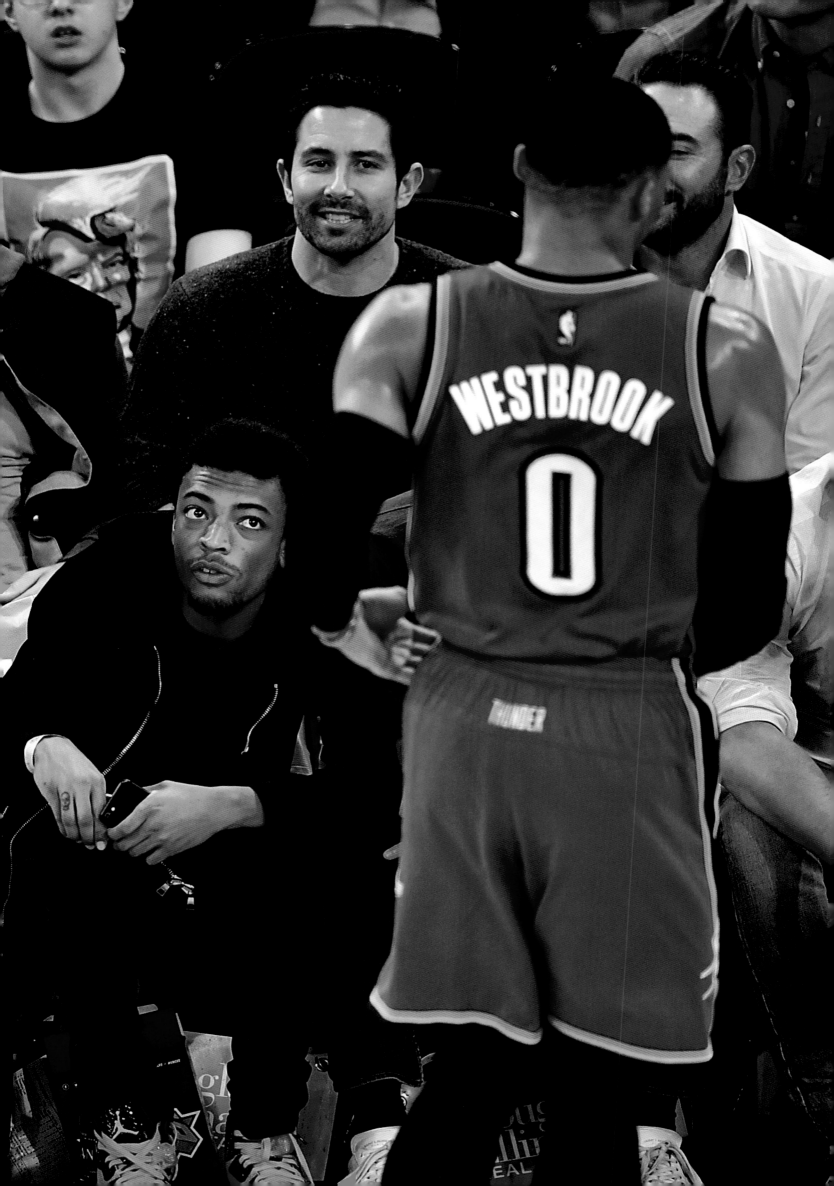

"

# I love Russell's style. I love that he's not afraid of anything on the court and outside the court. That's the same way I am. We're ourselves. If there's a key to get to the young world, it's to be yourself at all times. Be the coolest person in the world. You don't have to wait for somebody to say, 'Hey, you look good,' or, 'You're cool,' or whatever. Nah, we do what we want to do, which is being ourselves.

"

**DJ KHALED**

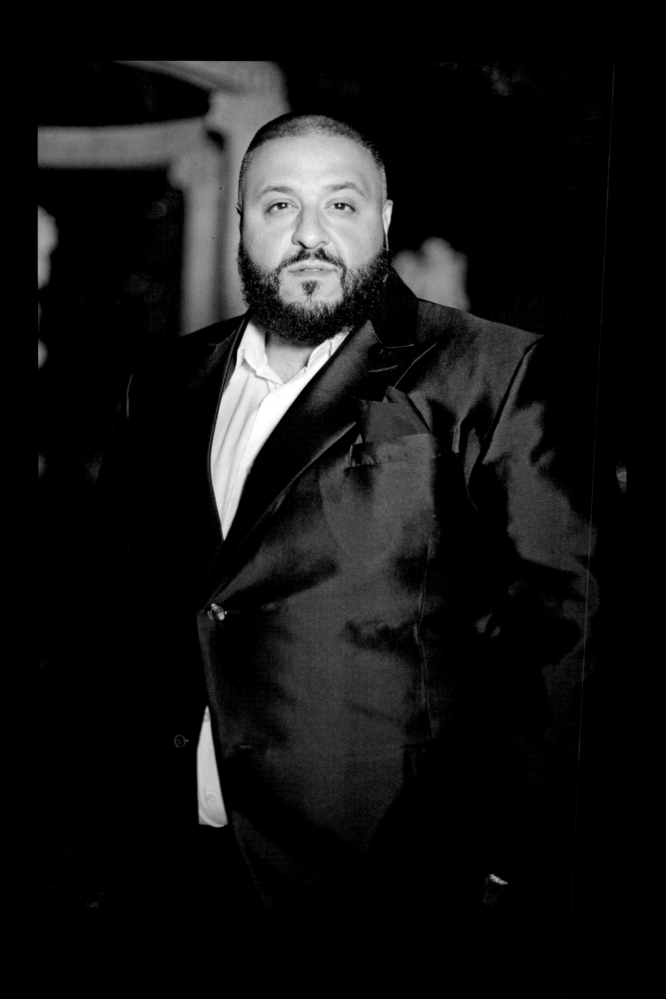

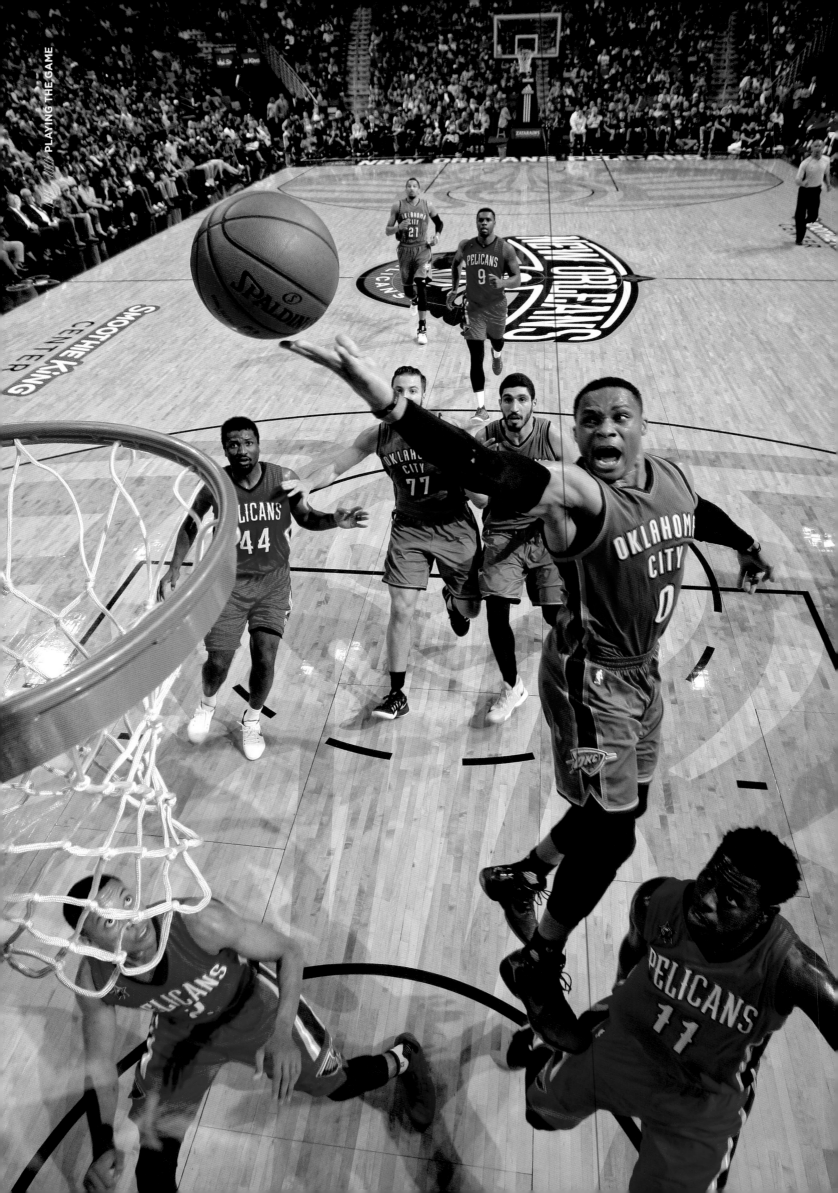

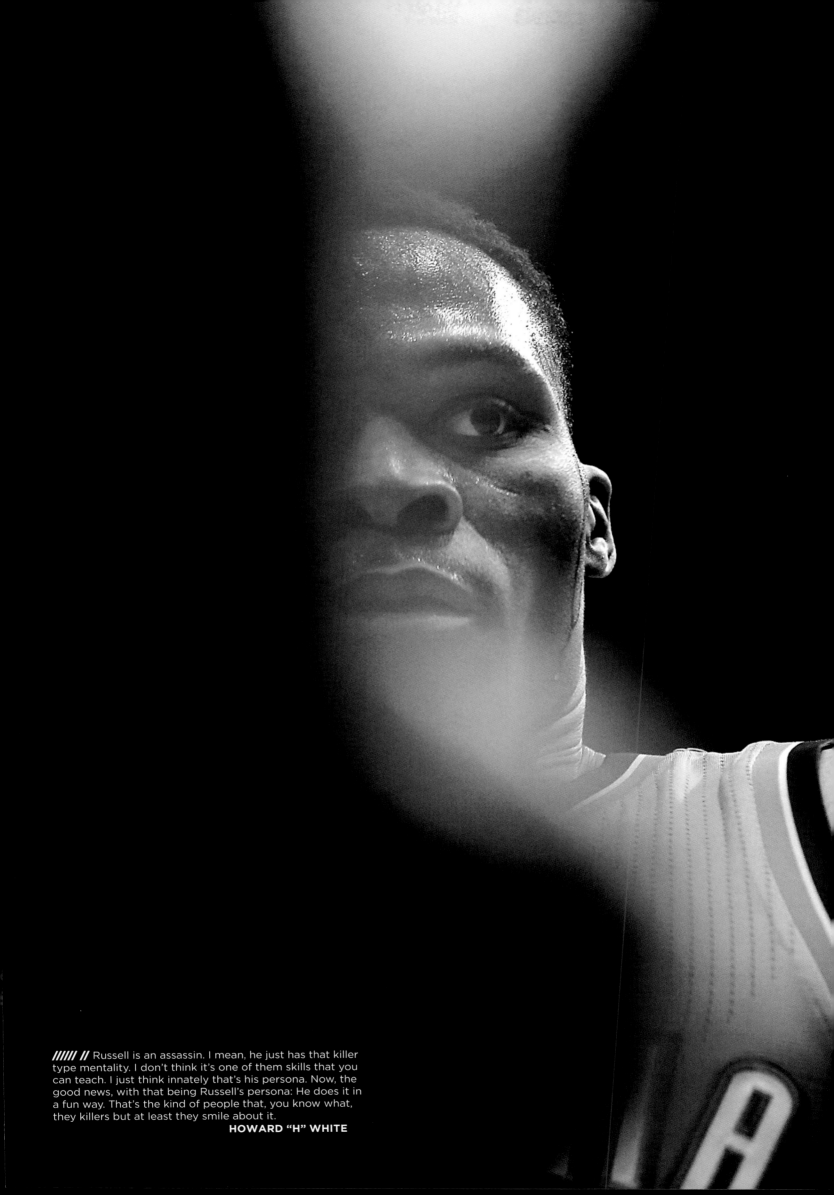

////// // Russell is an assassin. I mean, he just has that killer type mentality. I don't think it's one of them skills that you can teach. I just think innately that's his persona. Now, the good news, with that being Russell's persona: He does it in a fun way. That's the kind of people that, you know what, they killers but at least they smile about it.

**HOWARD "H" WHITE**

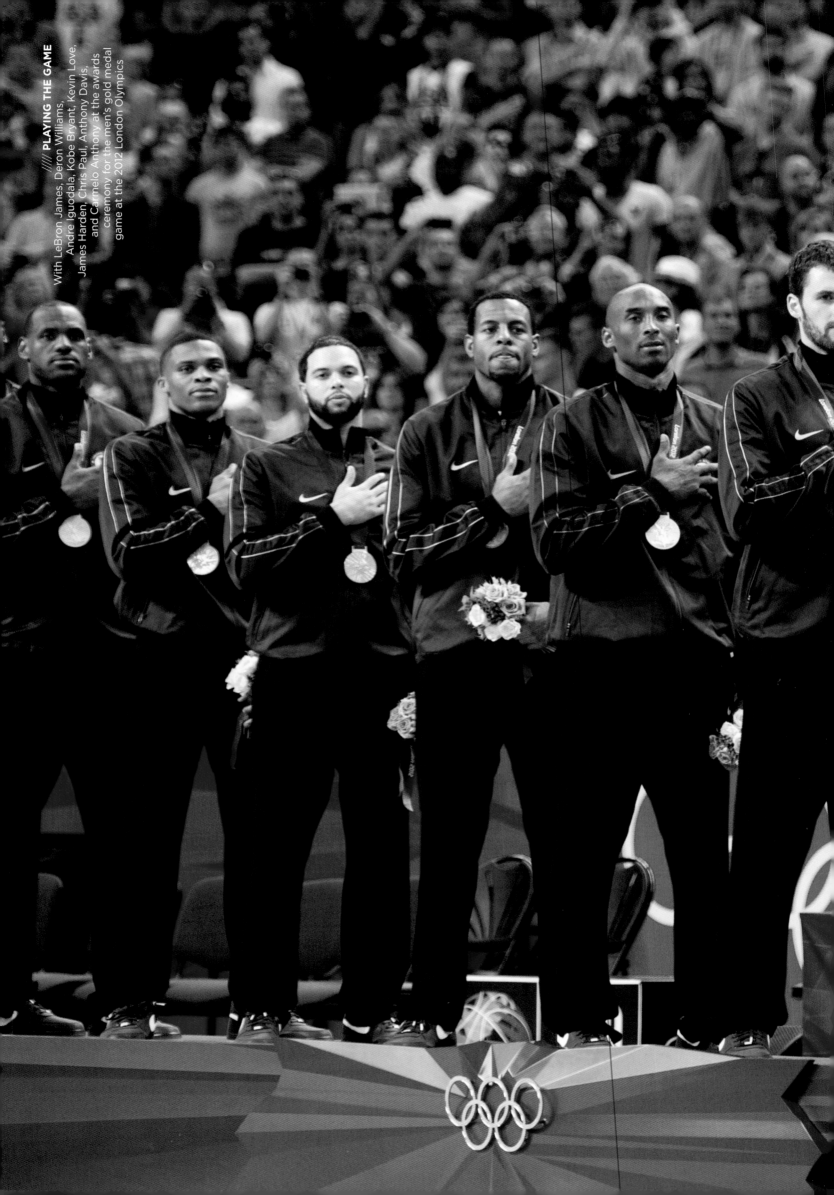

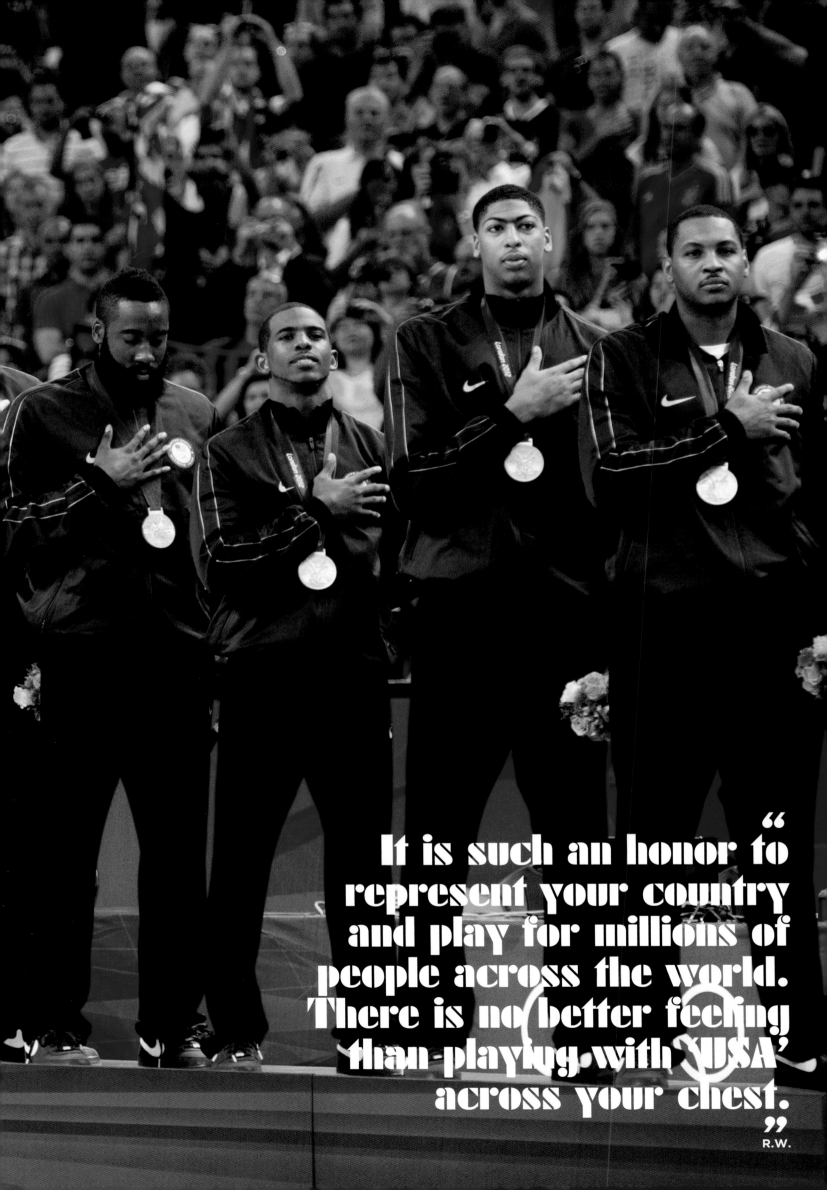

"It is such an honor to represent your country and play for millions of people across the world. There is no better feeling than playing with 'USA' across your chest."

R.W.

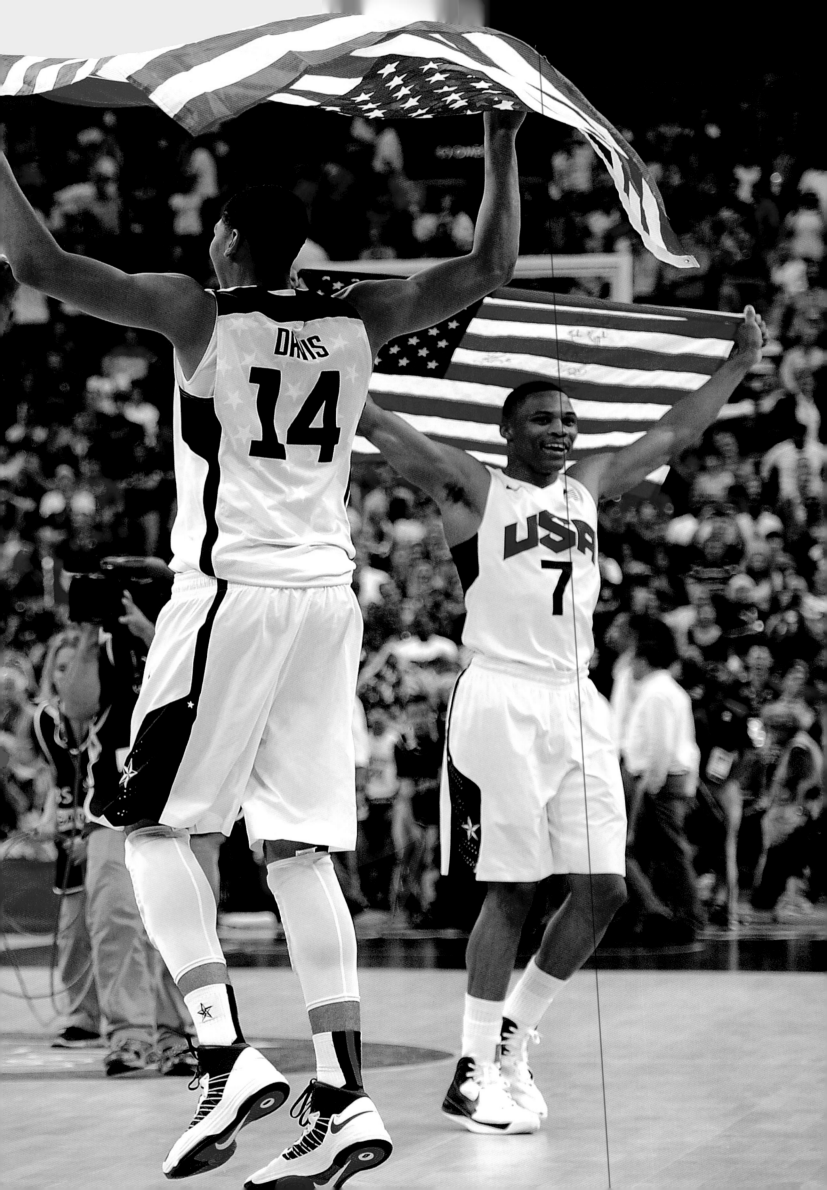

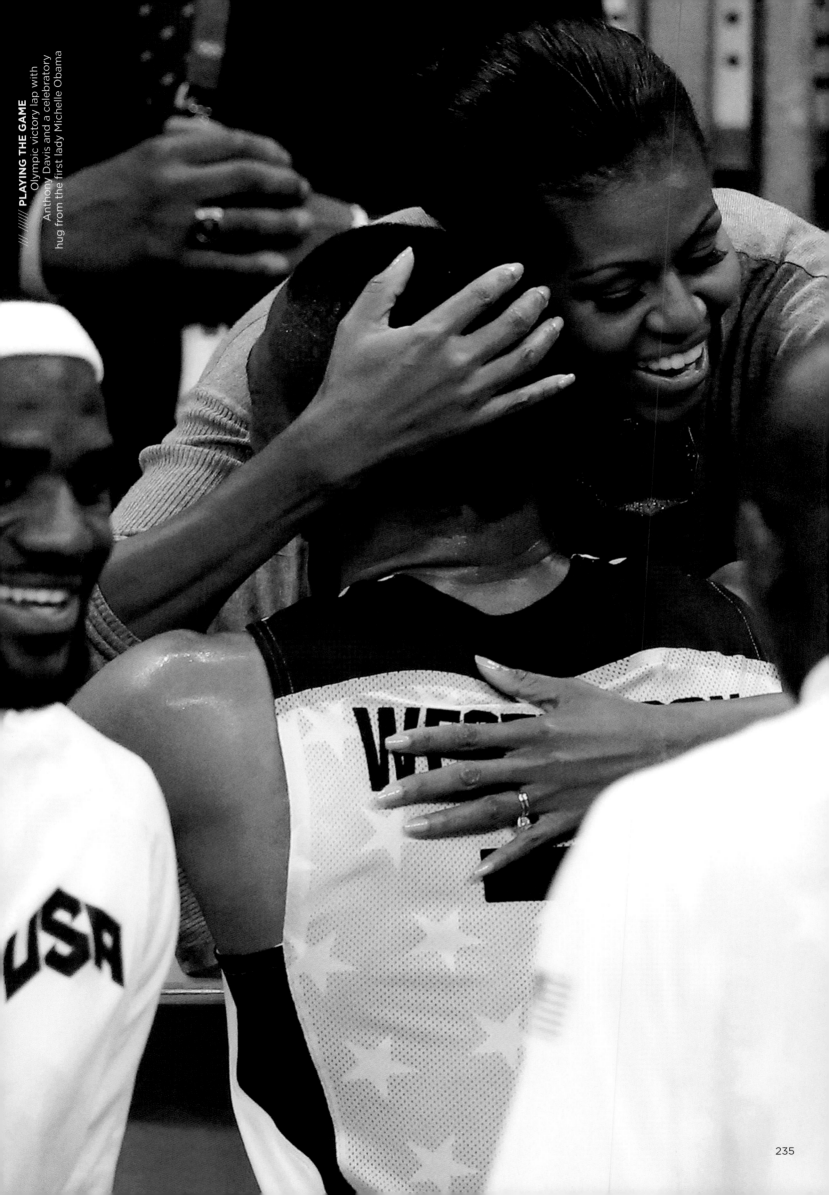

///// PLAYING THE GAME
Olympic victory lap with
Anthony Davis and a celebratory
hug from the first lady Michelle Obama

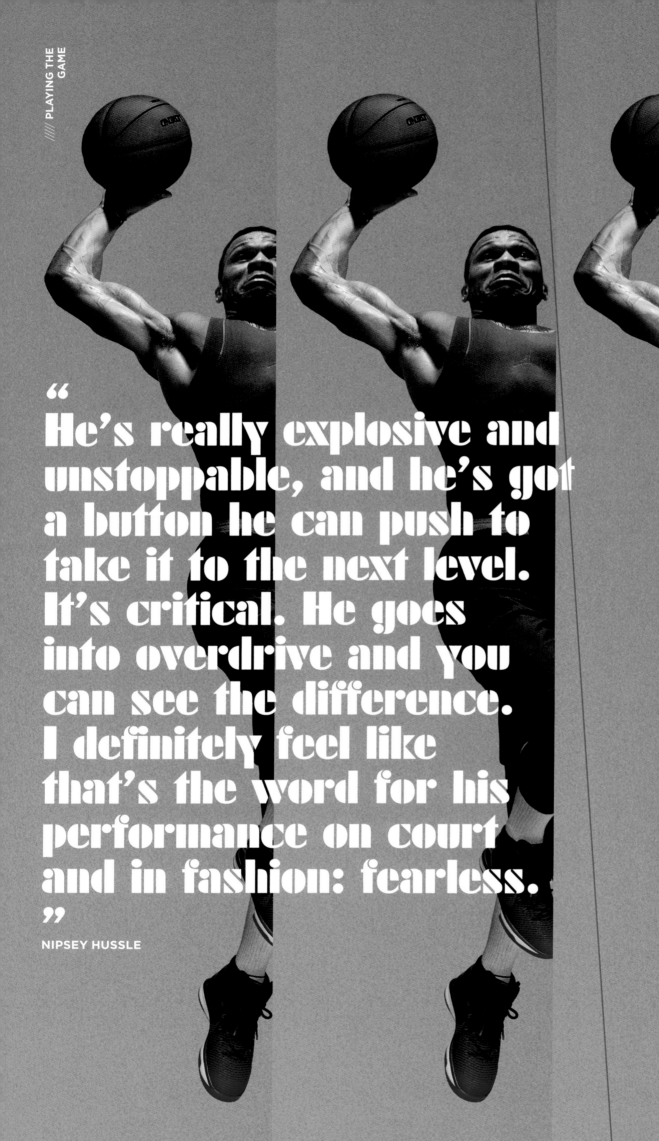

"
# He's really explosive and unstoppable, and he's got a button he can push to take it to the next level. It's critical. He goes into overdrive and you can see the difference. I definitely feel like that's the word for his performance on court and in fashion: fearless.
"

**NIPSEY HUSSLE**

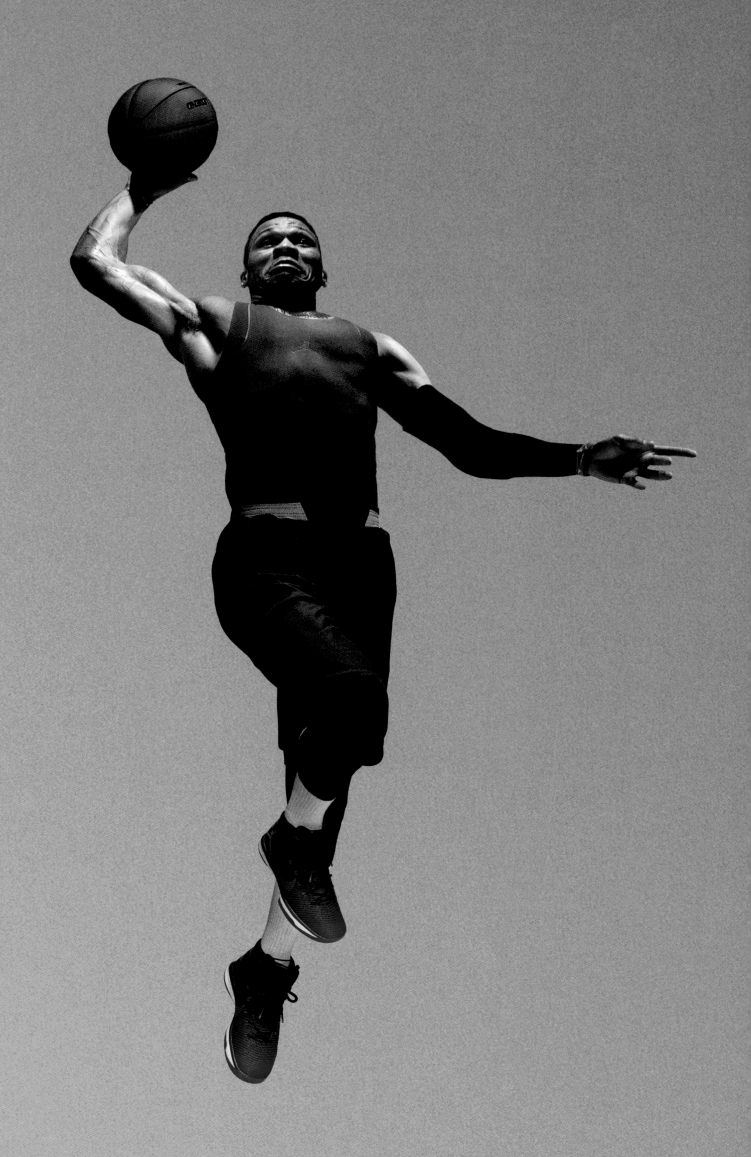

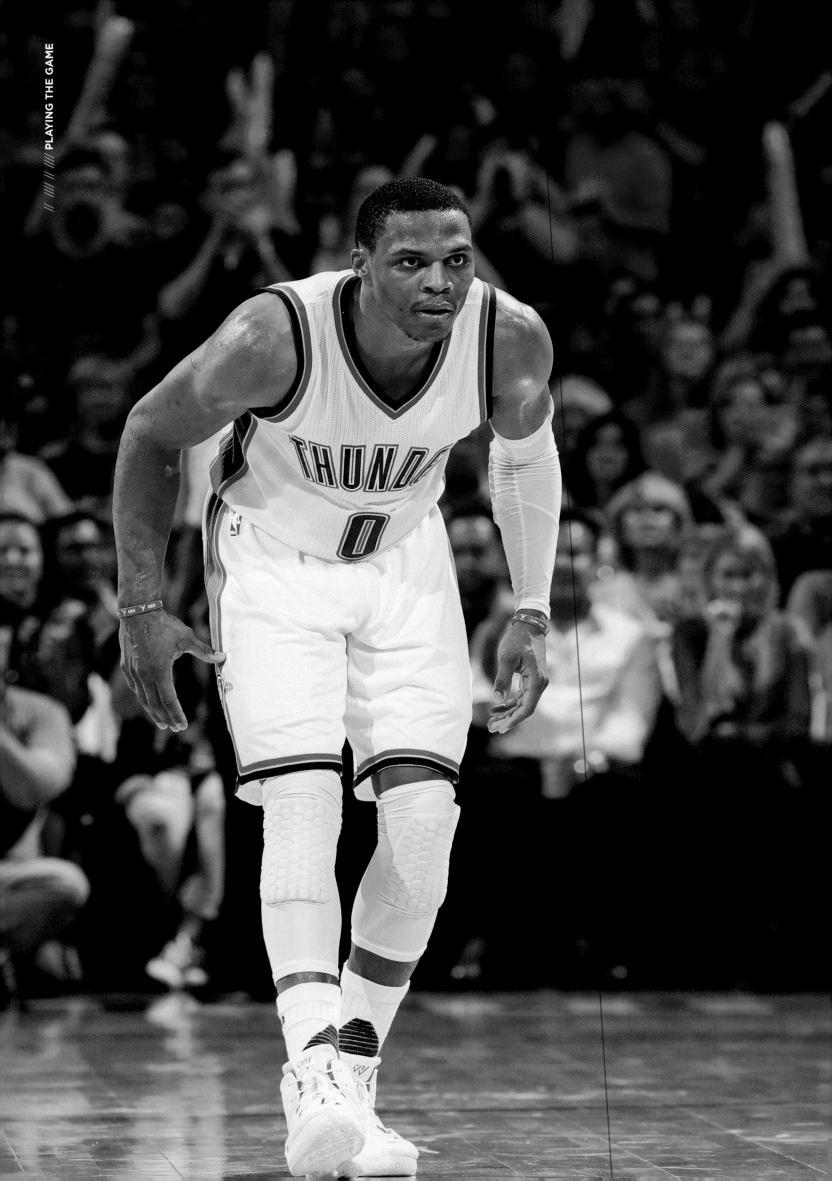

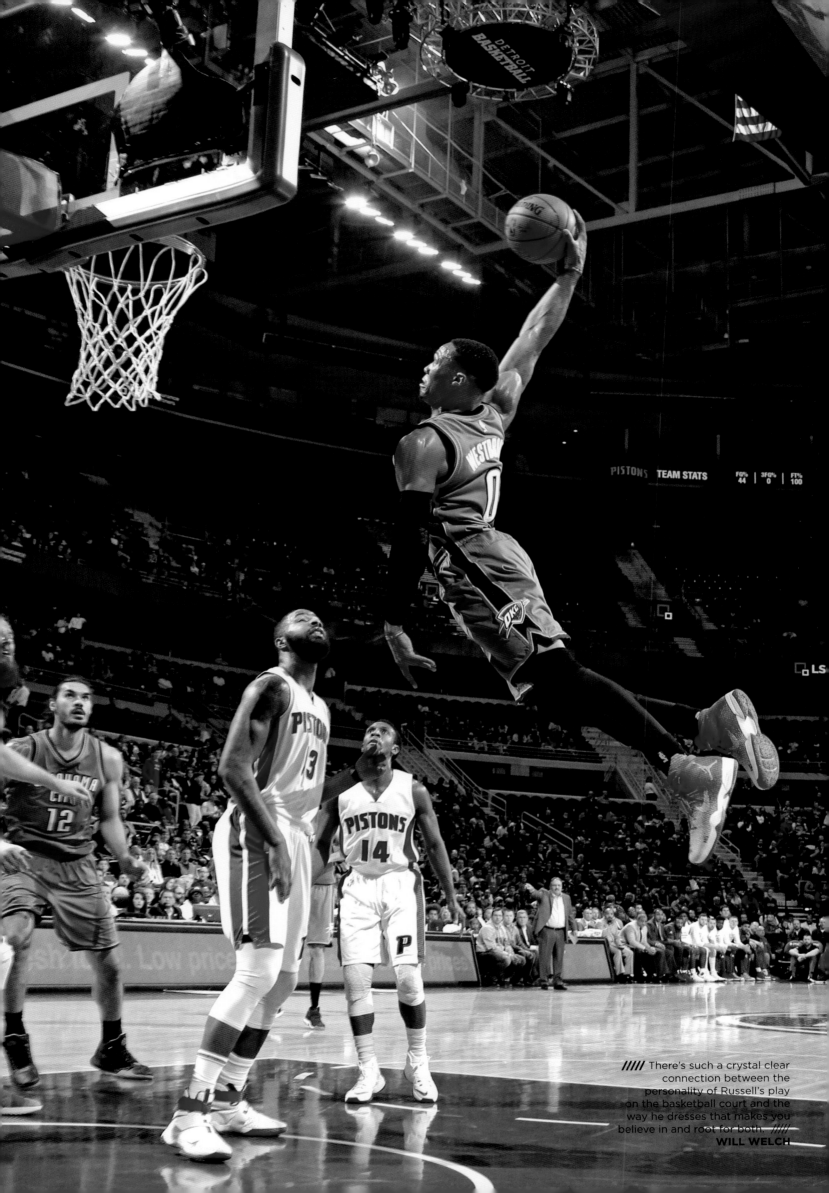

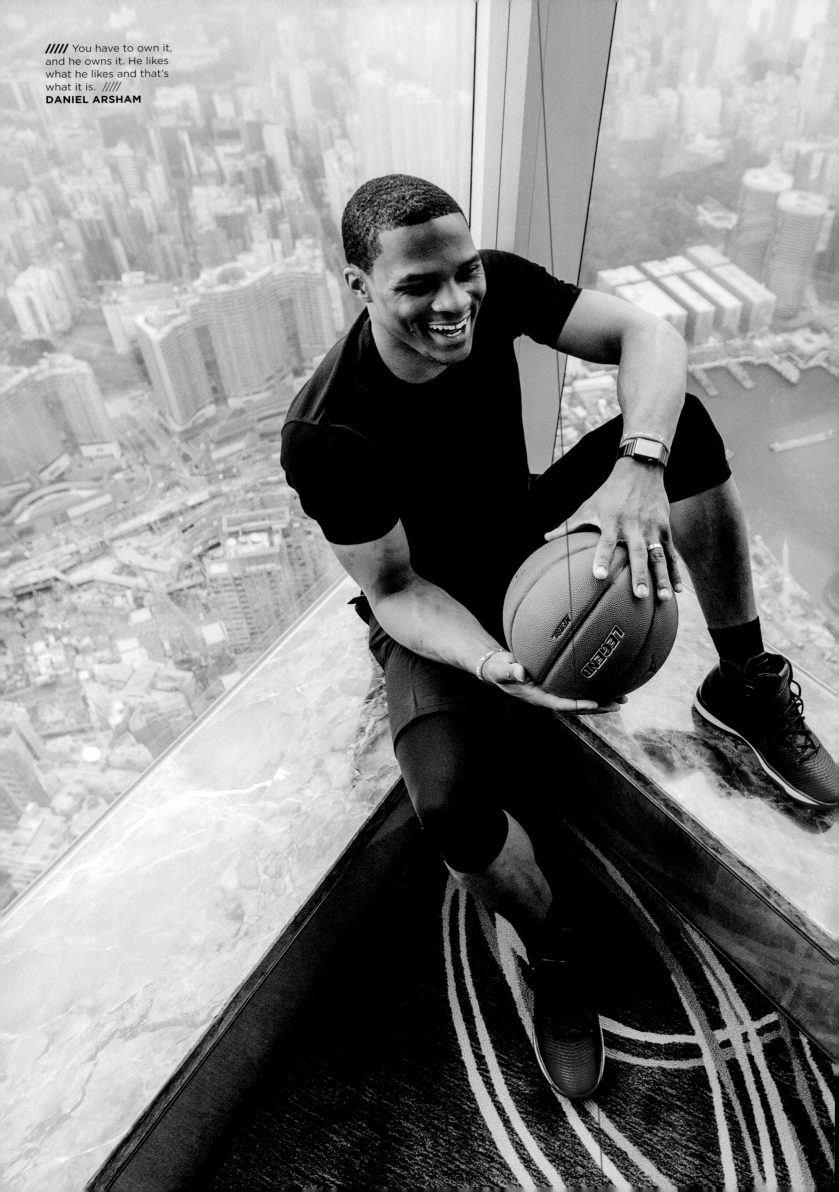

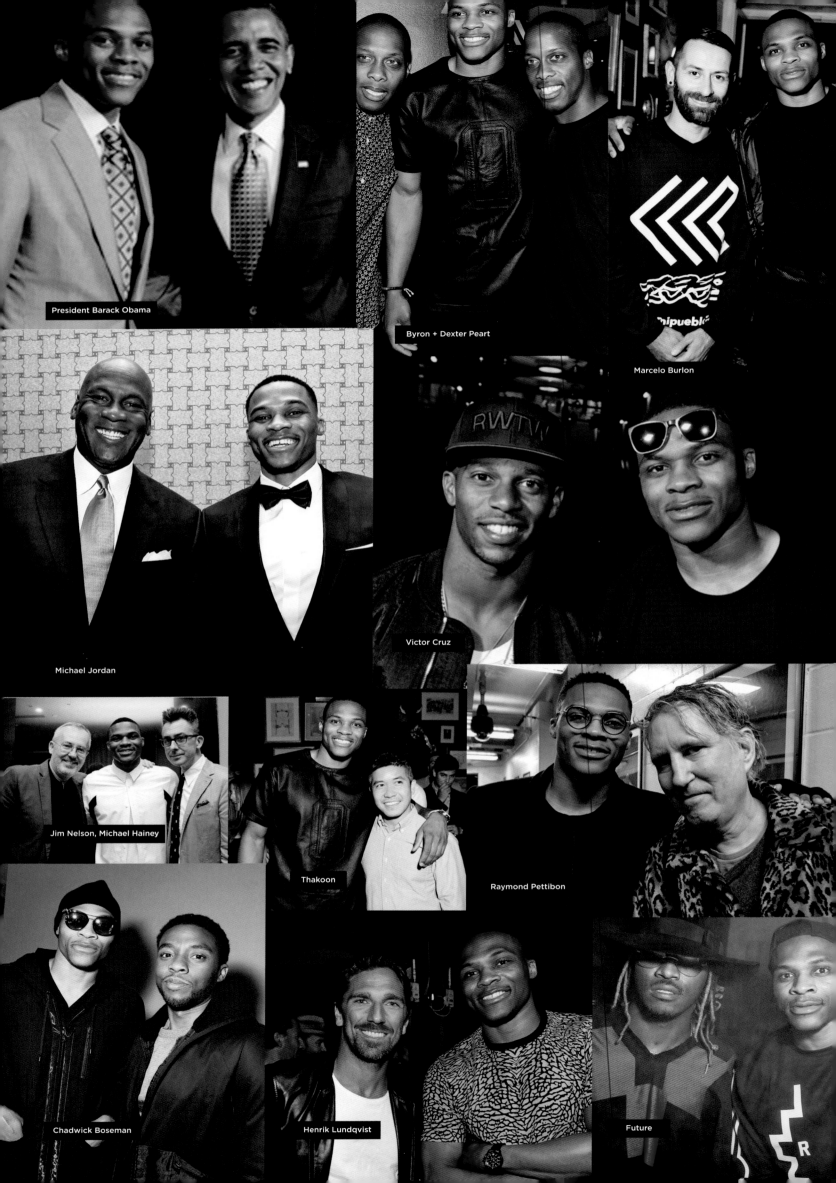

President Barack Obama

Byron + Dexter Peart

Marcelo Burlon

Michael Jordan

Victor Cruz

Jim Nelson, Michael Hainey

Thakoon

Raymond Pettibon

Chadwick Boseman

Henrik Lundqvist

Future

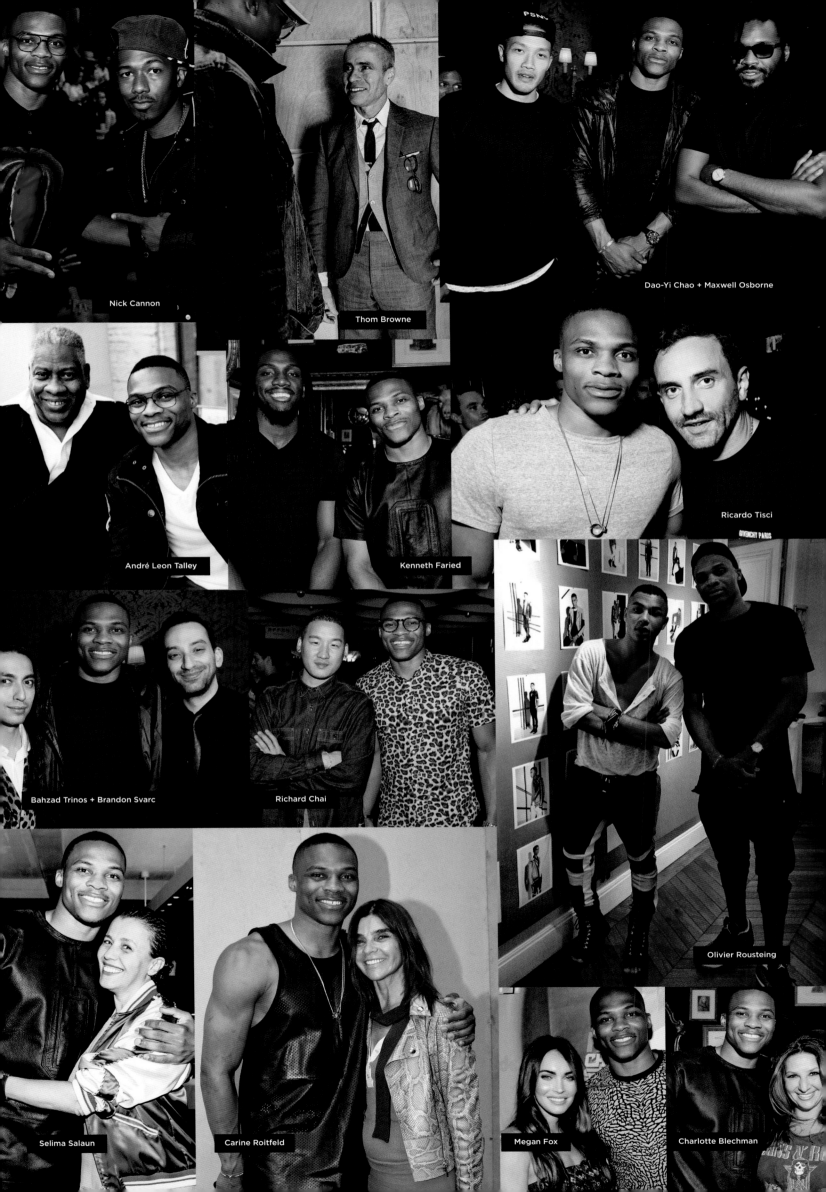

Nick Cannon

Thom Browne

Dao-Yi Chao + Maxwell Osborne

André Leon Talley

Kenneth Faried

Ricardo Tisci

Bahzad Trinos + Brandon Svarc

Richard Chai

Olivier Rousteing

Selima Salaun

Carine Roitfeld

Megan Fox

Charlotte Blechman

NBA FINALIST

OLYMPIC GOLD MEDALIST, LONDON

NBA SCORING CHAMPION

ALL-NBA TEAM

NBA ALL-STAR

ALL-STAR MVP

**Accomplished**
Too early to close the books.
Awards, accolades and records 2008
to end of the regular season 2017.

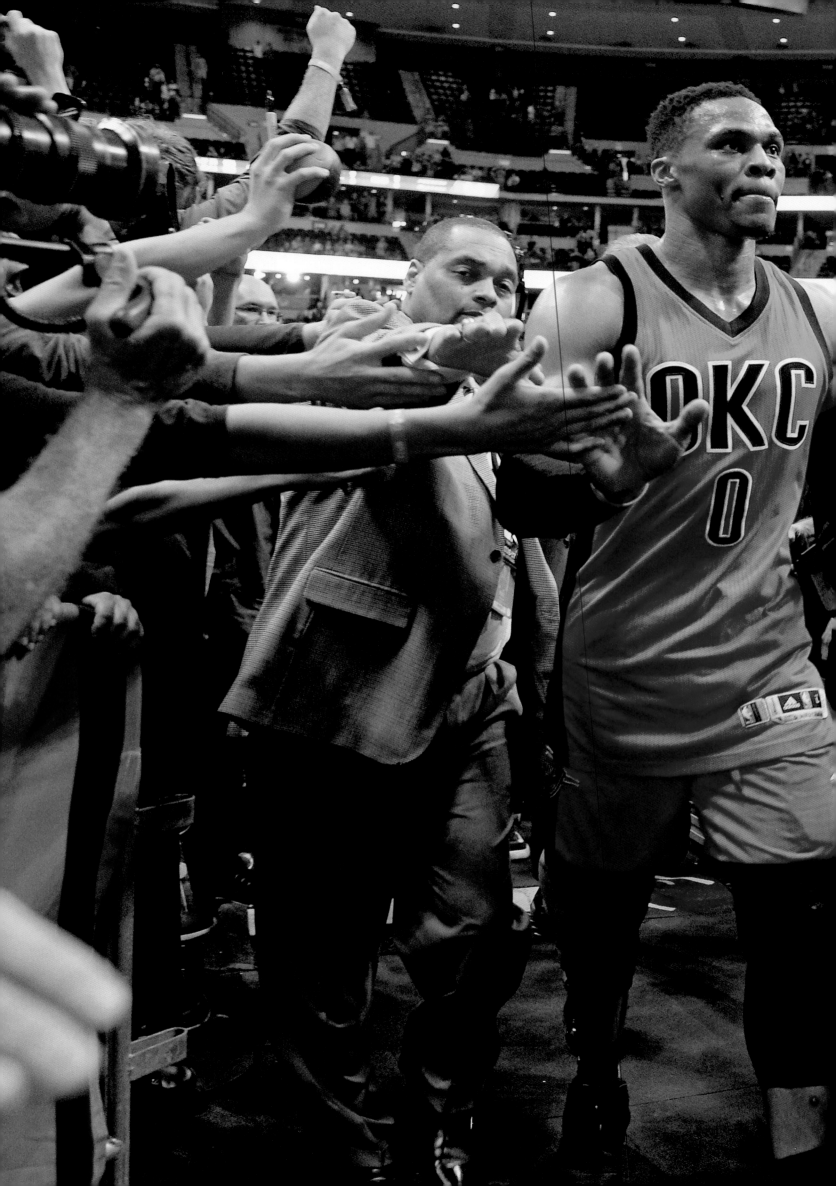

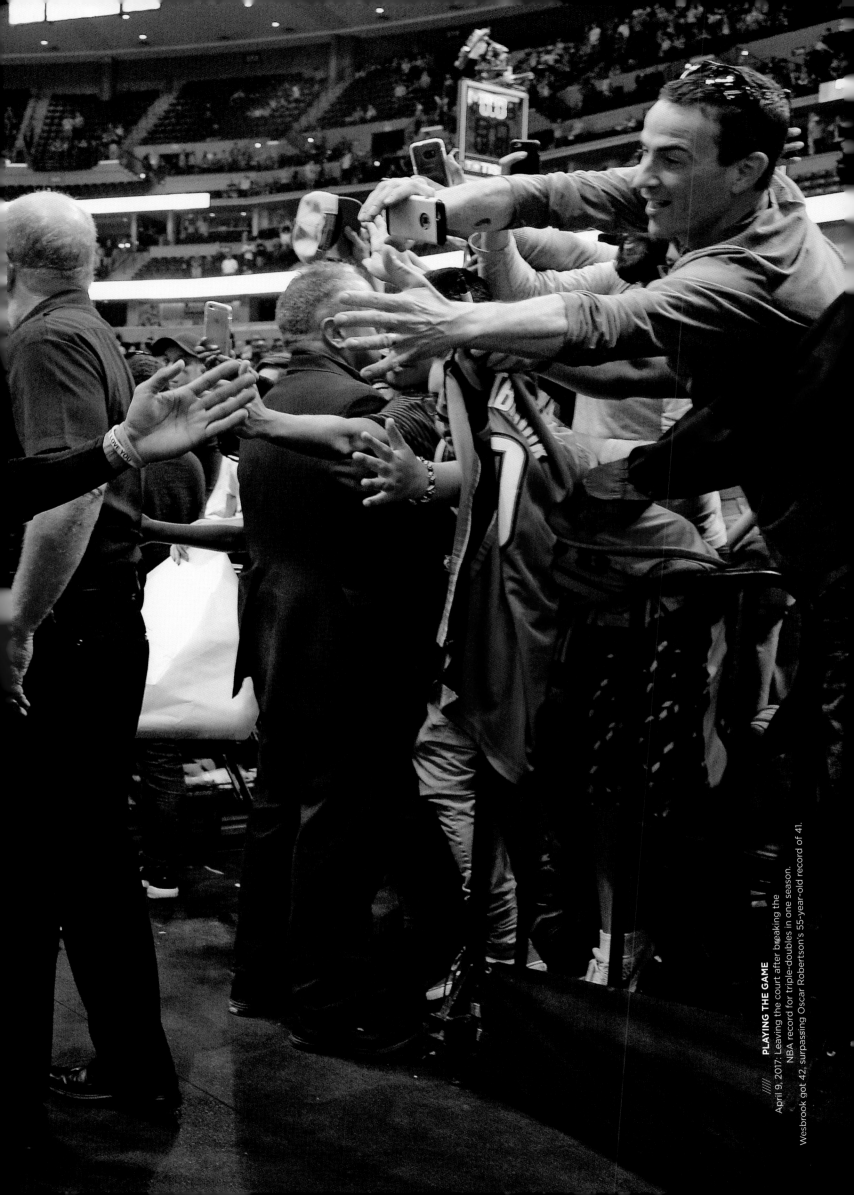

"
# I am so blessed and humbled by the things God has done for me thus far, and I look forward to the things he has planned for me.
"
**R.W.**

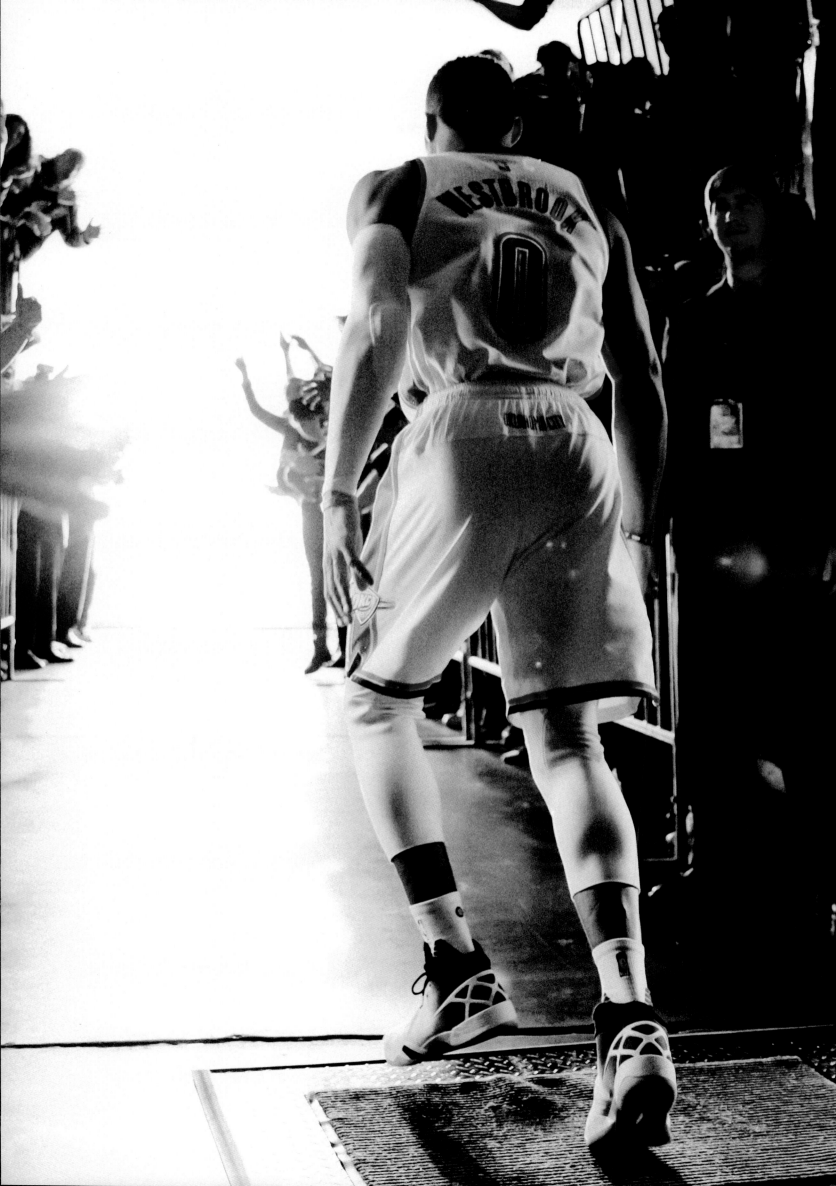

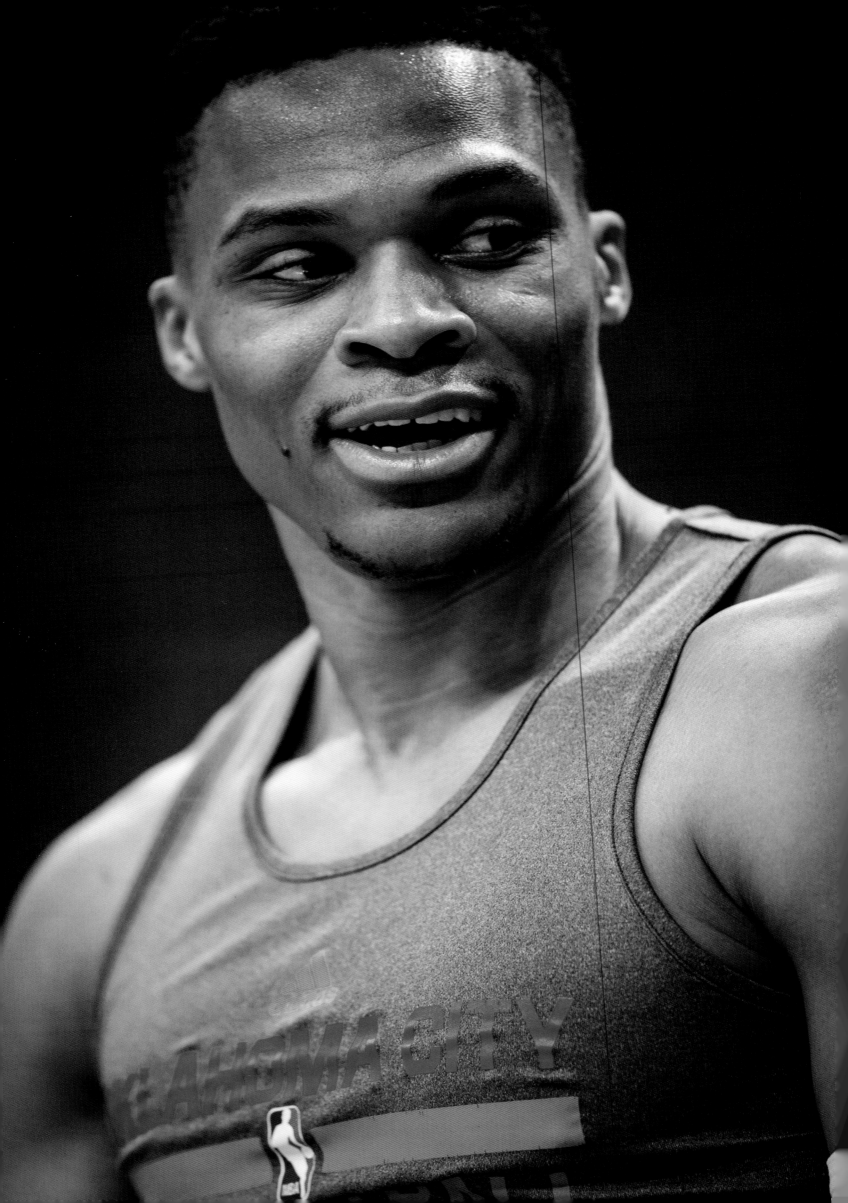

What does it mean to be a style driver? To be one of those rare few personalities who not only contributes to the conversation, but takes it to new and exciting places? When the old rules are off the table, what does it mean to play the game?

For some, it means showing up.
Doing what's required.
Doing what's necessary
to keep things moving along.

**But that's not enough.**

# "It's paying attention to the most minute details. It's seeing the little simple things that most people's eyes don't even adjust to. "

HOWARD "H" WHITE

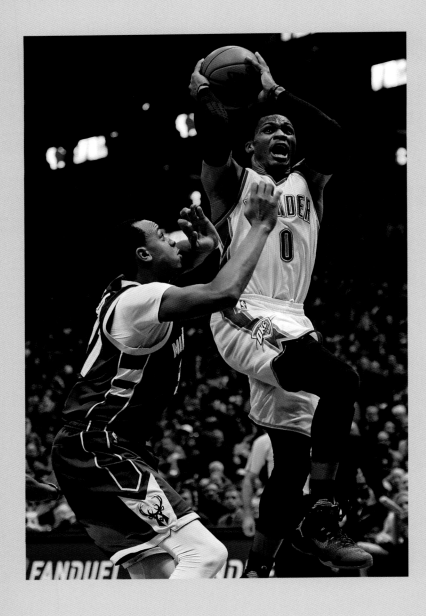

Because for others, it's so much more. It's driving, every night, toward a goal that we weren't even sure was possible. It's taking something that seemed unattainable and making it real. For more than half a century, that meant breaking Oscar Robinson's record of averaging a triple-double in a single NBA season. In the 2016–2017 season, Russell Westbrook did just that. Fifty-plus years of the same thing—and then a whole new paradigm.

But that's only part of the equation. Because playing the game means even more than just exceeding expectations when it comes to stats and scores. It means changing the nature of what we expect from the world—and ourselves.

"I think it's important that everybody exceed and do great in their primary thing that they do," says rapper Nipsey Hussle, who's happy to rely primarily on his music when it comes to success. But he also knows that it takes a little extra to rise to the top. "You got some hustlers in your crew? You got some entrepreneurs around you? If you come from that type of culture, it's going to be hard not to venture into some of those spaces where you see opportunity."

That's why Hussle launched his own streetwear line, which gives people yet another way into the world he's constructed with his music. And then there's Howard "H" White, who's seen what it takes to rise to the top of creative field over the course of three decades in the sneaker industry.

"To be successful, to move forward, to overcome, it's hard work," says H. "It's paying attention to the most minute details. It's seeing the little simple things that most people's eyes don't even adjust to. If you're willing to see those things and work toward your dreams, why not you?"

One big part of moving forward and finding a new audience is appealing to younger generations. That's

something Jennifer Fisher, who's worked with Westbrook on a collaborative line of jewelry, can attest to: "Russell's really kind of inspiring," she explains. "It's all ages, which is interesting about his style, because you've got the younger kids who watch him play."

Fisher's son has taken to wearing the slim sweatpants that Westbrook rocks on the regular as he makes his way to regular season games. But as for what's next, no one's quite sure. Even as the younger generation follows along, Russell's contemporaries are doing the same.

"He's best in class," says Byron Peart of WANT Les Essentiels. "But he still looks like someone who's having fun doing what he loves. I feel like he's got a certain edge, but at the same time, it's quite fun and quite functional."

In other words: he's having a good time. And if we all want to have a good time, too, we might want to consider breaking from the pack: "Don't let them put those four corners around you and say you can't do something," says Victor Cruz. "You can do whatever you want, as long as you put your mind to it, as long as you're passionate about the thing that you want to do and just take it from there and you can achieve everything."

Which is to say, as Barneys New York creative ambassador-at-large Simon Doonan puts it, "Style is a psychological weapon." It's how we show what we're made of—and why we won't back down. It's how we speak to the people we've never spoken to. It's how we establish identity in a world that makes it harder than ever to do so. It's the gunpowder, just waiting for a spark.

And that leaves one question, more important than anything in this entire book: where is the spark?

It's you. It's me. It's all of us. There's an explosion coming. Where will you be standing when it happens?

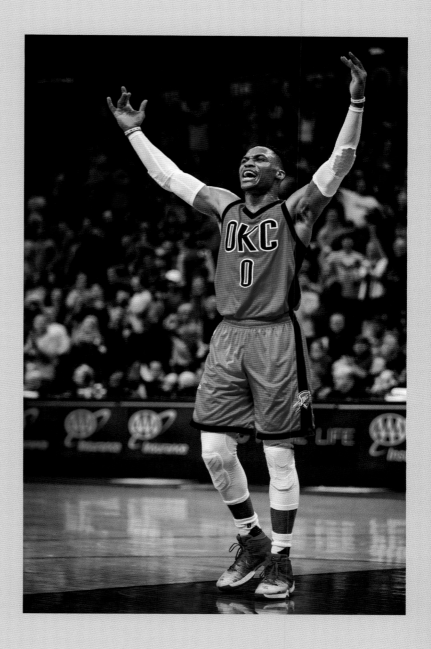

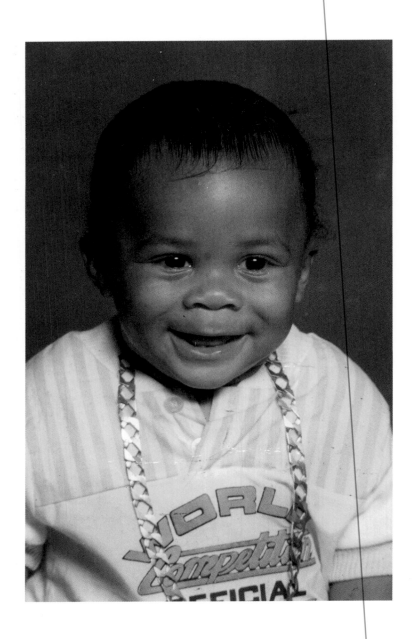

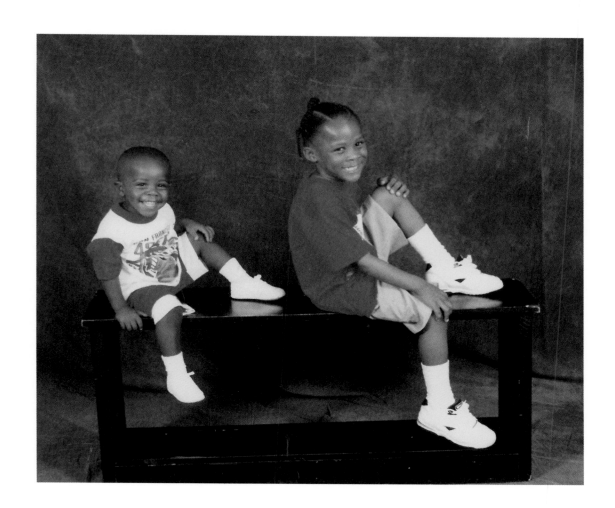

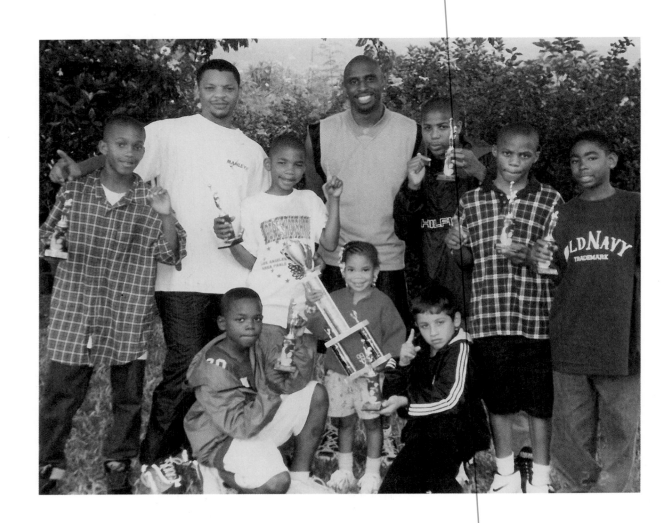

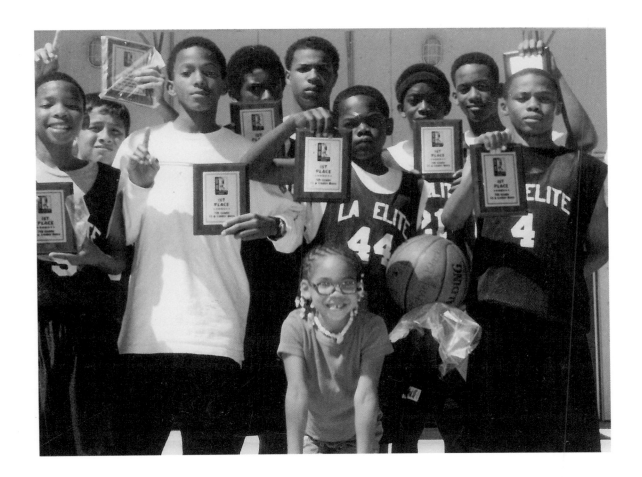

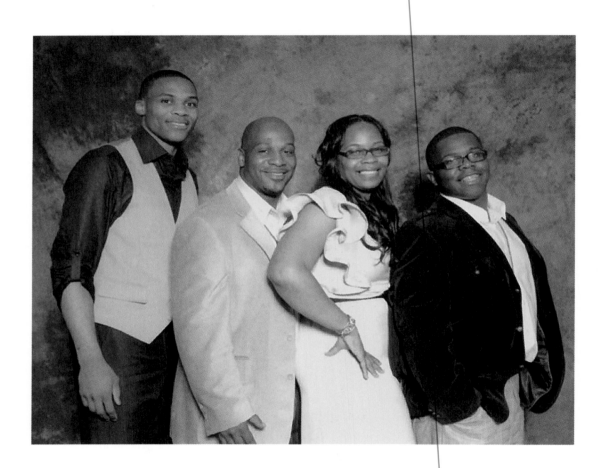

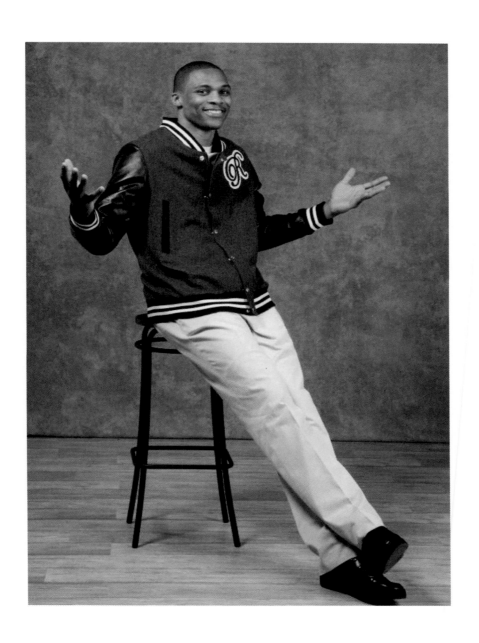

# PHOTO CREDITS

**Pages 134-135**
Larryl Pitts

**Pages 136-137**
Kevin Tachman, Trunk Archive

**Page 138**
Astrid Stawiarz, Getty Images

**Page 139**
Larryl Pitts

**Pages 140-141**
Andy Kropa, Associated Press

**Pages 142-143**
Larryl Pitts

**Pages 146-147**
Left to right, top to bottom: Dimitrios Kambouris, Getty Images for New York Fashion Week: The Shows (Prabal Gurung); Vivien Killilea, Getty Images (Opening Ceremony); Brian Killian, WireImage (Tim Coppens); Matteo Prandoni, BFA/REX/Shutterstock (Givenchy, top right); Matteo Prandoni, BFA/REX/Shutterstock (Public School); Michel Dufour, Wireimage (Givenchy, middle); Vivien Killilea, Getty Images (En Noir); Larry Busacca, Getty Images (Lacoste); Billy Farrell, BFA/REX/Shutterstock (Billy Reid); Diane Bondaref, Invision for Subway Restaurants, Associated Press (Project Subway); David X Prutting, BFA/REX/Shutterstock (Public School); Michael Stewart, WireImage (Billy Reid); Jason DeCrow, Associated Press (Altuzarra).

**Page 148**
Dominique Charriau, Getty Images

**Page 149**
Ben Gabbe, Getty Images

**Pages 150-151**
Julien Boudet, BFA/REX/Shutterstock

**Page 152**
Sam Deitch, BFA/REX/Shutterstock

**Pages 154-155**
Larryl Pitts

**Pages 156-157**
Adam Katz Sinding, Trunk Archive

**Pages 158-159**
Kevin Winter, Getty Images

**Pages 160-161**
Cedric Bihr

**Pages 162**
Adam Katz Sinding, Trunk Archive

**Pages 164-165**
Tristan Fewings, Getty Images

**Pages 166-167**
Stephane Cardinale, Corbis via Getty Images

**Pages 168-169**
Raymond Pettibon
No Title, 2016
Ink and acrylic on paper
40 x 55 inches
© Raymond Pettibon
Courtesy David Zwirner, New York

**Pages 170-171**
Emily Shur

**Pages 172-173**
Courtesy of Jordan Brand

**Pages 174-175**
Francesco Carrozzini, Trunk Archive

**Pages 176-177**
Larryl Pitts

**Pages 178-179**
Emily Shur

**Page 181**
Courtesy of Naked & Famous

**Pages 182-183**
Lauren Dukoff

**Page 184**
Jorge Peniche

**Pages 186-187**
Nipsey Hussle Social Media

**Pages 190-191**
Sebastian Kim, Management + Artists/AUGUST

**Pages 192-193**
Sølve Sundsbø, Art + Commerce

**Pages 194-195**
Unknown

**Pages 196-197**
Pari Dukovic, Trunk Archive

**Page 198**
Ben Watts, Trunk Archive

**Pages 204-205**
Raymond Pettibon
No Title (Moooovvoavv...) , 2010
Ink and acrylic on paper
Framed: 33 1/4 x 25 1/2 x 1 1/2 inches
84.5 x 64.8 x 3.8 cm
Paper: 30 x 22 1/4 inches
© Raymond Pettibon
Courtesy David Zwirner, New York

**Pages 206-207**
Harry How, Getty Images

**Page 208**
Bjorn Iooss

**Page 2009**
Zach Beeker

**Pages 210-211**
Left to right, top to bottom: Rocky Widner/NBAE via Getty Images; Ronald Martinez, Getty Images; Stacy Revere, Getty Images; David Sherman/NBAE via Getty Images; Andrew D. Bernstein/NBAE via Getty Images; Stacy Revere, Getty Images; Noah Graham/NBAE via Getty Images; Layne Murdoch Jr./NBAE via Getty Images; Andrew D. Bernstein/NBAE via Getty Images; Layne Murdoch/NBAE via Getty Images; Vaughn Ridley, Getty Images; Layne Murdoch/NBAE via Getty Images; Thearon W. Henderson, Getty Images; Jim McIsaac, Getty Images; Jed Jacobsohn, Getty Images; Nathaniel S. Butler/NBAE via Getty Images; Jesse D. Garrabrant/NBAE via Getty Images; Ronald Martinez, Getty Images.

**Pages 212-213**
Maddie Meyer, Getty Images

**Pages 214-215**
Zach Beeker

**Pages 216**
Robino Salvatore, GC Images

**Page 218-219**
Sølve Sundsbø, Art + Commerce

**Pages 220-221**
Stacy Revere, Getty Images

**Pages 222-223**
Larryl Pitts

**Pages 224**
Timothy Saccenti

**Pages 226-227**
James Devaney, GC Images

**Page 229**
Courtesy DJ Khaled

**Page 230**
Jonathan Ferrey, Getty Images

**Page 231**
Jonathan Ferrey, Getty Images

**Page 232-233**
Paul Kitagaki Jr., Zumapress

**Page 234**
Harry How, Getty Images

**Page 235**
Luke MacGregor, Reuters/Alamy

**Pages 236-237**
Timothy Saccenti

**Page 238**
Joe Murphy/NBAE via Getty Images

**Page 239**
Ronald Martinez, Getty Images

**Pages 240-241**
Courtesy of Jordan Brand

**Pages 242-243**
Left to right, top to bottom: Unknown (Obama); Joe Schildhorn, BFA/REX/Shutterstock (Peart); Matteo Prandoni, BFA/REX/Shutterstock (Burlon); Neilson Barnard, Getty Images for Mercedes-Benz Fashion Week (Cannon); Larryl Pitts (Browne); Unknown (Chao and Osborne); Layne Murdoch/NBAE via Getty Images (Jordan); Stephane Feugere (Cruz); David X Prutting, BFA/REX/Shutterstock (Leon Talley); Joe Schildhorn, BFA/REX/Shutterstock (Faried); Unkown (Tisci); Owen Kolasinski, BFA/REX/Shutterstock (Nelson and Hainey); Joe Schildhorn, BFA/REX/Shutterstock (Thakoon); Unknown (Pettibon); Matteo Prandoni, BFA/REX/Shutterstock (Svarc and Trinos); Jerritt Clark, Wireimage (Chai); Unknown (Rousteing); Matteo Prandoni, BFA/REX/Shutterstock (Boseman); Kevin Mazu, KCSports2014/WireImage (Lundqvist); Matteo Prandoni, BFA/REX/Shutterstock (Future); Joe Schildhorn, BFA/REX/Shutterstock (Salaun); Bertrand Rindoff Petroff, French Select/Getty Images (Roitfeld); Kevin Mazur, KCSports2014/WireImage (Fox); Joe Schildhorn, BFA/REX/Shutterstock (Blechman).

**Pages 246-247**
Bart Young/NBAE via Getty Images

**Pages 248-249**
Courtesy of Jordan Brand

**Page 250**
Zach Beeker

**Page 252**
Stacy Revere, Getty Images

**Page 253**
Zach Beeker

**Page 254-255**
Thearon W. Henderson, Getty Images

**Pages 258-269**
Courtesy of Russell Westbrook

056339709